T0304943

(UN)KIND

Also by Victoria Smith
Hags: The Demonisation of Middle-Aged Women

(UN)KIND

How 'Be Kind' Entrenches Sexism

VICTORIA SMITH

FLEET

FLEET

First published in Great Britain in 2025 by Fleet

1 3 5 7 9 10 8 6 4 2

A CIP catalogue record for this book
is available from the British Library.

Hardback ISBN 978-0-349-12713-2
Trade Paperback ISBN 978-0-349-12714-9

Typeset in Bembo by M Rules
Printed and bound in Great Britain by Clays Ltd, Elcograf S.p.A.

Papers used by Fleet are from well-managed forests
and other responsible sources.

MIX
Paper | Supporting
responsible forestry
FSC
www.fsc.org FSC® C104740

Fleet
An imprint of
Little, Brown Book Group
Carmelite House
50 Victoria Embankment
London EC4Y 0DZ

The authorised representative
in the EEA is
Hachette Ireland
8 Castlecourt Centre
Dublin 15, D15 XTP3, Ireland
(email: info@hbgi.ie)

An Hachette UK Company
www.hachette.co.uk

www.littlebrown.co.uk

To the women who've been told it's never enough

CONTENTS

Just Be Yourself

INTRODUCTION

The backlash is at once sophisticated and banal, deceptively 'progressive' and proudly backward. It deploys both the 'new' findings of 'scientific research' and the sentimental moralizing of yesteryear; it turns into media sound bites both the glib pronouncements of pop-psych trend-watchers and the frenzied rhetoric of New Right preachers. The backlash has succeeded in framing virtually the whole issue of women's rights in its own language.

Susan Faludi, *Backlash*

I'll define as female any psychic operation in which the self is sacrificed to make room for the desires of another.

Andrea Long Chu, *Females*

This is a book about kindness, relationships and creating a society in which everyone's needs are met. I thought I'd get

that out of the way in case it looks like I've written a guide to being a total arsehole. The truth is, I've nothing against being kind to one's fellow human beings. I just have some questions about how the newest, shiniest understanding of kindness operates. It seems that I'm not the only one.

In the autumn of 2023, Radio 4's *Woman's Hour* took to X, asking 'What does kindness mean to you?' Reader, it did not go well. Responses from women included the following:

Stop grooming women to 'be kind'. All it does is serve the interests of others.

Telling women we should be more kind when we are conditioned to put others before ourselves and the demands of our lives often mean we have no choice, should actually make women angry.

Be kind be kind be kind . . . GROAN

One woman complained: 'This is the adult version of all those little girls' clothing ranges with sparkly pink "be kind" crap':

Gender – the patriarchal tool you're all so in thrall to – teaches us to be kind no matter what, that's what facilitates us taking shit. How about asking women about FURY?

To which one man rather honourably added his agreement:

Nobody (and I mean *nobody*) expects blokes to be 'kind'. We're offensive knobs, and people just roll their eyes. Any man saying 'be kind' is being a massive hypocrite and/or wind-up merchant.

I bet *Woman's Hour* – who had painstakingly lined up some nice, gentle kindness tips from Caitlin Moran, Maureen Lipman, Anita Rani and Nadiya Hussain from *Bake Off* – seriously regretted what they'd started.

Why should a question about kindness provoke such a hostile response? Particularly when we are, according to some, experiencing a kindness revolution. A 2022 *Times* article declares kindness 'the new buzzword': 'Harry Styles lives by it. Lady Gaga swears by it. Elon Musk votes for it' (yes, even Elon Musk!) The quotation 'In a world where you can be anything, be kind', posted on Instagram by the TV presenter Caroline Flack two months before her death in February 2020, has become ever-present on social media, in political discourse, on clothing and mugs, alongside the exhortation to #JustBeKind. March 2023 even saw the University of Sussex launch the world's first Centre for Research on Kindness.

Flack was right: kindness really is more important than superficial distractions. In the face of economic instability, environmental collapse, online abuse and offline violence, what could be more restorative to the human spirit – more comforting, more essential – than empathy and compassion for one's fellow human beings? Kindness activism has been associated with suicide prevention, encouraging us to recognise that we can never be sure what others are going through, and to treat them accordingly. Yet at the same time, the 'just be kind' trend can have a darker side.

The pressure to be kind is steeped in gendered expectations and associations, even when the kindness message is deployed to challenge supposedly traditional or conservative social norms. This causes problems in several ways. Unless accompanied by significant structural change and a meaningful redistribution of resources, nominally gender-neutral exhortations to be kind will not impose the same demands

on men and boys as they do on women and girls. Moreover, the 'just be kind' requirement remains disproportionately directed at women and girls (even if it is claimed that this is not because they are female). Naturally, it is difficult to point this out without looking churlish or mean. Nevertheless, as a seasoned feminist hag, I am going to attempt it.

The belief that women and girls have a greater obligation to be kind to others – indeed, that it is our main role in life – has a long and painful history. Even if the question you are asking does not specify who should be kind to whom, millennia of social rules, expectations and conditioning affect how your question will be received. The designation of women as natural born givers is found in religious scripture which assigns us the position of helpmeet, and popular science books which claim to prove female people are more empathetic while male ones are more rational. Our supposedly greater capacity for kindness has been used to justify the disproportionate amount of care work and emotional labour we perform, and our corresponding exclusion from economic life. 'Women,' writes Katrine Marçal in *Who Cooked Adam Smith's Dinner?*, 'have never been allowed to be as selfish as men.'

It is not surprising, then, that many women do not read modern-day requests to 'just be kind' as neutral, and indeed, it is mostly women, not men, who are invited to drink from 'Kindness Every Day' coffee mugs; girls, not boys, to wear T-shirts which advertise their positivity, gratitude and generosity. Although she no longer uses X, for a time – when the site was still Twitter – the novelist Kate Long created popular threads showing photographs of T-shirts and sweaters sold in supermarkets and high street chains, highlighting the disparity between those that are marketed to girls versus those aimed at boys. Clothing for girls, she found, is festooned with the message 'that they are support animals for everyone else,

that their role is to placate, to smooth over, to make the world a happier, sunnier place and put their own needs second to that'. For boys, the message is 'to go get some'. Francesca C. Mallen, founder of the campaign Let Clothes Be Clothes, describes seeing girls' clothing with slogans such as Kind is the New Rich and Sprinkle Kindness Like Confetti. 'Kindness,' she says, 'has taken the place of the sugar and spice thing.' Slogans I've encountered myself include: It's Cool To Be Kind, Kind is the New Cool, Goals: Be Happy & Be Kind, Kindness is My Favourite Colour, Always Choose Kindness (on a Barbie pyjama set) and Bee Kind (with images of bees). At the time of writing, I also note that it is possible to purchase on eBay a set of pants for girls adorned with hearts and the slogans Be Kind, Be Happy, Be Brave and Be Nice. In case this sounds like an unfortunate one-off, in *The Keys to Kindness* Claudia Hammond reports being sent 'a picture of girls' pants in a shop with "kind" written along the waistband'. The equivalent for boys, she notes, 'had "Hogwarts" and "Xbox" on them'.

The 'gender-flipped' feminist social media account Man Who Has It All has responded to the problem by producing a range of T-shirts for women with slogans such as Not Kind and I'm Kind Enough Already Thanks (men, by contrast, are offered a bundle of man-sized shirts with Always Be Kind, Super Caring and Be a Kind Human). In an article for *Spiked*, Julie Burchill issues a 'note to clothing manufacturers – it's not girls who need reminding to be kind, judging from the violent crime statistics'. Of course, some will argue that the gendering of kindness is a hangover from less enlightened times, hence one shouldn't get too paranoid. 'Be Kind' knickers might be unfortunate, but the slogan itself is perfectly fine. The kindness activism of the 2020s is more apt to align itself with social justice movements than with the patriarchal

mindset that wishes to naturalise male aggression while pushing girls towards 'nurturing' roles. In this context, 'just being kind' can be viewed as perfectly compatible with 'smashing the gender binary' and being one's 'true self'. The problem with this is that gender, as a social hierarchy, relies on both double standards and the invisibilisation of female labour – that is, the idea that traditional 'woman's work' (particularly in the realm of caring) is a natural resource, supplied without effort due to women's 'loving' nature, hence unworthy of formal recognition. Even if you cease to differentiate between the sexes when asking for more kindness, more compassion, more inclusivity, this does not necessarily mean that your reading of what counts as kindness – or as cruelty – is the same for each. As I'll demonstrate in the coming chapters, a modern-day, superficially pro-equality version of kindness continues to interact with traditional beliefs about women and girls. The fact that much of the messaging purports to be gender neutral does not alleviate the problem so much as mask it. Nevertheless, more and more women are noticing.

In a 2023 blog post in response to the slogans on clothing marketed at her daughters, the writer Rachel Hewitt denounces 'the tyranny of nice and kind', which she argues 'has only intensified since the 1990s'. Noting that when she occasionally tells her feuding daughters to 'be nice' what she really wants is for them to be quiet, Hewitt suggests that this may be the broader cultural subtext of '#BeNice and #BeKind': 'Aren't girls and women really being told to "just shut up"?' A new way of selling old beliefs about who owes kindness to whom can start to feel like a more systematic dismantling of feminist gains, policing female speech, visibility and emotional expression. 'Until recently,' argues Burchill, '[enforced kindness] was quite rightly rejected by any fun-loving woman with a soupçon of self-respect. But it has now become a

shaming mechanism to be used against adult human females who refuse to toe the line.' Burchill's use of 'adult human female' points to the way in which this has gained particular traction in debates about sex and gender. Old entitlements are subtly reinscribed, not, we are told, because male people have the right to take whatever they want (the conservative position), but because everyone has the right to everything and 'rights aren't pie' (the 'progressive' one). As the feminist campaigner Helen Saxby has observed, 'the demand that women be "nice" and "kind" goes further than just being a matter of tone policing [...] Women are not just expected to be nice whilst fighting for our rights, we're expected to be nice instead of fighting for our rights.'

It's what I've come to think of as a 'soft' backlash, running alongside and sometimes intersecting with more obvious, hardline misogyny. So many of the things for which women and girls have fought are recast as entitlements and privileges which we should now give up. This time, it's in the name of creating a more caring, sharing world – if not for us, then for everyone else, all over again.

Introducing JustBeKindism

I've used JustBeKindism to capture the phenomenon this book explores. It is not the most elegant of terms, but I want to be clear that this is not an attack on kindness per se, and that it is distinct from (if connected to) earlier beliefs about femininity, femaleness and being kind. With JustBeKindism, I am describing a means of extracting female-coded goods that is reliant on a very particular set of cultural scripts, ones which entrench sexist expectations while purporting to do the opposite. These scripts emerge from a mixture of gendered

marketing campaigns, social justice activism, pornography and, crucially, some strands of feminism itself.

JustBeKindism is a modern, socially approved method of rehabilitating traditional, supposedly outdated ideas about the natural role, social status and inner lives of women and girls. It presents these ideas – which touch on topics such as free speech, sexual consent, reproductive justice, trauma and resource provision – as though they are a refinement of earlier feminist beliefs, ones which are now being rendered more nuanced and inclusive. At the heart of JustBeKindism is the demand that women once again embrace passivity, emotional suppression, intense self-monitoring, the erosion of boundaries, self-doubt and the transfer of female-created resources to male people. When women object to this, they are told not that they are unfeminine – an old-fashioned way of enforcing compliance – but that they are unkind.

One of the challenges of criticising JustBeKindism is that many of its proponents would declare themselves very much against the idea that women ought to be kinder than men. There is a stubborn insistence, particularly among some liberal feminists and 'progressive' male allies, that only right-wing traditionalists and those 'stuck in the past' remain attached to such an obvious double standard. In 2017's *Down Girl*, the philosopher Kate Manne powerfully critiques women's positioning as 'human givers' in relation to those she calls 'human takers', providing an analysis which had broad and extremely valuable applications. However, her preference is to focus on the misogyny of those she deems 'dominant' – that of 'the most powerful white men' – which maps, rather conveniently, onto those whom it is safe for women who move in 'progressive' circles to attack. Such an approach, justified on the basis that these men 'are the least subject to moral and legal sanctions and, indeed, may inflict harm

with impunity', necessarily pays less attention to how deeply embedded misogynist beliefs about women and girls remain in all social strata and across the political spectrum, or the way in which different social groups use different narratives to justify these beliefs and maintain their own forms of impunity. JustBeKindism provides a particular set of justifications for those who don't want to see sexism in those on 'the right side of history'. Such people just want to be nice, inclusive and empathetic, and can't bear it when others, who just so happen to be female, apparently are not.

Does it really have to be this hard?

It would be wonderful if kindness were the answer to everything. According to some, it is. Founded in 2019, the US-based Love and Kindness Project Foundation is a registered charity that 'focuses not on raising funds, like many public charities, but on "raising kindness"'. It does so by giving out love and kindness badges and providing materials and support for those who want to facilitate 'Kindness Activities'. According to their website, 'we believe that kindness is a human characteristic available to all and that it is not associated with any particular religion or set of beliefs. And we know that the antidote for unkindness is kindness.'

Who would want to disagree with any of this? Existing as pure sentiment, cleansed of the grubbiness of political bias, the kindness solution appears neat and elegant. If everyone were kind, no one would want for anything! Issues of competing rights, limited resources, physical differences and limitations – none of these things are so complex that a little kindness cannot overcome them. At a time when creating a fairer world seems difficult – when we may be told that the

experiences of people from other groups are unknowable to us, and that extensive Diversity, Equity and Inclusion training is required merely to get to grips with our own ignorance – kindness feels very straightforward. Indeed, it can be an area where not thinking too hard is not only permitted but encouraged. As the banners at the end of Juno Dawson's pro-inclusion picture book *You Need to Chill* instruct the reader, 'Don't be silly! Calm down! Chill out! No need to get worked up!' The easier it appears to 'just' be kind, the less of an excuse one has not to be. All you really have to do is listen to some Harry Styles, and maybe buy a nice mug, and ideally keep your mouth shut.

There are, alas, some problems with this. Isn't someone, somewhere, still deciding who needs to be kinder to whom, and who is receiving quite enough kindness already? Aren't political biases, tricky balancing acts and necessary harms still lurking in the background? For instance, the Love and Kindness Project declares – three sentences before insisting that kindness is not associated with religion or other beliefs – 'we believe in a pregnant person's right to choose'. As it happens, I do, too, but I know many people who would not associate such a position with kindness (in some cases due to religion, in some cases not). Not every dilemma can be solved with a love and kindness badge, and kindness advocacy can be a way of demanding one's own views are prioritised by mischaracterising any other position as motivated by a lack of empathy.

The denial that there are costs to kindness is especially risky for women and girls. This is both because feminine-coded labour – seen as coming from the goodness of our hearts – has been treated as cost-free to start with and because modern-day 'progressive' politics has begun to associate any recognition of sex difference with conservatism, limitation

and even bigotry. If traditional patriarchy has treated kindness as an unlimited resource supplied by women because it is 'in our nature', JustBeKindism promotes the unregulated redistribution of kindness on the basis that dependency on female givers will vanish if we stop noticing female people exist as a distinct sex class at all. There is a giver/taker hierarchy underpinning JustBeKindism – it's just not one that is acknowledged very clearly, not least because the very act of acknowledging has become inextricably linked with being unkind.

In writing this, I know I am hardly the first feminist to point out the injustice of expecting women to be kinder than men. It is not even the case that any criticism of kindness as a gender norm has become unfashionable due to the rise of JustBeKindism. Right now, we see feminist books with titles such as *Rage Becomes Her: The Power of Women's Anger*, *Women Don't Owe You Pretty*, *Good and Mad: The Revolutionary Power of Women's Anger*, *On Our Best Behaviour: The Price Women Pay to Be Good* and, as mentioned earlier, *Down Girl*. We see plentiful analyses of the way in which female socialisation functions to limit female entitlement to resources, and of the way in which certain behaviours – crying, complaining, the expression of anger, the withholding of care – are understood differently in women. These sit alongside nominally gender-neutral injunctions that *everyone* become more compassionate, empathetic and inclusive. Of course, defending a woman's right to express rage in the face of injustice is not necessarily at odds with expecting her to show basic human kindness. However, there is a tension in 'progressive' politics and it is one that seems to me insufficiently acknowledged. JustBeKindist feminism encourages a woman to express her feelings, set boundaries and say no to *some* people, in *some* situations, but as soon as her needs – for

attention, for sex, for babies, for language, for spaces – run up against those of other members of the 'progressive' group she may be shoved straight back into the 'be kind' box. At the same time, the earlier encouragement provides an alibi for those doing the shoving. 'Look,' they might tell her, 'you are allowed to be angry, bold and self-interested – here are all the books we have written saying so! All the T-shirts and tote bags affirming our belief that well-behaved women seldom make history! Just don't be angry about *this*, just not towards *them*, just not *right now*.'

To be fair, the JustBeKindists have a point. It *could* all be straightforward. Were it not for the inconvenient realities of female personhood, female emotions and female embodied experiences, certain 'rights' could indeed not be 'pie'. And what if kindness could be construed as women teaching themselves not to care about such realities at all? What if they could do so for the greater good, a good which includes – somehow, if you squint a bit – bringing down the patriarchy?

At some distant point, if we need to. That is, if anyone still cares.

The commandments of JustBeKindism

This book is structured around certain 'commandments' which JustBeKindism imposes on women. These all begin with 'just' because each is presented as a small, simple, trivial thing. Put together, however, they can add up to a very clear re-inscription of female duties and roles, ones which impose a high physical, economic and psychological cost on women and girls.

Just be pure

The first three chapters of this book explore the relationship between 'progressive' politics, feminism and the history of kindness as a female-coded good. Chapter One looks at kindness within feminist discourse and activism, while Chapter Two shows how kindness messaging gets distorted in male-dominated leftist spheres. Chapter Three delves into gendered socialisation and the way in which old-style expectations can be endlessly repackaged as 'new' understandings of roles and relationships.

There is no single narrative regarding the feminist position on kindness, nor is it my intention to make any sweeping (and ultimately unprovable) assertions as to whether one sex is innately kinder than the other. While most feminists have sought to unsettle assumptions about what is 'natural' in terms of female behaviour, emotions and social status, some have consciously exploited the idea of women as more nurturing and caring in order to make their case for women's rights. As today's feminism seeks to embed itself within popular social justice narratives, there are new ways in which feminists can seek to advertise their 'kindness' in order to show themselves deserving of consideration come the next round of promised social change. I will suggest this leads to a contradiction, whereby in order to reject gender norms women must first show themselves willing to embrace them, albeit using coded terminology (inclusion and allyship, for instance, rather than care and nurture).

In Chapter Two I explore the overlap between kindness as a gendered good (and bargaining tool) and as a defining feature of one's 'progressive' politics. As the psychologist Paul Bloom argues, people on the left often perceive themselves to be 'the caring ones, while conservatives are vindictive, cruel, punitive, and unfeeling'. What this means for the man on

the left can be very different to what it means for his female counterpart. Rather than be emasculated by his own politics, today's Progressive Man has the option of deploying a macho, slogan-driven version of 'kindness' with which to keep others in line. His lack of interest in feminist legacies or the roots of feminist beliefs allows him to reduce complex arguments, many of which remain unresolved amongst feminists themselves, to simplistic, often deliberately misunderstood statements: *biology is not destiny, rights aren't pie, her body, her choice.* These then operate as a shield against charges of misogyny, in a process I have dubbed 'kindsplaining'.

The overlap between nominally 'progressive' characteristics and traditionally 'feminine' characteristics also enables a blurring of the distinction between the bigoted, exclusionary woman and the merely unfeminine or gender non-conforming woman. In the context of 'progressive' politics, 'just be kind' can function as a stand-in for the more obviously regressive 'just be more feminine'. This is particularly useful when many are keen to reject gender norms without actually relinquishing any of the goods and services that women are traditionally expected to supply. In Chapter Three, I suggest that supposedly 'new' understandings of sex and gender not only continue to rely on an old-style female giver/male taker binary but make the very questioning of the hierarchy an 'unkind' act. As Tabitha Kenlon puts it in *Conduct Books and the History of the Ideal Woman,* 'the female ideal shifts very little. What changes is the justification for or the method used to achieve that ideal.'

Just be giving

One of the big sells of liberal, third-wave feminism has been that it won't cost men anything. They have nothing to lose but their inability to cry in public! This is not in fact true,

for two reasons: men are not idiots, and women are not useless. Social and economic structures which disadvantage women would not have arisen were they not providing men with something which might otherwise be withheld, or at least not supplied consistently. As some (more realistic) feminists have pointed out, the construction of women's supposedly kinder, more self-sacrificing nature functions to make resources and labour which men appropriate from women – resources and labour which they could not acquire independently – appear to be freely given. One of the problems with JustBeKindism is that while it does not specify that women should continue to be more self-sacrificing than men, it still expects enough of the same resources and labour to be floating around. As Adrienne Rich noticed in 1976, there are '"profeminist" men' who 'secretly hope that "liberation" will give them the right to shed tears while exercising their old prerogatives'.

In Chapters Four to Six, I look at three of the key forms of labour men have coercively extracted from women under patriarchy – sexual, emotional, reproductive – and how the same expectations of female service are reconfigured under the 'progressive' rubric of 'being kind'. That women should mop brows, provide men with babies and prioritise male sexual pleasure because they are nicer, softer, more passive and more giving is hardly a novel proposal; it has been the standard message of many a religious tract or conduct guide, and is still expressed, more or less explicitly, by right-wing populists. A feminism that challenges this understanding of women's 'true' nature implicitly challenges men's assurance of receiving the same goods as before. 'Just be kind' culture has found a way around this by embracing the liberalisation of laws relating to the sex trade and commercial surrogacy – industries that are not known for their kindness to women

themselves – and treating the centring of male emotional lives as a way of countering tough-man gender norms.

JustBeKindism tells men that they can be feminists, or at least feminist allies, without missing out on anything their fathers took for granted. There will be enough female emotional attention, female reproductive labour and female sexual services to go round, only this time there will be no need for coercion. It is not the sovereignty of female bodies and inner lives – the possibility not enough women will *want* to give – that could get in the way of this utopia, but 'unkind', exclusionary thinking. Women, meanwhile, will be told that progressive politics grants them total emotional, reproductive and sexual freedom, and that no one is forcing them to do anything they do not wish to do. The trouble is, many of the old-style patriarchs – who are just as keen to use moral shaming as physical force – would say that, too.

Just be inclusive

In Chapters Seven and Eight I explore the way in which being kind is associated with inclusion, in line with the use of 'exclusionary' as a term to dismiss the 'wrong' forms of feminism. Much recent social justice rhetoric treats inclusion as an unmitigated good. I'll argue that there is good inclusion and good exclusion, and that feminism has always called for a mixture of the two. Men's rights activists have often insisted that demanding both is hypocritical, as though wanting to be included in male-dominated spheres alongside asking for women-only spaces is 'trying to have it both ways'. That these are different sorts of requests should not be difficult to understand, yet it has become increasingly common for people who claim to be pro-feminist to use terms such as 'inclusion' and 'inclusive' without specifying who is being included in what.

Forgotten is the fact that sometimes feminism must ask that others stop expecting to be included in everything women are and do. Sometimes it is about insisting, as Marina Strinkovsky writes, 'I am not permeable, penetrable, all-containing. I have a border, a definition, a limit to my physical and psychic self which you are not allowed to enter.'

Chapter Seven considers how the double standard of kindness – whereby female acts are invisibilised while male ones are exaggerated – is accompanied by a double standard of inclusion. JustBeKindism enables male people to claim more space than before, with female people encouraged to make do with less, yet both are able to define themselves as 'being inclusive'. Either women include so that men don't have to, or men's 'including' takes the form of outsourcing and project managing the inclusion work done by women (and punishing those who are insufficiently inclusive). The ultimate impact of this is not to make everyone more kind and inclusive, but to reinforce already excessive boundaries for men while further eroding insufficient boundaries for women.

One of the ways in which this process can be marketed as pro-feminist is via the conflation of the boundaries patriarchal beliefs impose on women with the boundaries women might assert to defend their own bodies and spaces. In 2024's *Who's Afraid of Gender?*, Judith Butler argues that 'feminism has always insisted that what a woman is is an open-ended question, a premise that has allowed women to pursue possibilities that were traditionally denied to their sex'. While it is true that feminism has challenged the idea that a woman cannot, for instance, be a person in possession of an education, financial independence or political power, one could add that this has not been reliant on feigning confusion over the sex that is being denied such privileges. Moreover, while it can be superficially appealing

to embrace an utterly unbounded concept of 'womanhood', this runs into particular problems when addressing issues of male sexual violence. In Chapter Eight I look at the impact 'anti-exclusion' narratives have had on feminist analyses of rape, with special attention paid to those which align victim responses with bigotry, with some even going so far as to compare the desire for female-only spaces with the right-wing policing of geographical borders. The rape survivor is, as ever, subject to pressure to be nice – to not cause social and political disruption by making her complaint – only now this has been absorbed into lectures on how to be a good progressive subject. Feminist anti-rape activism has long argued that women's bodies are not unlocked properties or unconquered territories. Now, however, unkind lessons in 'inclusion', which refuse to distinguish between different types of border protection, veer towards telling victims of sexual violence to see themselves as just that.

Just be perfect

Chapter Nine focuses on the psychological impact of JustBeKindism on younger women in particular. Those who promote 'just be kind' messaging tend to be extremely mental health literate, yet this does not necessarily translate into more compassion for those who find the pressure to be ever more quiet, giving and open unbearable. The monitoring and suppression of 'bad' emotional responses is a key part of 'progressive' teachings on kindness. I trace a line back from this to earlier guidance for girls on controlling their feelings in order to become socially acceptable as adult women, exploring how female objectification encompasses politics and morality as well as physical and sexual attractiveness.

Looking good on social media means not just having the

'right' face and body but demonstrating one's commitment to having the 'right' values. In doing so, young women are often forced to suppress significant parts of themselves, while also policing and potentially withholding their empathy for and identification with other women. For some, this disproportionate degree of suppression can have serious emotional consequences, pushing them to seek other, more acceptable ways of accessing status and sympathy, given that 'weaponising' their actual traumas or demanding redress for their actual pain is deemed unkind to others. These trauma responses can take the form of punishment or rejection of the body, as modern-day porn-based definitions of femaleness merge with traditional conflations of female biology with nurture, leaving no space for independence, self-interest or autonomy.

Female personhood cannot be made less real than it actually is; female need persists, even when gets in the way of the smooth manoeuvres of the invisible hand of kindness. By denying this, we risk inflicting genuine long-term harm.

Just be yourself

In the final chapter, I ask what a genuine model of kindness and care might look like. Defining kindness in terms of allowing everyone to 'be their true self' – a definition that has positive roots in feminism and gay rights activism – is insufficient. Being kind also requires us to adapt ourselves, to suppress some characteristics at some times, to emphasise others at others. It involves an understanding of selfhood which doesn't see it as pre-formed, requiring only external validation from kind, inclusive others. The JustBeKindist model reinforces the giver/taker hierarchy by reinventing it as oppressor/oppressed, or privileged/marginalised, without allowing for shifts, reversals and overlaps. It views one set of

identities as sacrosanct and untouchable, with other people –
who, far from being 'the privileged', all too often turn out to
be the same givers as before – ordered to make space for them.
Instead of seeing us all as porous *to a degree*, JustBeKindism
sees one group as impenetrable, another as passive, vacant,
existing only to be occupied and used.

To challenge neoliberal capitalism's devaluation of care,
argues Kathleen Lynch in *Care and Capitalism*, 'one of
the first tasks is to put the relational self at the centre of
meaning-making, to move beyond the idea of the separated,
bounded and self-contained self'. This is relevant to the
hands-on, everyday work of caring for the bodies of others
(and recognising that one's own body is dependent, too), but
also to an understanding of identity as constantly, repeat-
edly co-created, as opposed to independently experienced
then witnessed and validated by an external other. The
two are interrelated, not least because while proponents
of JustBeKindism might pay lip service to the injustices
of the unpaid carer economy, they tend to see solutions in
identitarian terms (such as by shaming spoilt ladies who
outsource their duties to others) rather than recognising the
dependency denialism that extends right across the political
spectrum.

Several themes run through all of these commandments: self-
monitoring and self-objectification; emotional suppression,
shaming and self-doubt; the idea of the 'true self' versus the
'relational self'; purity policing; the invisibilisation of giver/
taker dynamics, and of gender as a hierarchy as opposed to
a flat system of differentiation. Over the course of the book,
I'll examine several recent 'feminist' texts which instruct
women – particularly younger women – to ignore feelings

of fear, disgust, resentment, anger and desire if such feelings are deemed an obstacle to other people's self-realisation. Instead of being told their feelings are sinful or unfeminine, they might now be told they are evidence of fragility, privilege, bigotry or even latent far-right tendencies. With regard to topics such as commercial surrogacy and prostitution, they may even be told that any empathy and compassion they feel for more marginalised women is proof of a less evolved moral outlook. Whenever kindness is politically inconvenient, it is recast as unkindness. (This is one of the curious features of JustBeKindism: kindness is on the one hand positioned as straightforward, natural and easy – there is often a wide-eyed 'But why would anyone . . .?' in response to the behaviour of one's political opponents – but on the other hand, kindness must sometimes be taught by expert voices, with any inappropriate interest in others recast as 'being judgemental', 'concern trolling' or 'denying other women agency'.)

There is a rampant individualism underpinning JustBeKindism. Essential elements of human experience – that we are always in the act of giving parts of ourselves away, forming and reforming ourselves in response to other people, trying to make ourselves feel what others feel – are dismissed as conservative and oppressive in calls to 'just be kind'. That the patriarchal construction of male selfhood as self-contained and self-sufficient depends on the denial of dependency on women, and the erasure of female reproductive and emotional labour, has long been noted by feminists. Over time, this dependency denialism has forced female people to contort themselves, denying their own complex relationships and needs so that the solid, true selves of male people might be endlessly reaffirmed. (That we now speak of gender itself being 'affirmed' on behalf of individuals is not so much a challenge to this process as an extension of it.)

It is possible to reject the most obvious, visible gender stereotypes while protecting those that do the most harm. Many people quite rightly reject restrictive (and clearly arbitrary) expectations placed on what they should wear, what job they should do, what their interests should be etc. simply because of the sex they are. At the same time, what they may accept, without realising it are the less visible but far more intractable moral and behavioural expectations placed on women and girls – expectations which may not be inevitable, but are in no way arbitrary, either. 'The myth of care as an inexhaustible natural resource that we can reap from feminine nature is unshakeable,' writes Marçal. 'Because we need it to be.' All too often, we only see the gender we want to see.

The cost of JustBeKindism

One way of controlling others is to embed such a deep sense of guilt and shame that it becomes part of their identity. Domestic abusers encourage their victims not to trust themselves, to always feel there are rules they haven't quite grasped, to be fearful of 'getting it wrong' and to constantly berate themselves for not 'being better'. When pleasing others is difficult, and the consequences of failing to do so are extreme, we become desperate to 'crack the code'. 'Just be kind' presents itself as one such code. Just do this one thing – how hard can it be? – and no one will have to discipline you.

In this way, JustBeKindism is a continuation of the female socialisation which leads women and girls to internalise ideas of inferiority and participate in their own marginalisation. In 1990's *The Beauty Myth*, Naomi Wolf suggested that making women feel fat and ugly was a way of countering second-wave feminism's assault on 'the feminine mystique of domesticity'.

The anti-feminist backlash, argued Wolf, was 'so violent because the ideology of beauty is the last one remaining of the old feminine ideologies that still has the power to control those women whom second wave feminism would have otherwise made relatively uncontrollable'. One can debate whether or not this was true for most women; for my part, I think one can rationally reject beauty standards as absurd while still experiencing a perpetual sense of discomfort at inhabiting an 'imperfect' body. Such a sense of discomfort can be profoundly limiting, creating a constant, low-level feeling of inadequacy which prompts us to give more to others and take less for ourselves. No one else hears this background noise; all they see is someone who is 'naturally' restrained. The difference between beauty standards and those relating to kindness, empathy and inclusion is that beauty and thinness can be dismissed as trivial in a way that kindness can't and indeed shouldn't be. It is much harder to get to the stage of critiquing one's own feelings of inadequacy when they have been tied to something that even those who denounce 'traditional' values would deem to be a universal good.

Just as it is impossible to achieve the perfect body, it is impossible to 'do kindness' perfectly. More than that: just as a woman's work is never done, women's acts of kindness are instantly coded as 'natural' and hence not really kindness at all. There is always more to be done, always more space to cede, always too much ugly, unsightly female selfhood remaining. Until the double standard of kindness is acknowledged and dismantled – which it cannot be until we face up to how and why kindness is gendered to begin with – women and girls will be made to feel terrible about themselves in the name of 'doing good'. I find this intolerable. I refuse to accept that constantly feeling ashamed and inadequate demonstrates a more refined feminist sensibility. It is not helping women at all.

Kindness, feminism and the 'war on woke'

I am conscious that, to some, everything I have written thus far may sound like an excuse. Perhaps I don't *really* have an issue with the pressure to be kind as it is currently manifested in contemporary social justice movements. Perhaps I just don't like social justice.

This book is not a criticism of kindness, empathy, compassion etc. as 'woke' concepts, but a critique of how a particular interpretation of kindness functions to condition, exploit, shame and/or silence women and girls. It is not written from a left or right perspective, but a feminist one. My own view is that, all things being equal (which of course they rarely are), feminism, as a project that opposes hierarchy and favours resource redistribution, has a more natural home in left-wing politics than on the right. However, like many women who hold this view, I do not always find the politics of those who call themselves left wing particularly feminist. The misogyny shown by many self-styled 'progressive' men, and by many mainstream left-wing parties, can be dismaying, even when set against the right's more rampant refusal to accommodate the social change that feminism demands. I do not want to fall into the trap of denouncing 'snowflakes' and viewing all demands for care and inclusion as potential manipulation. Indeed, one of the reasons for writing this is my own fear of hardening towards that to which we should remain soft and open. When the phrase 'just be kind', or even the word 'kindness', starts to trigger an angry or even fearful response – when women respond to questions such as that asked by *Woman's Hour* with such open mistrust – there is a problem.

Some of the positions with which I take issue have already been challenged from a non-feminist perspective. For instance,

in works such as Andrew Doyle's *The New Puritans* and Jonathan Haidt and Greg Lukianoff's *The Coddling of the American Mind* it has been suggested that demands for more kindness and inclusivity become a means for pampered left-wing elites to play the victim, encouraging young people to react to imaginary threats while bullying others via charges of bigotry. These analyses tend to position feminism in general as implicated in progressive overreach, whereas I would argue that in JustBeKindism we see a convergence of left and right expectations of women (the same goods and services are being sought, albeit via different routes). One thing I wish to do is tease out the gendered coding of mainstream politics, and the way in which it interacts with gendered positions and attitudes. The right, which tends to code itself as masculine, responds to the feminine coding of kindness by using it as a means to attack a supposedly 'feminised' left, perhaps even blaming this 'feminisation' on feminists themselves. When feminists point out that 'kind' authoritarianism has come for them, too, potential right-wing allies often suggest we should have been careful what we wished for. If left-wing politics is not actually kind to women, well, then, feminists shouldn't have been so hasty to throw our lot in with it. To this I would counter that even if the 'feminised', 'soft' qualities of kindness and inclusion have been claimed by the mainstream left, this does not make its embrace of JustBeKindism feminist. On the contrary, by sharing with the right the belief that kindness is female-coded (even if this is more implicit than explicit), much of the left shares a horror of kindness being directed towards the 'wrong' group, the designated givers as opposed to the takers.

The belief that women are simply meant to be kinder – that it costs us less to give and that, therefore, what we do give doesn't have to be appreciated – has never relied on just one script in order to justify itself. Sometimes it uses religion;

sometimes it is science; sometimes it is nature. Multiple scripts can co-exist and be deployed by different groups, in different ways, at the same time. For many people today, the belief that women should be kinder than men remains rooted in the kind of social conservatism that the self-styled 'woke' would actively reject. The latter, however, have their own scripts. Much of the 'new' positioning of woman-as-giver draws on scripts provided by queer theory and pornography, repackaging the old idea of female people as passive, hollowed-out masochists as one of the edgier insights of twenty-first-century gender and sexual liberation. Because both groups consider their beliefs to be polar opposites, it is difficult to critique one without being accused of supporting the other, in what I have come to think of as feminism's jealous boyfriend problem: *if you're not with me, it's because you're with him.* If women are not accepting all that comes with being at one end of a highly polarised political spectrum, it's assumed it's because we're accepting all that comes with being on the other. Since both sides wish to position us as subordinate, one could say there is a startling lack of imagination on the part of those who cannot conceive of there being any other explanation.

There are analyses of contemporary political polarisation and leftist authoritarianism which take a more nuanced approach (one example would be Yascha Mounk's *The Identity Trap*). Still, while these defend some feminist positions which are under attack from the left (such as the right for women to organise politically on the basis of sex), these are not feminist texts per se. Relatively little attention is paid to the way in which leftist authoritarianism intersects with left-wing anti-feminism, or to arguments against identitarianism which have their roots in feminist theory (one honourable exception is Umut Özkirimli's *Cancelled*). To claim, for instance, that we are witnessing an unhealthy fracturing of identities due to an

identitarian approach which aligns with or has some roots in feminism is to overlook the stress many feminists have placed on the importance of identity formation through relationships. There are strands of feminism – especially maternal feminism, and feminism which focuses on the ethics of care – which have long warned of the problem of prioritising a 'true' self at the expense of a relational, dependent one. Not just left and right, but also many 'voices of reason' in between ignore feminist thought which stresses the importance of mutuality and dependency, and the way in which patriarchy's division of the world into the givers and the takers (or, more recently, the allies and the deserving marginalised) denies this.

Social justice is not simply about sex and gender, nor even the way in which sex and gender intersect with other experiences, positionings and/or identities. However, there is something specifically gender normative, anti-woman and anti-feminist about the current approach taken by many 'progressives'. It is not the case that one side (the kind, woke side) 'does' feminism because it 'does' all social justice issues, while the other (the mean, right-wing side) ignores them. There's also the question of *how* these issues are done, and here I will argue that a good deal of feminist thought and female experience have been left outside the binaries that characterise the so-called culture wars of the 2020s. There's a crude narrative that suggests second-wave radical feminists were too extreme and unrealistic to have lasting mainstream influence, whereas more recent liberal feminists have gone all out to embrace sex difference denialism and the porn industry, and can hardly complain now if women's rights are in jeopardy. What this excludes is feminist thinking which pre-emptively offered a diagnosis – and the beginnings of a solution – for the problems we are facing now. For instance, in 1982's *In a Different Voice* Carol Gilligan interrogates what empathy, kindness and

justice mean for different people, not least in relation to a person's sex and the socialisation they have experienced. Current one-sided demands for kindness lack this nuance; they cleave to a masculinist understanding of how people are constructed (independently, with relationships only coming later) and how need operates (in one direction only).

In a 1987 speech Andrea Dworkin complained that both 'the right and the left appear not to understand what it is that feminists are trying to do'. This was, she said, 'to destroy a sex hierarchy, a race hierarchy, an economic hierarchy, in which women are hurt, are disempowered, and in which society celebrates cruelty over us'. Right now it can feel as though the sex and gender component of the culture wars is not a battle between the forces of feminism and those of anti-feminism, but a disagreement over how best to exploit female bodies and labour. It is not so much a matter of whether to do so, but how, and women and girls are pressured to pick a side – either that of the 'woke' feminists, cobbling together moral justifications for the sex trade and commercial surrogacy, or that of 'reactionary' feminists, calling for a return to 'traditional' values as though this was the best we could ever have hoped for. Yet we can do better. The enormous gains women have already made show that we can do better. Vital in this is that we do not allow ourselves to be told we are cruel, or selfish, or have allied ourselves with the wrong people. It is not unkind to say women should get to define our politics for ourselves.

A note on language

Yes, I know – why would you want a note on language from someone who's trying to make JustBeKindism and kindsplaining happen? I'm going to provide one all the same.

Over the course of this book, when I refer to women and girls I am referring to the female sex class. I should probably give a long explanation as to why this is the case, peppered with over-laboured qualifications and apologies. I'm also conscious that were I to do this, it would suggest there was something slightly questionable – unkind, even – in me choosing to allocate these words to this particular group as opposed to anyone else who might want them.

I don't think it's entitled or greedy for me to do this. On the contrary, it speaks to the nature of the problem I am describing that anyone might think this (and I know some will). To reject what some might consider a kinder, more inclusive definition of women and girls is not an arbitrary act of cruelty; it is to declare myself unwilling to pay the cost of giving up clarity, boundaries, coherent analysis – all things that have been considered unfeminine and which women have been considered selfish for wanting to claim for themselves. Discussions about femaleness and kindness continually return to the question of socialisation: who is doing what to whom, who expects what from whom, and why. They necessitate the identification of connections. I could, for instance, have disconnected Chapter Six from the rest of this book by referring to surrogate mothers as 'gestators' rather than women – Sophie Lewis boasts of having 'felt no need to use the phrase "women and girls" at any point' in her 2019 book *Full Surrogacy Now* – but I do feel this need, very deeply.

I don't suggest there is no cost to my approach, but this does not make it unjust. That some might feel pained by this is not due to female people claiming something which isn't theirs to take. There is, I find, something slightly torturous in reading feminist arguments where the author means 'biologically female people' but also demands that you bear in mind that they might not mean it – that really, to be on the safe

side, they could mean anything at all. It feels as though you are being handed something with the proviso that anyone can chip away at it. As though the act of holding is, for women, much too close to withholding. Don't take your selfhood too seriously! Don't be getting any ideas!

Please: do be getting ideas. We owe it to ourselves.

JUST BE PURE

1

WHAT IS YOUR FEMINISM EVEN FOR?

Some people ask, 'Why the word feminist? Why not just say you are a believer in human rights, or something like that?' Because that would be dishonest.

Chimamanda Ngozi Adichie,
We Should All Be Feminists

I believe it is negligent for feminists to focus only on those who are female-bodied.

Julia Serano, *Whipping Girl*

When I was growing up, there was a phrase I'd sometimes hear when it was felt another person was taking advantage of your goodwill: *Shall I just stick a broom up my arse and sweep as I go along?* It's the kind of thing you'd say if you'd been asked to do one thing, then another thing got added, and ooh, just one more, since you're already doing the other two. These days it's a phrase I often find myself thinking of in relation to feminism. Feminism: the movement for women,

and children, and hey, why not men as well? You know, just while we're at it? We could even rebrand it 'liberation for all genders'! Of all branches of social justice activism, feminism seems to be the one that's not permitted to focus on the original job in hand, the liberation of all women (god knows, there's enough of us, with enough variation between us). Feminism must stick a broom up its arse and sweep as it goes along.

'There is no longer any expectation that being a feminist requires you to do anything feminist whatsoever,' writes Julie Bindel in 2021's *Feminism for Women*; 'feminism has been rebranded and repackaged as a "just be kind and nice to everyone" cause.' There's another phrase I think of in this context: it's when you're on your hands and knees, clearing up someone else's mess, and someone utters the words 'while you're down there ...' (usually with more than a hint of innuendo). Always there's that implication that someone else *would* do whatever the additional task happens to be, but the thing is, you're already in the right place. It can feel like that with feminism. It's not that women *should* be expected to be kinder, more inclusive, more self-sacrificing, more generous, but you know ... since we're conditioned to be that way ... since we're already down there, wouldn't it be a terrible waste not to put it to good use? Sure, men *could* have a movement of their own, but let's face it, we've seen what happens with that. Women have all that lovely female socialisation, making them perfect should there be a need for someone to prioritise others, wait their turn, or maybe not have a turn at all.

It's not that feminists are supposed to be against the whole idea of women asserting themselves and saying 'no'. 'I myself have never been able to find out precisely what feminism is,' wrote Rebecca West in 1915. 'I only know that people call me a feminist whenever I express sentiments that differentiate

me from a doormat or a prostitute.' It's a quote one still sees reproduced on feminist merchandise today (albeit with the rather problematic 'or a prostitute' removed – indeed, I was quite tempted to miss it off here). Part of the way in which feminism is marketed – or exploited by people wishing to sell mugs and tote bags – is through the image of the non-compliant woman. At the same time, the movement has been absorbed into a broader, more powerful social justice project that prizes feminine-coded qualities such as generosity and inclusion without always acknowledging the gendered double standards underpinning them. To make matters even more complicated, part of this generosity and inclusion involves feminism being required to validate (or at least maintain an uncritical position on) supposedly 'progressive' causes – particularly those relating to pornography, the sex trade and gender identity – which conflate femaleness with the absence of boundaries. There are tensions here, ones that no amount of anti-doormat posturing can counter. Feminism promises to shatter gender norms, yet at the same time feminism won't be difficult; it can fit around everyone else; there's nothing about women's liberation that will inconvenience anyone else's liberation.

Feminism's relationship with kindness is complex. Over the course of this chapter I'll look at the ways in which feminists have exploited ideas of kindness and unkindness and found themselves exploited in return. I'll explore how feminism can end up using the language of virtue to support anti-feminist aims, and how 'unkind' poses can often mask compliant political positions. When I have told other feminists that I am writing this book, one common response has been to emphasise that, tired though they are with #BeKind culture, I should not throw the baby out with the bathwater. Genuine, non-confected kindness matters enormously to feminism, and

there are specific ways in which feminist thought on care, in-clusion and empathy can help to shape a better, less divisive political landscape. Even if we cannot know whether women are 'naturally' kinder than men, this does not mean that feminism has nothing to teach the world about kindness. We should do this as intellectual and political equals, though, not just the feminine givers we are expected to be.

Kindness, misdirected

Really depressing that now when I see 'women's book fes-tival' my immediate thought is, but is it trans inclusive or is this another terfy thing.

I absolutely feel this with anything that calls itself women's anything now, it's really sad ☹

The above exchange, caught on X in early 2023, exemplifies a problem that's been creeping up on us for a while. Or rather it's one that's always been there, albeit expressed using slightly different language. Should there be a political movement – should there be festivals, books, speeches, gatherings, even words themselves – just for the half of the human race who have vaginas? Or is that a bit, you know, mean? If your fem-inism (or just your book festival) is restricted to a mere four billion humans, what is it even for?

Feminism is not a man-hating movement. It's not just that, as Germaine Greer put it, 'though all kinds of women are re-viled as man-haters no woman has ever tortured a powerless man in the way that some men torture powerless women'. It's not even that, as has so often been pointed out, too many of us have personal lives that are deeply intertwined with those

of men and boys to hate them as a dominant class. Hating men isn't a feminist priority (indeed, feminism would pose far less of a threat to male authority if it was; put simply, we'd lose). The thing that really disturbs people is the idea of a feminism that directs attention, care and compassion from women towards other women, rather than from women to men. There are many ways to vilify such a proposition; 'man-hating' used to be the most popular term of dismissal. Now it appears 'exclusionary' has taken its place.

In *Down Girl*, Kate Manne proposes that women are not dehumanised by patriarchy so much as demonised should they be deemed to be using their humanity in the 'wrong' way. '[A woman] is often understood perfectly well to have a mind of her own,' she writes, 'yet punished in brutal and inhumane ways when that mind appears to be oriented to the wrong things, in the wrong ways, to the wrong people – including herself and other women.' The feminists who attract the most ire are not judged for their cruelty towards men, but for their 'misdirected' kindness. They are diverting the acceptable flow from human giver to human taker and making it a purely giver-to-giver exchange. This is perceived to be unnatural, a malfunction. It creates a closed circle, which is then described in terms evoking sickness, violence or malice because female need is not viewed as significant in its own right.

Anti-feminist propaganda has often focused on the idea of women abandoning their nurturing role. Anti-women's suffrage posters showed hungry babies and neglected husbands; 1980s backlash films depicted women becoming too hardened and career-focused to love their families. A woman's care for another woman, or even herself, does not count as 'proper' care. Right now anxiety over women wasting all their care by keeping it within the closed circle manifests itself through a purported concern about trans inclusion. The phrase

'women's book festival' is enough to strike fear into the hearts of any self-respecting 'kind' feminist because, as Kajsa Ekis Ekman notes, 'it has become taboo to say "woman" if one means only biological women'. There is, though, 'a different word to refer to this group, one with the obligatory prefix "cis", which equals privilege'. This new framing facilitates the reinforcement of a very familiar set of beliefs: that women cannot be defined in terms of their own interests, only those of others. When we express interests of our own, what is distinctive about them is not what they are, but the fact that they are not other people's interests. This has always been a concern, regardless of whether the illegitimacy of the interests is claimed to stem from female people's inferiority and failure to know our place, or from our privilege and failure to mitigate it.

In January 2017 women across the world donned shocking pink pussy hats to march in protest at the (first) election of Donald Trump, a man known for literally declaring he could grab any woman 'by the pussy', and for opposing abortion rights. Model and activist Munroe Bergdorf was quick to express dismay at feminists for responding so selfishly. 'Centring reproductive systems at the heart of these demonstrations is reductive and exclusionary,' Bergdorf tweeted. 'Not all women have reproductive systems, not all women have a vagina, not all women's vagina's are pink. Think about your message, use your voice for ALL women. Not just yourself.' It is very easy to make women feel bad about having something just to ourselves. Evidence of just how primed we are for this – and just how keen the world is to make us feel it – is shown by the way we can even be shamed for hoarding the experience of misogyny and not letting others lay claim to it. While part of Bergdorf's criticism is a plainly silly attempt to smear pussy hat-wearers as racists (is any woman's vagina the colour of a

pussy hat?), the real objection is obvious: there shouldn't be specific demonstrations for the kind of people that Trump himself was targeting in his comments, regardless of what anyone calls those people. It's 'reductive and exclusionary', leaving feminists with a choice: either you respond to this as an objection to feminism's very existence, or you change your own understanding of feminism and whose interests it is supposed to serve. The second is the less threatening approach, and it's one that many women have chosen to adopt. It can even feel like a nice, relatively low-cost thing to do. Donald Trump is the baddie here; don't go spoiling things by making his badness all about yourself. But if feminism isn't about female people, what is it about?

As Kathleen Stock points out, insisting feminism is for everybody 'isn't the reasonable idea that a world free of sexism is better for both women and men', but 'the idea that feminism as a political project should no longer be just about sexism [...] In other words, feminism is now supposed to be everybody's mum.' This trend is not exclusive to women's rights. As others have noticed, in-group thinking and increased political polarisation have led some to merge all social justice priorities into one (the 'omnicause'), with the consequence that supporting one cause means that you are expected to support a laundry list of others because everything is about everything else. 'If somebody wants to join a feminist movement committed to intersectionality,' writes Yascha Mounk, '[some] activists now also expect that person to agree with a set of specific positions about such varied topics as the nature of race discrimination, the injustices suffered by disabled people, and the conflict in Palestine.' There is a logic to this, insofar as any experience of discrimination on the basis of one characteristic is affected by your status in relation to others. For women, though, there can be some slipperiness regarding

the 'other' positions which are now expected to be covered
by feminism. Because 'progressive' politics has not – and may
not want to – come to terms with men's very immediate, far-
reaching dependency on female bodies and labour, many of
these additional priorities are of dubious value to feminism.
Some of them may actively work against women's interests,
but women are expected not to say so on the basis that they
should be making their feminism – and themselves – more ac-
commodating. This a roundabout way of achieving a familiar
objective: preventing women from focusing their attentions on
other women, even within the one political space where this
should not just be accepted but celebrated.

A feminism which refuses to unashamedly prioritise
women is less likely to be deemed man-hating, exclusionary,
selfish or bigoted. This may not be enough for it to be trusted,
though. Insisting the word 'woman' does not indicate 'another
terfy thing' when you use it – that it could in fact mean an-
ything – is one way of signalling that your compassion and
care will never be diverted towards vagina people only, but
you may still find yourself obliged to issue regular reassuring
statements. Indeed, this may be all your feminism becomes.

Stock mentions the website Everyday Feminism as an ex-
ample of this problem. Here, one finds a feminism of vaguely
defined universal kindness descending into one of obsessive
self-observation, self-policing and performative self-shaming,
with an education in the prioritisation of other people's needs
delivered using the language of privilege and allyship. There's
an awful lot on how, whatever the goodness of their inten-
tions, young women will still get everything wrong, witnessed
in article titles such as 'Is Your Trans Allyship Half-Baked?
Here Are 6 Mistakes That Trans Allies Are Still Making',
'When Privilege Goes Pop: How Today's Mainstream
Conversations on Privilege Can Hurt Justice Movements', and

'5 Ways to Avoid Common Ally Pitfalls by Learning From Your Mistakes'. Reading these, it is difficult not to reach the conclusion that being a feminist is, in moral terms, far more risky than doing nothing at all.

The creators of Everyday Feminism might argue that any objections to this approach are objections to intersectional feminism, a feminism which, as law professor and civil rights activist Kimberlé Crenshaw wrote in her 1991 article 'Mapping the Margins', recognises 'the need to account for multiple grounds of identity when considering how the social world is constructed'. However, the link is tenuous. When Crenshaw argues that 'because women of color experience racism in ways not always the same as those experienced by men of colour and sexism in ways not always parallel to experiences of white women, antiracism and feminism are limited', she is making a case for more informed social and legal responses, not shaming and self-flagellation. She does not content herself with telling black men and white women that, even with the best of intentions, they will mess up anyway. Everyday Feminism picks up one thread of truth – that some feminist activism has prioritised solutions that benefit only a limited number of women and positioned these beneficiaries as the default female humans – while ignoring another – that the social construction of femininity positions women as inherently selfish and exclusionary whenever they consider their own needs independently of those of men. It conflates privileged women atoning for the genuine sins of a privileged feminism with women atoning for the imaginary sins of feminism full stop.

In addition to positioning feminism's prioritisation of female people as inherently privileged, the 'progressive' backlash seeks to prevent genuinely privileged women from directing their kindness towards some of the most marginalised women. This

particular kindness is recast as prurience, interference, stigmatisation or 'denying marginalised women agency'. Feminist compassion for other women is, to some people, always toxic and insincere; if its true purpose is not to exclude male people, then it is to pass judgement on 'lesser' women, for whom it is felt we cannot really care. For instance, in her 2023 book *Naked Feminism*, Victoria Bateman recasts feminist compassion for women in the sex trade as 'white middle-class women rendering working-class women and women of colour unrespectable'. 'Feminism,' she complains, 'increasingly appears to be a group of "clever" women talking down to those they see as "selling themselves": a feminism of brain versus body, where only those with privilege [...] are entitled to a respectable body.' This sidesteps the fact that it really is 'only those with privilege' who have a (relatively) free choice about how their female bodies are treated. While Bateman's own background is not privileged – she associates her own teenage 'prudishness' with a desire not to be written off as '"trashy" or "common"' – she is now a Cambridge academic and writes from that perspective, not that of a prostituted woman. Is it really plausible that all feminists who object to the sex trade are motivated by a desire to divide 'lesser' women up 'into good girls and whores'? In *Feminism for Women*, Julie Bindel describes meeting young women who are told they are bigoted and phobic 'for simply stating the basics of feminism', including the idea 'that prostitution is dangerous'. It is: one study indicates women who sell sex are eighteen times more likely to be murdered than women who don't. Yet feminists who point this out are somehow cast as complicit in the stigmatisation of sex workers, as though male clients would have a much better attitude if feminists would just shut up.

Once you see the degree to which anti-feminism is based not on feminism being hateful, but on it being explicitly

female-orientated, it is impossible to unsee it. That is feminism's original sin. There is nothing new about the taboo, only new ways of framing objections. Feminism is a movement for people who are supposed to share everything with men, even including the experience of being oppressed as women. It is difficult to make a case on behalf of a group which is, by definition, not supposed to require the making of cases. It's for this reason that the newest apologetic feminist has multiple predecessors.

We promise we'll be good

In *Conduct Books and the History of the Ideal Woman*, Tabitha Kenlon describes a tactic deployed in Richard Allestree's 1673 guide *The Ladies' Calling*. 'Anything that might be thought to advance women's interests,' she notes, 'is almost always accompanied by reassurances that the change in thinking carries no threat':

> Unwilling or unable to make an argument for women's value as humans simply because all humans are valuable, Allestree (and most conduct book writers) contextualizes any positive claim about women with a reassurance that the idea being presented benefits men. So even these small steps remain firmly rooted in a rigid patriarchal structure that continues to assert its right to define, explain and justify the very existence of women.

If I were going to create a version of feminism in the image of *The Ladies' Calling*, what might it include? A reaffirmation of femininity as essential to women's nature; assurances that feminism would not dream of taking away a man's right

to pornography, sex, babies or female emotional labour; an 'equal but different' restating of the giver/taker binary, perhaps recast in terms of inclusivity and allyship duties. In short, it wouldn't be very different from what is sold to women as a vast improvement on the problematic feminism of days of yore. The bright, shiny feminism that has come to replace the second wave is incredibly modern – so modern, you'd think it came straight out of 1673.

To be fair, feminism, just like any good conduct book, has always been under pressure to reassure anxious men. Its most basic assertions are reasonable and straightforward – 'the radical notion that women are people', as Marie Shear famously put it – but that does not make it an easy sell. It is not hard to accept, in the abstract, that women are just as human as men, but what of the practical implications of treating them as such? 'The problem,' noted Janet Radcliffe Richards in 1980's *The Sceptical Feminist,* 'is that it is extremely difficult to be a feminist of any sort, even a relatively inconspicuous one, without doing and recommending things which people will certainly dislike and disapprove of.' This is not to say that many have not attempted to win approval. Indeed, if you work hard enough, it can sometimes be possible to make feminist demands map onto what is already believed about women, while editing out anything that doesn't map onto what is already expected from them. Yes, you'll be left with less actual feminism at the end of it, but at least you'll have something that goes by the name.

Conforming to feminine stereotypes of subservience and self-abnegation has provided women with a back-door route to self-assertion. You can have a voice as long as it doesn't look too much as though you are speaking for yourself. Perhaps your priority is God, or your children, or the rotten souls of men, or the good of society as a whole. Perhaps it is

ending cisnormative heteropatriarchal capitalist cultures of exclusionary radicalisation (aka Mumsnet). As long as your priority isn't just yourself or other women. This approach has sometimes been viewed as a 'feminine' way of exercising power. Alternatively, it can be viewed as a last resort for those denied the ability to express their needs plainly. Denied the direct route, women find workarounds. For many, appeasement and false promises are everyday survival strategies. It should not be surprising, then, that these approaches have found their way into feminism.

One argument that was commonly used to promote women's access to education in the nineteenth century was that their 'natural' goodness might then be exploited to its full potential. 'First and foremost, feminists maintained that women needed to be educated in order to improve society,' writes historian Laura Schwartz. 'This was an argument common to discussions of women's emancipation generally, whereby it was insisted that women needed to be freed from the home and allowed into the public sphere so that they could "do God's work in the world".' Far from downplaying what many modern feminists would regard as socially constructed (and highly restrictive) differences between men and women, many campaigners emphasised them. In 1868's *The Education and Employment of Women*, Josephine Butler argued that the educated, financially independent woman would 'become the more and not the less womanly', on the basis that 'every good quality, every virtue which we regard as distinctively feminine will, under conditions of greater freedom, develop more freely'. It would, Butler claimed, always be in woman's nature 'to foster, to cherish, to take the part of the weak'. Frances Power Cobbe's 1882 work *The Duties of Women* positions women's political emancipation as 'a means, a very great means, of doing good, fulfilling our Social Duty of

contributing to the virtue and happiness of mankind, advancing the kingdom of God'.

Schwartz is careful to point out that not all Victorian campaigners shared these views, noting there were some who saw gendered characteristics as 'predominantly socially constructed' and education as 'the means by which women might free themselves from the debilitating effects of convention'. The latter seems similar to the outlook of feminists today, most of whom would declare themselves eager to reject conservative gender norms. Even so, when sites such as Everyday Feminism insist that 'feminism evolved to be for everybody (not just women)', it is hard not to feel this approach has more in common with pushing young women 'to foster, to cherish, to take the part of the weak', making use of 'every virtue we regard as distinctively feminine', than with freeing oneself 'from the debilitating effects of convention'. Freeing yourself from convention might have been fine for Victorian women, but now it's all about feminism making you 'a more compassionate, ethical, and responsible person and community member'.

In *For Her Own Good*, Barbara Ehrenreich and Deirdre English trace the way in which the US women's suffrage movement of the early twentieth century positioned women as deserving the vote 'because they were homemakers'. The conflation of femaleness with domesticity was also used in attempts to grant women access to academic subjects reserved for men ('the truly scientific housekeeper needed to have studied, at a minimum, chemistry, anatomy, physiology, and hygiene'). This is a feminism of deal-making, whereby access to traditionally male entitlements is bought in exchange for assurances that the supply of feminine-coded goods and services will be even better than before. In a modern context, one might compare it to the way in which women's access to

abortion is couched in terms of legitimising a broader choice narrative regarding sex work, surrogacy and plastic surgery, or women's right not to be treated as biologically inferior to men is used to grant men even more permission to disregard the specificities of female bodies.

Past feminist campaigning which relied on the promotion of female virtue to win rights tended to rely on white, middle-class constructions of femininity. For this reason, today's conduct guide-style feminism may consider itself completely different in its approach. *That* feminism sold an exclusionary, unrealistic image of female perfection; *this* feminism is for everyone. Yet it makes the same promises: better women for a better society, and the same inexhaustible supply of care as before. It is largely the same class of women who present themselves as unthreatening and submissive, even if, as Everyday Feminism will be on hand to remind them, they're bound to fail and must always have their apologies at the ready.

Finding the balance between strategic compromise and the effective abandonment of feminist principles is difficult. In *The Guilty Feminist*, her book based on the podcast of the same name, Deborah Frances-White argues that we don't just need feminism from 'the most self-assured, academic, gung-ho, self-sacrificing, full-time, right-on feminists', but also from 'an army of uncertain, amateur feminists'. In general, I agree with this; no woman should be alienated from feminism. Yet I also hear something else being said: *I'm not one of those hard, extreme feminists. I'm too nice and normal.* The positioning of 'uncertain' and 'amateur' against 'self-assured, academic, gung-ho' brings to mind the traditional positioning of the feminine woman against her less appealing, unfeminine counterpart. What feminism needs is women who aren't so sure of their own convictions ('self-assured'), who aren't so

aggressive ('gung-ho'), who don't think too much ('academic'). Unlike old-style feminists, these uncertain, amateur feminists are sensitive and must be handled with care. There's a similar impression of the hardcore feminist alienating the 'normal' woman – and being quite unkind in the process – at the start of Caitlin Moran's *How to Be a Woman*, where we are told 'God, feminism is so serious [...] The feminist organisation Object are nuts when it comes to pornography! Germaine Greer, my heroine, is crackers on the subject of transgender issues!' If you are a feminist who has ever been considered 'gung-ho' or 'crackers on the subject of transgender issues' – it can, in either case, be for the flimsiest of reasons – it can be difficult not to find this annoying. On the other hand, any feminist who falls into this category may be told that, whatever her principles, she is tactically naive.

One way of offering up a form of radicalism without appearing to submit to feminine norms is to abstain from being female-focused while still expressing hostility towards certain groups of men. This is a position that for many, particularly in US feminism, seems to have taken the place of directing attention towards women only. It is undoubtedly less taboo, but whether it is more effective is another question.

Hating men or loving women?

In July 2014 the feminist writer Jessica Valenti responded to Twitter trolls by posting a photograph of herself smiling in a T-shirt that declared 'I bathe in male tears'. Writing for *Slate*, Amanda Hess positioned this as part of a new trend – ironic misandry: 'The ironic misandrist sips from a mug marked "MALE TEARS", frosts her cakes with the phrase "KILL ALL MEN", and affixes "MISANDRY" heart pins to her

lapel.' As Jess Zimmerman, a *Medium* editor and ironic misandry enthusiast, told Hess, 'It's inhabiting the most exaggerated, implausible distortion of your position, in order to show that it's ridiculous.' The 'ironic' misandrist is not someone who really hates men; on the contrary, she knows that only people who hate women view feminists that way.

While the trend has since died down, one can still buy 'male tears' mugs on Amazon, alongside variations such as 'white male tears' or – to really stick the boot in – 'mediocre white man tears'. Alongside the #BeKind T-shirt, man-hating merchandise suggests something of an identity crisis in early twenty-first-century feminism. We want to simultaneously say 'we're not born to be kind' (because that is a gender stereotype) while presenting the movement itself as kind. A way of getting around this has been to grant ourselves certain areas in which we are exempt from performances of niceness, while remaining accommodating to all other people at all other times.

An in-joke intended to disarm critics – *you can't call me that because I've called myself that already, and anyhow, if the designation was correct, I wouldn't have used it* – ironic misandry has much in common with the 'ironic' sexism and 'self-aware' embraces of the slut identity of the nineties and noughties. Far from wrong-footing critics, it offers ammunition to anyone who wishes to say, 'Look! That really is what feminists are like!' (Or at least, 'They obviously aren't that bothered if we call them that.') In response to ironic misandry, men get the chance to perform some 'ironic' (or not) embitterment without actually being asked to give up anything. As Rebecca Traister points out in relation to man-hating mugs and T-shirts, 'while plenty of men's rights activists did not see these sentiments as funny or ironic, the exaggerations radiated reassurance: that a truly abrasive challenge to patriarchy

wasn't a real political threat, rather the stuff of screen-printed punchlines'. It was a rejection of feminine stereotypes – that we are non-aggressive, polite, always attentive to the male ego – which steered clear of any deeper embrace of behaviours and demands which might be perceived as cruel, but which remain absolutely necessary to enacting change. It allowed women to feel that their feminism was not making conces-sions to outward appearances when what it really said was 'I am not asking too much'. In the novel *Gone Girl*, the narrator Amy claims that '"I love strong women" is code for "I hate strong women"'. I've sometimes felt the mass-market version of 'I hate men' operates in much the same way, only in reverse.

Hostility towards men, even a hammed-up version, is not the same as love for women. This is shown by the way in which this performative hostility can also extend to those women who are deemed to be too close to its initial targets. The independent academic Sara Ahmed has based much of her feminist theorising around the persona of the 'feminist killjoy' who dares to inconvenience others. 'To become a feminist killjoy,' she writes, 'is to get in the way of happiness or just get in the way.' The *Guardian*'s Kira Cochrane has described the concept as 'brilliant [. . .] because feminism isn't about making everyone around the table feel comfortable'. This is true, but making others uncomfortable is also not the same as redirecting care towards women themselves, and can even function as a diversion. Feminism is more than refusing to follow particular social norms, which can in itself be an expression of privilege. Killjoy politics is clear about creating space for the powerless by not pandering to the feelings of the powerful, but deciding who belongs to which group – and whether they do so at all times – is another challenge entirely.

In a blog post entitled 'Becoming Unsympathetic', Ahmed refers to a rape survivor who wrote about the importance of

women-only spaces during her recovery. After claiming to have 'much sympathy with this sentiment', Ahmed complains that the survivor 'then created a category of "women" that was about women she could relate to defined not in terms of women who had shared this experience of sexual violence, but women who were not trans women, whereby this "not" was defined in terms of biology'. This is a very long-winded way of saying the original writer defined women-only spaces as female-only. The strange wording – 'created a category', 'this "not" was defined in terms of biology' – makes such a definition sound novel, as though the concept of 'adult human female' was a recent invention whose sole purpose is to exclude. The existence of female people as a coherent political category did not emerge from a blog post in 2015. Nonetheless, Ahmed goes on to suggest that the rape survivor is withholding sympathy from those who are not her 'kind', as though personal perceptions of 'relatability' play more of a role here than an acute awareness of the relationship between male power, male bodies and sexual entitlement. Later in the post – and not in relation to the rape survivor – Ahmed reminds us that the feminist killjoy becomes 'unsympathetic' due to her disruption of other people's comfort. Why, though, can we not say that the rape survivor deserves respect as a killjoy who is 'getting in the way of happiness'? To be clear, I don't think that is what women are trying to do when they ask for female-only spaces. They are simply seeking to meet a need of their own, not to cause pain to others. Indeed, one could argue this is one of the problems with the 'killjoy' construct: unless we as feminists remain conscious of our own capacity to dismiss other women's needs as driven by bad faith or prejudice, we risk reinforcing patriarchy's narcissistic insistence that women do not have real needs at all, but merely confect them in order to offend, exclude or withdraw

services from male people – as though killing joy were the entire objective.

Drinking from a misandry mug, or vaunting your killjoy credentials, is not an expression of feminist solidarity. The distinction is important. There is an understanding of feminism which prioritises disliking particular 'dominant' men (and the women deemed to be politically or socially aligned with them), and there is one which prioritises finding compassion for all women, something which goes radically against how women are socialised to behave. As an example of the former, in 2023 the *Salon* writer Amanda Marcotte produced an article in which she attacked Republican women for holding views on gender identity with which she disagreed. Marcotte claimed that such women enjoyed 'cruelty to others'. 'They can't yell at condescending husbands or abusive fathers,' she wrote, 'not without losing status in their communities.' This led her to deduce that bigotry gave them 'a chance to step out of the thankless role of being servile and deferential, letting them play the role of the bully'. For someone such as Marcotte, it was hard to imagine 'being so incredibly petty', but she concluded that 'these women don't have a lot else going on in their lives'.

Many of the women I grew up with held right-wing political views. While I don't profess to know the detail of each person's motivations, to make them all about 'status' is trivialising (in a way that simultaneously manages to deny women any degree of choice and demonise them for their apparently unlimited choices). 'Condescending husbands or abusive fathers' are no small thing to 'yell at'. Furthermore, there are some issues (relating, for instance, to female-only sports or spaces) where left-wing women are far more at risk of 'losing status in their communities' should they take the feminist position. As Gerda Lerner argued in *The Creation of Patriarchy*,

'the connectedness of women to familial structures made any development of female solidarity and group cohesiveness extremely problematic'. This is why when Andrea Dworkin defined feminism as 'a political practice of fighting male supremacy in behalf of women as a class, including all the women you don't like, including all the women you don't want to be around, including all the women who used to be your best friends whom you don't want anything to do with any more', what she offered was something far more challenging to male power than Marcotte's swipe at conservative women with their apparently boring lives.

If feminism really is, to quote Munroe Bergdorf again, 'for ALL women', then it includes the women whose politics you oppose, whose compromises you may not understand and may never have to make yourself. What it doesn't prioritise is men. This is not to say, however, that men cannot learn from feminist thinking on kindness, compassion and inclusion.

While we're down here . . .

'Feminism,' said Dale Spender, 'has fought no wars. It has killed no opponents. It has set up no concentration camps, starved no enemies, practiced no cruelties. Its battles have been for education, for the vote, for better working conditions, for safety in the streets, for child care, for social welfare, for rape crisis centres, women's refuges, reforms in the law.' As a movement it is not perfect but the positioning of feminisms past and present as selfish, suspect, prejudiced, in need of significant moral reform – not just by the usual suspects, but by 'progressives' whose own idols may be complicit in genuine acts of barbarism – is truly remarkable. At this point in its history, a woman cannot claim, as Kathleen

Stock has done, that 'feminism is only for women and girls, in the sense that women and girls should be its exclusive political project', without being roundly condemned for it. There is always some convoluted argument which will be deployed to suggest that, actually, feminists might not be out there committing atrocities, but their speech, their writing, their exclusionary thinking will have prompted someone to do so on their behalf.

Whenever I witness the harsh judgements passed on earlier feminists – women who opened up amazing possibilities for those who came after them, only to be written off as problematic by the beneficiaries of their activism – there is a part of me that wants to say, 'But hang on – we *have* been better than the men.' It feels like the political equivalent of the invisibilisation of women's domestic labour. No one notices our non-violence, our patience, our tendency not to send rape threats to those who provoke our ire. They only notice when said patience appears to be a little bit lacking. When women such as Frances Power Cobbe and Josephine Butler appeal to angel in the house-style stereotypes of female moral superiority, it feels essentialist and restrictive. At the same time, women *are* less violent and more engaged in care work than men – significantly so, on both counts – and whatever the reason for this, it ought to count for something. One additional struggle feminism has faced is finding a way to discuss this without reinforcing regressive ideas about women's true nature.

There is a risk that in seeking to validate approaches to kindness, compassion and moral reasoning, demonstrated more by women than men, we end up reinforcing stereotypes. The science writer Angela Saini suggests that the desire of some feminists to uncover evidence of 'special' female values in the past can work against women by trapping them in 'a set of expectations that does not fit all women, and has proven a

burden to many'. When the 2023 Women's Prize for Fiction announced that 'all funds raised in March will go towards a new reading programme exploring books by women as a tool to increase empathy, empower connection and encourage community cohesion', there were echoes of the familiar argument that women's access to spheres men have appropriated for themselves, such as the arts, can be justified not on the basis that women are human, too, but that women's feminine, nurturing natures might bring particular benefits. In her 2018 feminist handbook *A Good Time to be a Girl*, which exhorts women not to 'lean in' but to 'change the system', City CEO Helena Morrissey highlights the supposedly female qualities of 'empathy, social sensitivity, collaboration and gentleness' as a means by which the system might be changed. Tapping into her 'own, feminine brand of power', the virtuous woman is able to clean up after less attentive men not just in the home but the workplace too. At an even further extreme, in her 2023 bestseller *On Our Best Behaviour* – which I bought on the basis that the subtitle *The Price Women Pay to Be Good* would mean the book wouldn't actually be telling women to be good – Elise Loehnen declares it 'imperative that women reclaim our precious energy so we can bring forward the feminine principle, the Divine Feminine, with the full force required to rebalance society's ills'. I cannot see this kind of argument being out of place in a nineteenth-century tract on why women, as unique vessels for goodness, should no longer be kept away from the voting booth. Nevertheless, there are other ways of understanding moral differences between men and women. In 2000's *The Myth of Matriarchal Prehistory*, religious studies professor Cynthia Eller argued that rehabilitating 'activities and values habitually defined as – and denigrated as – feminine' becomes 'problematic' if we continue to associate them with women only. Much as I

agree with this, there has to be a space in which to recognise what women do in the here and now, and how it deviates from male-defined norms. Differences between men and women which, unlike biological sex, are not immutable, need not always be used to justify women's subordinate position in relation to men. What if the argument is that women can provide an ethical model to which men could one day aspire?

Some feminists have suggested that women's subordinate status grants them moral insights which men might lack. 'As marginal beings whose authentic personal interest is not served by the rigidities of power,' wrote Mary Daly, 'women have the potential to see through these.' Instead of understanding this in terms of 'what men and women are, now and forever', we can look at it in terms of 'what alternative models for understanding the world might women offer' (regardless of whether or not they are 'natural'). In 1982's *In a Different Voice*, Carol Gilligan explored the way in which traditional understandings of psychology, human development and moral reasoning centred male experience and either excluded women or treated female morality and psychology as inferior and underdeveloped. Gilligan argued that differences existed, but that the value judgements that accompanied them were incorrect, based on a failure to understand why women made the choices they did. In a 1993 preface to the book, she challenged what she saw as misrepresentations of her work as being about essential differences. 'My questions,' she wrote, 'are about our perceptions of reality and truth: how we know, how we hear, how we see, how we speak. My questions are about voice and relationship.' More recently, Gilligan has gone back over her original thinking and identified it as not so much female as human. There is a link with sex difference, but it is tied to power, status and who is deemed to be 'the norm' rather than any essential, immutable 'female' or 'male'

worldview. We need, she writes in *In a Human Voice* (2023), 'to hear the different voice, the voice of care ethics, for what it is: a human voice; to recognize that the voice it differs from is a patriarchal voice (bound to gender binaries and hierarchies); and to realize that where patriarchy is in force and enforced, the human voice is a voice of resistance'.

Gilligan's stress is on relational ethics, and the way in which these can be sidelined in favour of dichotomous or hierarchical approaches to problems. JustBeKindism – which positions those who believe questions of justice to be complex, involving competing demands and shifting relationships, as morally inferior – favours what would, in Gilligan's earlier work, be the male default model. A hierarchical understanding of what is right neatly maps onto the idea that kindness is a simple transfer from designated giver to deserving taker. 'Male' morality's prizing of separation and independence can be seen in the modern left's insistence, with regard to gender, that people are not defined via networks of relationships, but have pre-social 'true selves' which it is the duty of everyone to liberate. This rejection of the salience of socialisation and the way in which we are defined as individuals only in relation to one another – the paradox 'that we know ourselves as separate only insofar as we live in connection with others, and that we experience relationship only insofar as we differentiate other from self' – is the hallmark of a politics which insists even the smallest children 'just know' who they are and that the only thing the 'kind' person need do is respect that.

In a Different Voice argues that one model is not necessarily superior to the other, but that one has dominated and been perceived to be the only one that matters:

The moral imperative that emerges repeatedly in interviews with women is an injunction to care, a responsibility

to discern and alleviate the 'real and recognizable trouble' of this world. For men, the moral imperative appears rather as an injunction to respect the rights of others and thus to protect from interference the rights to life and self-fulfillment.

What I think has happened with 'progressive' politics' embrace of 'kindness' is that, rather than integrating the two models Gilligan first identified, a focus on rights and self-fulfilment remains dominant, although it has been rebranded to suggest it represents the values of kindness, empathy and compassion in their entirety. Those who complicate things are viewed not as prioritising 'real and recognizable' troubles but as being difficult, uncaring and lacking in a certain maturity. 'The thinking of women,' writes Gilligan, 'is often classified with that of children.' One might think of the way in which 'exclusionary' (that is, woman-orientated) feminists are either ordered to educate themselves or dismissed as unevolved 'wrong side of history' failures.

Looked at from a distance, so-called 'difference feminism' can still seem a little like biological essentialism. There is, however, a meaningful difference between essentialising 'feminine' submissiveness and a feminism which proposes the dominant moral discourse learns alternative modes of decision-making. The latter constitutes a more fundamental challenge to prevailing power structures. It does not promise anyone, man or woman, any particular boost in status as 'a kind person'. It is not about self-monitoring or the adoption of a persona in relation to particular values. Crucially, it does not involve the male gaze sexualising women's 'giving nature'. It is not an easy sell. Nonetheless, I think it is the only way of tackling the actual unkindness that results from the current, flawed 'be kind' approach.

A re-evaluation of feminist care ethics can help to draw a link between contemporary complaints about 'identity politics' – frequently (and wrongly, in my view) conflated with too much, rather than not enough, feminism – and traditional sexism. The fetishisation of 'just be kind' (with its 'feminine' overtones) is part of a moral worldview which remains in thrall to hierarchy and views interdependency with mistrust. It wants an ethics of care without the compromise demanded by care, which necessarily loosens rigid definitions of privilege, victimhood and self-determination.

Feminism is not just about challenging gender norms. It is about the redistribution of finite resources and the reclaiming of concepts – roles, words, status – that one sex has appropriated from another. It is about the redirection of care and attention away from men and towards other women. It is about taking as much as it is about sharing. From the perspective of those who lose out, feminism done properly may well be experienced as mean and selfish, particularly if they are continually being told that 'good' feminism will not take anything from them. Foregrounding a feminist ethics of care will not change this. A feminist ethics of care is valuable in its own right, as a way of approaching the genuine problems and tensions that arise when we seek to change relations between men and women. To those who regard concepts such as competing rights as political dog whistles or equate defining people by their relations with others as denying people's true selves, this approach will still seem unkind. We have to do it anyway, not because it looks good, but because it is good. This means moving beyond 'kindness' as an element of self-objectification – one way in which the self-contained object attracts the approving gaze – towards understanding it, rightfully, as one of the values underpinning the choices we make within multiple networks of relationships.

Feminism is not unkind, but as long as it is needed, it will be regarded by many as such, and feminists will be asked to apologise, to do better, to make sure all their activism is about everything and everyone, all the time. We do not need to be playing to the 'ironic misandry' crowd in order to be seen as cruel. Any act of women prioritising other women or themselves at the expense of men – or simply prioritising other women or themselves without assuming that this will indirectly benefit anyone else – will be perceived not as a neutral act, but a deliberate choice to disrupt and exclude. Yet feminism is the only movement that is only for us. We could get more support for feminist aims if it wasn't, but then it wouldn't be feminism.

In a 2024 piece for the *Guardian* attacking the value of female-only spaces, the columnist Zoe Williams drew on her own experience of an all-girls private school to ask feminists, 'Wait, are you saying all-female spaces are kinder? Purer? Inherently less violent? More supportive? Are you joking? Are you out of your mind?' Well, yes. We are in fact saying that. We're not suggesting girls can't be cruel to each other, but we are – by a staggering degree – less likely to rape and kill one another. Girls are passive, masochistic, pink-loving princesses is a stereotype; girls are less likely to beat one another to death is a fact. What we're also saying is that this is not the way things need to remain. Men could be more like women. They could start by treating us as actual examples to follow rather than objects to fetishise. First they can let us have our movement – then they can learn from it.

2

KINDSPLAINING

The surest way to work up a crusade in favor of some good cause is to promise people they will have a chance of maltreating someone. To be able to destroy with good conscience, to be able to behave badly and call your bad behavior 'righteous indignation' — this is the height of psychological luxury, the most delicious of moral treats.

Aldous Huxley, Introduction to
Samuel Butler's *Erewhon*

You reject the very concepts of compassion and kindness, why should we treat you as anything but the absolute scum you are?

Anon, X

While some of us might be feeling frustrated by the rise of JustBeKindism, there's one person who appears to be loving it. I refer, of course, to Progressive Man, that left-wing stalwart who's never knowingly on the wrong side of history. He just can't wait to demonstrate how much kinder he is than you.

Perhaps you know the type. He may or may not describe himself as a feminist. If he does not, it is because he feels men can 'only be allies' (though the entitlements of allyship can, in this case, be fairly extensive). He knows women are equal to men; so equal, it only degrades them if you point out any ways in which they are different. He believes in a woman's right to work and hates the fact that some female-dominated jobs – such as sex worker and porn star – are so stigmatised. He is pro-choice, which must be recognised not as a bare minimum expectation but an act of great generosity on his part, and one which definitely differentiates him from 'the sexists' (the same goes for 'not liking the far right' and 'not being Andrew Tate'). He's au fait with the way in which 'our understanding of gender' has changed, and happy to use inclusive terms such as uterus haver, menstruator, sandwich maker, washer upper etc. for people of the opposite sex. Many of his friends are women, and they agree with him on all things feminist, which shows he's right (when women do not agree, it is usually because they are old and will die out soon, so no need to worry about them).

Such a man has spent years standing for fairness and equality. Not for him the boorish, chest-beating, red-blooded masculinity of the conservative right. He's always supported the non-men, because that's what his side does. He will assure you he has never felt that his manhood was undermined by his kinder, gentler politics (on the contrary, aren't the incels of this world *so insecure?*) What's more, he's never expected women to thank him. He's perfectly happy to lift up their voices, providing they're not saying anything he doesn't like.

It's been decades since second-wave feminism emerged in response – at least in part – to left-wing men's failure to integrate feminism in their revolutionary politics. Back then, women were mightily pissed off, and a good thing too, when

one considers all that was achieved: anti-discrimination laws, rape crisis centres, women's refuges, women's studies departments, new understandings of sexual violence, a greater visibility of women in public life, a coherent analysis of the relationship between biological sex and gender as a social hierarchy. Since then, feminism has been welcomed back into the leftist fold, at least in theory. Without having dramatically altered its attitude towards issues such as female leadership, gender stereotyping and the sex trade, this side of the political spectrum now sells itself as the one that 'owns' both kindness and gender equality.

If you are a left-wing feminist, it is hard to refuse this. Partly this is because many leftist concerns – especially those relating to racism, child poverty, reproductive choice and economic redistribution – genuinely are and should remain feminist priorities. Partly this is because you will always be reminded that if you don't like it on this side, there is always the other side. You know, the side that wants to take away your abortion rights, leave you impoverished and chain you to the kitchen sink. Or if not you, then other, less privileged women. Leftist feminists must put up with being blackmailed because their blackmailers are, sort of, the goodies. It would be selfish to kick up a fuss about this side's sexism when there is a greater good at stake.

Like many women, I feel my own relationship with Progressive Man has gone through several stages. At first, gratitude that some men seemed so willing to reject traditional gender norms, and a conviction that these must be the new, improved men of the future. Then, a certain suspicion at just how far this rejection really went, and how selective it appeared to be (why are labour rights for strippers so much more interesting than pensions inequality?) Next, the bargaining stage, during which I'd tell myself that a bit of feminism,

even if it is only the bits that benefited Progressive Man directly, was better than nothing. Finally – and I have to say this is where I'm at now – a fear that this whole rejection of gender norms has been illusory. Particularly in recent years, during which Progressive Man has thrown himself into challenging 'bad' feminists, both online and outside feminist gatherings, it has seemed to me that being a kind, inclusive, pro-feminist man provides a surprising number of opportunities to showcase one's new, improved masculine dominance and put the ladies back in line.

I suppose I once thought that since so many 'progressive' values – empathy, compassion, kindness – have been coded as feminine, this meant that men who identified as progressive were by definition gender non-conforming. Unlike right-wing men, Progressive Man didn't mind being 'emasculated' because he didn't take masculinity seriously to start with. Yet today, in the face of a 'progressivism' which prioritises sexual liberalism and ending the 'stigma' of female exploitation as opposed to the exploitation itself, I am not so sure. A kind of macho kindness – or rather, a machismo which uses the language of kindness – has been turned on women who fail to adopt leftist men's ideas of what feminism is and should be. If sexual liberalism is a virtue, and kindness is a virtue, then abusing women for their failure to be sufficiently sexually liberal and politically submissive is a virtue, too. It is how we end up with feminists being told we are 'unkind' and 'right-wing' for questioning what once might have passed for anything from everyday boorishness to outright woman-hating. Suddenly men who seem very disinterested in what feminists actually think – all the different things we have done and written and said – believe themselves to be the judges of whether we are good feminists at all.

One thing that has struck me when being lectured by men

on how to be a better feminist is how little feminism most have actually read. Perhaps they consider treating feminism as a serious political project with a complex, diverse legacy to be women's work, whereas their job is to manage actual feminists in the here and now. What these men do tend to know are slogans: *rights aren't pie, my body my choice, biology isn't destiny*. Slogans have been useful to feminism, as they have been for all social justice movements. They make demands simple and accessible, binding them to basic ideas most people would support. Yet the things we put on placards can limit our ability to think if they become the main way we communicate, as is increasingly the case as we shift to shorter, hashtag-based ways of sharing messages. Slogans become distorted when taken out of context. Progressive Man has a habit of using feminist slogans to suit his own ends.

I have started to think of this particular habit as 'kindsplaining'. This is inspired by the term 'mansplaining', which arose after Rebecca Solnit published her 2008 essay 'Men Explain Things to Me' (which does not include the term itself). In the essay, Solnit recalls telling a man about a book she has written, whereupon he holds forth about the 'very important' book on the same topic that came out that year. It takes several interruptions from Solnit's friend before he realises that this is Solnit's own book, which, it transpires, 'he hadn't read, just read about in the *New York Times Book Review* a few months earlier'. On its own it is an amusing anecdote, but Solnit extrapolates from it to explore the broader problem of women having to fight 'wars on two fronts, one for whatever the putative topic is and one simply for the right to speak, to have ideas, to be acknowledged to be in possession of facts and truth, to have value, to be a human being'. When it comes to issues of social justice, particularly those relating to sex and gender, there are men who take this a step further, claiming

a position not just of intellectual but moral and emotional superiority, again on the basis that anything of which they themselves are ignorant isn't worth knowing.

Kindsplaining involves taking a feminist slogan, or more generally a social justice slogan with specific feminist applications, and explaining it to a feminist, badly, as though she is an idiot and you are a genius. It involves treating the slogan as a fundamental truth that only someone who is either incredibly stupid or incredibly mean would deny. It requires the kindsplainer to ignore the fact that particular slogans were created for particular scenarios, or that slogans might function as a shorthand and are not supposed to be taken literally ('Believe Women', for instance, is a protest against the credibility gap faced by female victims of sexual violence, not an assertion that women never lie). The kindsplainer isn't interested in context and treats any disagreement as the resistance of someone who doesn't like having their deeply held prejudices exposed. He also believes that if you do not agree with the slogan in the way he is using it, you are not allowed to use it yourself, or even to claim that you still believe in the principles that the slogan was originally used to promote.

In the section that follows I will examine a few of the kindsplainer's favourite slogans. These are not, I hasten to add, bad slogans in and of themselves. For each, however, there has been a toxic mutation, allowing the kindsplainer to use them for purposes which are self-interested, while at the same time posing as selfless. I am conscious that in doing this I, too, may be being a bit 'splainy', and for this I apologise in advance. In my defence, I would point out that feminists have listened to so many egregious misuses of 'biology isn't destiny' that I feel we are owed an opportunity (or several, in fact) to set things straight.

'Rights aren't pie'

Let us start with the classic 'rights aren't pie', or to quote it in all of its patronising glory, 'Equal rights for all does not mean fewer rights for you. It's not pie.' You can buy T-shirts and badges with this slogan, some of which even include cartoons of pies. The intention is to reassure you that others gaining access to resources which are already available to you, or re-defining concepts that already apply to you so that they apply to others, will not mean that you are suddenly excluded. On the contrary, you would be a bit foolish to think otherwise.

The problem with 'rights aren't pie' isn't just that it fails to consider whether some entitlements are misunderstood as rights, or whether some rights ought to be restricted to cer-tain groups on the basis of need. It's that it takes something that might be technically true – you might not literally lose something just because someone else has it too – and treats it as the only thing that matters, devoid of any broader context. It ignores the fact that extending their application to other in-dividuals and groups changes the nature of particular rights, even if the original holders (nominally) retain them. Whether or not worrying about this makes the latter selfish surely de-pends on the situation.

For instance, those who want marriage to be between a man and a woman do not lose the right to get married if same-sex couples can do so, too. Changing the rules regarding who can get married does, nonetheless, change what marriage is. Indeed, many of those in favour of change were keen to em-phasise this. In her essay 'In Praise of Threat', Solnit stresses that the meaning of marriage is 'opened up' when same-sex couples are included. 'Marriage equality is a threat,' she writes, 'to inequality.' Except some people value inequality (though they'd probably call it by another name). Like Solnit,

I think equal marriage is morally important and socially beneficial. This is not the same, however, as traditionalists merely imagining they are losing something; they are, even if it is something that the rest of us consider to be of little value.

'Rights aren't pie' becomes particularly inappropriate when dealing with the question of whether male people can be considered women. All too often, those who object are dismissed as mean girls cruelly hoarding all of the 'womanhood' without realising there is an infinite amount to go round. Womanhood isn't pie! It's an abstract concept, so there's plenty for everyone! This rather misses the point that feminists are not concerned that they will suddenly stop being female or being treated as women (regardless of whether they even want to be) if male people can call themselves women, too. They are concerned that women are losing a concept that is needed to describe the social and biological experience of being female, and around which we may organise to express specific needs and defend specific resources. As the philosophy professor Clare Chambers puts it, 'If a category is removed before the oppression that creates it, the oppression stays in place but the ability to describe it is lost.' Some meanings are mutually exclusive: woman cannot mean both 'female people' and 'female people and people who have a feminine gender identity'. As soon as you add gender identity into the mix, you are forced to concede that some female people are not women after all. If you wish thereafter to organise on behalf of biologically female people, you may only do so in a piecemeal way, using language which reduces female people to biological processes or events, denying them any form of continuity or connection. (You will be told this is not a problem because you can still call yourself a woman. Just not in any scenarios where it's socially, economically, politically or biologically important.)

I can see why, to those who insist that 'rights aren't pie',

pointing out that 'woman' cannot mean an infinite array of things sounds unkind. It requires greater cognitive effort to acknowledge that adding rights to one group really does mean taking something away from another, even if the latter technically retain the same entitlements as before. It also takes effort to see that even if the second group have a right the first have been denied, this does not mean the second group are privileged. It doesn't take that much effort, though. For instance, people don't generally struggle to see why allowing middle-class people the right to call themselves working class is unacceptable, even if their doing so does not prevent working-class people from referring to themselves in the same way as before. The misapplication of 'rights aren't pie' is particularly frequent in relation to sex and gender because it ties in with the social construction of femininity as infinite, cost-free giving. 'Rights aren't pie', in this context, tells women 'How dare you behave as though what you have to offer is finite!'

It's not telling us women's rights *aren't* like a foodstuff. It's more that, rather than pies, they should be like the porridge in the magic porridge pot. There should be no limit to the things we share with others: words, spaces, our bodies. Otherwise, it's suggested, we're just being mean.

'My body, my choice'

Another slogan which suffers from the refusal to recognise the significance of bodies, context and hierarchy is 'my (or her) body, my (or her) choice'. Historically, this phrase has been associated with abortion rights, where it makes perfect sense. Pregnancy is not analogous to any other experience. Once you are pregnant, the experience cannot be deferred or offloaded

onto someone else; there is no social arrangement that can make you never-pregnant; there are not multiple alternatives to having an abortion. There is only one: carrying a pregnancy to term. No one else can choose that option for you. We can try to create a world in which unwanted pregnancies are rare, but it is impossible to make the alternative to abortion *when you are already pregnant* any less extreme than it is.

This is what makes the kindsplainer's embrace of 'my body, my choice' to mean literally anything to do with bodies and choices – from cosmetic surgery to surrogacy to sex work – particularly shameful. There has been a forced-teaming of abortion rights and other supposed 'rights' – generally ones which involve female bodies being modified, or female sexual or reproductive services being sold – which is then used to imply that if you are not fully behind every single cause, you are not really committed to pro-choice principles. The statement becomes a general declaration that nothing anyone chooses to do with their own body should be subject to moral scrutiny, with the implication that the social and political context in which a woman or girl makes a nominally 'free' choice should not be questioned, lest this put every aspect of her bodily autonomy under threat.

This is not the first time that Progressive Man has expected women to be so, so grateful for his support for abortion care, and so, so fearful of losing it that we will be happy to conflate our specific right to reproductive autonomy with a more general right to 'bodily freedom'. In the eighties, Andrea Dworkin characterised the leftist male position as 'we will allow you to have an abortion right as long as you remain sexually accessible to us'. Nearly forty years later, the position is similar (while abortion rights themselves have been further eroded). The fight for abortion cannot be just about abortion; it must be about freedom in the abstract, thus rendering the

female body a depoliticised zone, open for modification and commoditisation. With abortion rights under threat globally due to the rise of far-right parties, there has been an opportunistic drive to put abortion into the same category as 'gender-affirming' surgeries, especially where younger women are concerned. (If the possibility of regretting an abortion is no reason to deny abortions to minors, why, so the fatuous argument goes, doesn't the same thing apply to cross-sex hormones and mastectomies?) As the title of a 2022 *Seattle Times* article puts it, 'Attacks on Abortion and Gender-Affirming Care Dismiss Bodily Autonomy'. We are told that 'protecting and advancing bodily autonomy for all isn't just about any specific health care service [...] We cannot stay in our silos and think only about ourselves'. Munroe Bergdorf would definitely approve.

Just as it is supposedly selfish for feminism to be exclusively for women, it is supposedly selfish to make the case for female reproductive autonomy without bringing in other issues. This is a political and ideological land-grab, leveraging the anxieties and vulnerabilities of women of reproductive age in order to make them feel that if they are insufficiently 'progressive', they will only have themselves to blame if they lose the most basic rights of all.

'Biology isn't destiny'

Now we come to what is perhaps the most ridiculous, but also the most hurtful, kindsplain of all: 'biology is not destiny'. The widespread misinterpretation of this slogan manages to be both stupid – betraying a complete lack of interest in what feminists have meant when discussing the relationship between female biology and gender – and revealing of an

incredibly low opinion of those of us who have female bodies. When the kindsplainer insists that 'biology is not destiny', usually in response to being told that women are adult human females, or that women's rights ought to take account of biological sex, he positions himself as doing women an enormous favour: he will ignore the unpleasant fact of our femaleness and allow us to transgress gender norms in return for us ceasing to make any demands or maintain any political definitions that relate to said femaleness. Then again, he's not sure we even want to transgress gender norms as opposed to just prevent others from doing so. Feminists who think women are biologically female, he tells himself, obviously can't imagine the trauma of having a vagina and not being a stereotype of femininity (since the latter is apparently all that women are, which isn't sexist if you can choose whether to be one or not). To be clear, there are also women who support this position (I, too, can recall wanting to cleanse the 'woman' category of the taint of femaleness in the hope that none would rub off on me).

It is at this moment that it becomes clear how many men (and some women) walk the earth with absolutely no idea how much the performance of femininity is at odds with the inner lives of the women around them – how much we suppress ourselves, how much we still hold back. It turns out that our adaptation to the norms imposed on us has, all along, been taken for enthusiastic consent. The kindsplainer marvels at how selfish we are never to have considered that not everyone feels so at ease in their bodies and with their social status. One has to wonder what these men have been assuming feminism is for. Women should not have to deny our own femaleness for it to be understood that we do not personally identify with sexist beliefs about what women are.

'Basic to the position of the radical feminist is the concept

that biology is not destiny,' wrote Anne Koedt in 1973, 'and that male and female roles are learned – indeed that they are male political constructs that serve to ensure power and status for men.' That is, the statement 'biology is not destiny' – understood in feminist terms – does not mean that women are not biologically female, but that their biological femaleness should not determine their role and position in relation to men. This should not be difficult to understand. Obviously biology *is* destiny insofar as there are fundamental ways in which our bodies determine our futures – we all age, we all die, only some of us have the capacity to get pregnant – but we do have control over the relationship between biological sex and the social, economic and political structures that surround us.

It is fair to say that some feminists have muddied the waters. In *The Dialectic of Sex* (1970), Shulamith Firestone claimed that the 'end goal of the feminist revolution must be [. . .] not just the elimination of sex male privilege but of the sex distinction itself: genital differences between human beings would no longer matter culturally'. Some have taken this to be an outright endorsement of sex denialism. There is, however, a clear difference between arguing that we need to overthrow 'the oldest, most rigid class/caste system in existence, the class system based on sex' and pretending sex difference does not exist, or that maintaining the class system (gender) will become morally acceptable as soon as everyone ceases to talk about its origins. Some feminists might disagree with Firestone about the extent to which sex difference can ever cease to matter culturally (and I would be one of them), but we can be united in believing it should cease to be used to order human beings hierarchically.

Recognising the importance of biology is vital not just for ending sexism. It is essential if we want to create a kinder,

more caring world for everyone, at all stages of their lives. Embedded in the misuse of 'biology is not destiny' is the insinuation that focusing on biology is politically conservative and intellectually unsophisticated, as though it is pure prejudice to think that our bodies restrict us at all. Biology is limitation; destiny is a wide open space. Yet as Clare Chambers writes, rejecting the realities of bodies makes us 'unable to theorize the way that those bodies operate in the world, the physical needs they have, and the way they are nurtured or harmed by the environment they live in and the politics that controls them'. In *Care and Capitalism*, the sociologist Kathleen Lynch describes how 'those in need of embodied care are treated as abject, as is the hands-on work of bodily caring, especially in societies that see both death and bodily fragility as problems to be eradicated'. An age-old distaste for biological reality and, with it, the idea that certain things to do with bodies – dependency, sickness, mess, death – are inevitable, can hide behind 'biology is not destiny'. Just as feminists end up being blamed for sexism, carers and the sick end up being blamed for their marginalisation. Why can't these people just get over biology? If so many able-bodied men with no unpaid caring responsibilities can, what's everyone else's excuse?

Kindness and the kitchen sink

Many men who insist they do not have a problem with feminism do little to hide their problem with feminists themselves, convinced that they'd do it all better (more kindly, more inclusively, with less stigmatisation of the most marginalised women, allowing them to be exploited in peace). The rise of 'be kind' rhetoric has served such men well, giving them the chance to put any woman failing in her duties as a

human giver back in her place. As Julie Bindel has pointed out, these men have 'very successfully misappropriated the term "intersectional"', using it to differentiate themselves from boring, old-style feminists who put male entitlements in jeopardy. 'Their responsibility as part of the patriarchy has been eroded,' she writes, 'and been replaced with the perfect opportunity to denounce the witches whilst being seen as the good guys.'

I am sure many of these men believe that they are wonderful feminist allies. They can always tell themselves that, even if some women disagree with them, there are others who support them. What this misses is that disagreements between women on feminist topics are not the same as disagreements between women and men; the stakes are entirely different. There is no need for men to consider the compromises and survival strategies women engage in and deploy when debating their own position in the world. Men can simply pick the feminist argument that suits them best and claim it is the kindest and most inclusive. They can persuade themselves their disgust at any woman who disagrees with them is not disgust at the norm violation committed by the defiant woman; it's their righteous disgust for all those who cannot just be kind.

There are particular ways in which the left's self-identification as the 'caring' side has lent itself to a denial of the more boring, mundane aspects of sex-based oppression in favour of something more abstract and less focused on individuals who are close to you and certainly less focused on the body and its unsexy needs. In an article on a perceived well-being gap between liberals and conservatives, the sociologist Musa al-Gharbi argues that 'liberals tend to be troubled not just by the state of their own nation and community, but by the plight of animals and nature, of people and events in other

countries, by hypothetical and projected future trends as well as historical injustices – most of which the typical person has little to no meaningful control or influence over'. None of this need be an act. The feelings expressed in response to global events are real. However, this focus on that which is not close to home, and over which one has little control, is status-bestowing while requiring little hands-on effort. It tells you that you are sophisticated, sensitive, more attuned to injustice in its broadest sense, whereas those who focus on small, domestic matters – possibly because they are doing the most work to deal with them – are selfish and parochial.

This marries up with the 'progressive' disregard for a feminism that is just for women and focused on domestic as well as public life. Old-style feminism is low status because women are everywhere. Half of us *are* women. There's nothing heroic or glorious about empathising with your mum. Much of what is associated with social conservatism – that oppressive mindset which prevents everyone from being their unique, special selves – is related to the family, social rituals and the dependent, sexed body. Dismissing all of this as unthinkingly traditionalist and unprogressive is convenient if you want to focus on the needs of the gender marginalised in some vague sense but not, say, on all of the ways in which you benefit from the unpaid labour of the 'privileged' women around you. In a 2018 interview with his daughter, Labour's Alastair Campbell claimed to 'absolutely believe in equality of opportunity'. 'I don't have an inbuilt objection to doing things 50–50,' he admitted, 'but it's true, on the housework front, I've never, ever done it.' Such admissions might irritate plenty of women, but they are rarely viewed as hateful or having a serious impact on the creation of a more just world. Yet as Lynch writes, recognising unequal distribution of household labour is an essential part of recognising 'the interests of

men, qua men, in upholding a capitalist system from which they are net beneficiaries relative to women of their class'. It's very handy to be too busy criticising women for stigmatising strippers or upholding the gender binary to notice the dirt and dust, and very easy to think this makes you someone who is generously choosing to empathise with the world at large instead of remaining small-minded enough to be conscious of your immediate environment.

The fact that so many left-wing men have not, in fact, dealt with the day-to-day basics of domestic labour redistribution before moving on to the big ideas may be one reason why a feminism that recognises sex difference is opportunistically conflated with a feminism that is right wing. This feminism's recognition of limitation and restriction, alongside its willingness to admit we cannot have everything we want – that some rights are indeed pie – is wilfully conflated with telling people to know their place. Of course, these are not the same things, but it doesn't matter. If you have found a new way of positioning a woman saying 'no' as selfish, cruel and politically suspect, what is to stop you running with it? Especially if you have been virtuous enough to commit yourself to being on the kind, feminine side of the political spectrum. Aren't some bullying rights – of the bad, unkind women, that is – the very least you are owed?

Macho kindness for culture warriors

In the spring of 2023, a mob of male protestors violently attacked a group of women in a public park in Auckland, New Zealand. A seventy-year-old woman was repeatedly punched in the head, while two female speakers had tomato juice thrown over them. The men who did this claimed to be

shattering gender norms. It might have looked entirely norma-
tive – female people want to organise and speak on their own
terms, male people resort to violence in order to stop them –
but actually, we were told, the men were being kind. As
Chloe Swarbrick, the Green MP for Auckland Central, later
described it, the protest was one of 'love and affirmation'.

The Auckland mob were, supposedly, protesting against
the alleged transphobia of Kellie-Jay Keen's Let Woman
Speak tour. LWS are an organisation that claims to raise
funds to defend 'women's sex-based rights and protections'.
Unlike groups such as Woman's Place UK, their background
is neither left wing nor definably feminist, with many femi-
nists – myself included – finding little common ground other
than on the most basic issue of whether adult human females
exist. Nonetheless, there was much about the Auckland
attacks that would have felt familiar to organisers of any pro-
female gatherings in recent years. Standard male aggression
was being presented as motivated by empathy and open-
mindedness. Image after image showed the kind of man you
would struggle to imagine picking his own underpants off the
floor suddenly feeling inspired to 'smash the binary' when pre-
sented with the chance to spit in a woman's face. Being kind is
incredibly complex if it involves giving your hard-earned cash
to a women's refuge or allowing a woman's perception of her
own reality to challenge your own; thankfully, it's really easy
if all it requires is assaulting women.

Writing in response to the scenes, *Trans* author Helen Joyce
connected them to the way in which the dehumanisation of an
entire group can be recast as kindness towards all whom that
group supposedly threaten. The popular claim that believing
biological sex matters means denying other people's right to
exist has created a loophole many men, frustrated after years
of having to be 'more feminist' than the other side, have been

more than eager to exploit. No one, other than children who have been terrified by controlling adults, actually believes the existential threat is real, but just being able to claim that it is makes monsters of women who speak the truth. 'When you suggest that people are outside civilised society,' wrote Joyce, 'you position them as suitable targets for violence.' Women should fear this. Describing the same events in the *Spectator*, Brendan O'Neill argued that 'we glimpsed the iron fist of authoritarianism that lurks in the velvet glove of "Be Kind"'. The 'progressive' response to this would be 'yes, but that's Brendan O'Neill in the *Spectator*'. That does not make the statement wrong. On the contrary, if the behaviour of 'your' side is giving your sworn enemies the moral high ground, perhaps a little more self-reflection is in order.

Many women are shocked – and perhaps we shouldn't be – at the enthusiasm with which men whom we did actually think were kinder and more receptive to women's perspectives have taken to the policing and punishing of women who commit what they deem to be social justice (aka feminine) norm violations. 'Woman-hating,' writes Bindel, 'has been dressed up as progressive politics.' It certainly feels as though some men have been waiting for this moment. Treating us as equals was an irritation, a polite lie with which they were forced to go along in order to play on Team Progressive. Now that anyone claiming biological sex matters can be portrayed as hateful, there is a plentiful supply of women whom it has become socially acceptable to terrorise and exclude. Writing in the *Critic*, Yasmin Zenith describes how 'in the UK, women's voices at [Let Women Speak] events are drowned out by authoritarian activists with megaphones who follow and harangue us at every meeting'. The impression is one of men who have been desperate, for years, to have the chance to put women in their place, call them names, threaten violence, hit

them, tell them they're to blame for their responses, tell them they're disgusting, without losing the status that comes with being one of the good guys. The new 'kindness' has given them what they've always been looking for.

Making up for the world

'As a way of practicing equality,' Andrea Dworkin told a gathering of male allies in 1983, 'some vague idea about giving up power is useless.' Equality, she argued, is not something you can 'try sometimes, when it works to your advantage, and throw out the rest of the time. Equality is a discipline.' More recently, and somewhat less confrontationally, Laurie Penny has reassured men that 'feminism is not a set of rules', nor is it 'about taking rights away from men, as if there were a finite amount of liberty to go round'. There is, apparently, 'an abundance of liberty to be had if we have the guts to grasp it for everyone'.

It is clear which interpretation of feminism has the most appeal for Progressive Man. Should you challenge him on this, he will tell you that he has made an informed choice between old, exclusionary, problematic feminisms and new, inclusive ones. It's not just that he's plumped for the one that causes him the least inconvenience. He has, he will insist, done 'the work'.

I am not suggesting that, in order to truly support women, men need to know everything feminists have ever said or written (who does?), or that there is not a great deal of valid disagreement among some of the most significant feminist activists and thinkers. When faced with a confusing array of viewpoints, all of them purporting to be feminist, why shouldn't Progressive Man select those which work most in

his favour? Nonetheless, what is difficult for the less compliant feminists among us is to then be told that Progressive Man's choices demonstrate a deeper level of empathy and a more modern, open-minded sensibility than we can possibly possess. It can be hard to argue against this due to the overlap between 'progressive' interpretations of goodness and ongoing, unspoken expectations of how 'good' women ought to behave. Sometimes, however, the switch from one set of criteria to the other is all too obvious. For instance, in June 2024, when the then Women and Equalities Minister Kemi Badenoch spoke of the importance of clarifying the definition of biological sex in law, political journalist Ian Dunt denounced her 'spiteful, toxic political personality', describing her as the 'full package: her policies, her arguments and her manner are all ghastly'. It is difficult to imagine a man having his 'manner' analysed in such a way.

Many of the deficiencies of the stereotypical racist, xenophobe or transphobe – his or her lack of kindness, generosity, inclusivity, nurturance, love – correspond very neatly with the supposed deficiencies of the unfeminine woman. This does not mean that the woman who is deemed unfeminine is more likely to be bigoted or unkind; her crimes against femininity may amount to no more than, to use the philosopher Kate Manne's terms, taking masculine-coded goods for herself or directing feminine-coded goods towards herself or other women. It does, however, create an opportunity for people who wish to police the behaviour of 'unfeminine' women and/or avoid challenging that of actual bigots to focus on such women rather than doing something more useful. By taking social justice slogans out of context and treating them as all-purpose principles – at least where women's rights are concerned – the kindsplainer conflates the bigot he claims to be fighting with any woman who suggests that situations

are complex and that endless accommodation on the part of women is not the solution to everything.

In this way, kindsplaining reminds me of a quote from Barbara Ehrenreich and Deirdre English's 1978 book *For Her Own Good*. Discussing the hypocrisy of the separate-spheres ideology which sought to confine middle-class wives and mothers to the home, they argue that by placing 'all the responsibility for love and caring [...] on the backs of women alone', patriarchy 'chose not to remake the world, but to demand that women make up for the world'. By falling in line with whatever slogans are thrown at them, no matter how broad the interpretation, good women are expected to compensate for the sins of others. By treating the unfeminine woman's transgressions as equivalent to those of the bigot, Progressive Man can tell himself he is on the side of the righteous without having to give up any of his own entitlements. This leads not to an erosion but an entrenchment of inequality and exploitation.

3

NATURAL BORN GIVERS

We have to face the fact that pieces have been cut out of us to make us fit into this society. We have to try to imagine what we could have been if we hadn't been taught from birth that we are stupid, unable to analyze anything, 'intuitive', passive, physically weak, hysterical, overemotional, dependent by nature, incapable of defending ourselves against any attack, fit only to be the housekeeper, sex object, and emotional service centre for some man, or men, and children.

Meredith Tax, 'Woman and Her Mind: The Story of Everyday Life'

GLORIA: It is literally impossible to be a woman.

Greta Gerwig, *Barbie*

In 1984, German lawyer Marianne Grabrucker published a diary she had been keeping for the first three years of her daughter's life. She had been using each entry to track all the ways in which her female child was treated differently from the male children around her. As she wrote in the introduction

to *There's a Good Girl*, her desire from the start was for her daughter Anneli to have more freedom than women of her own generation:

> I did not want her to be compliant [...] I did not want her to be always checking and rethinking her ideas before daring to open her mouth [...] And I did not want her to be completely devoted to some man who would be continually finding fault with and criticising her until she lost faith in herself.

What Grabrucker found was that she faced an uphill battle. Charting all of the little, usually unconscious, ways in which girls are conditioned to be smaller, quieter, more selfless, less demanding, she began to feel that the world was 'building brick by brick a woman governed by patriarchy, and not a human being with female or male components'.

Like so many feminists before and since, Grabrucker was interested in the process of female socialisation. She wanted to explore how a female child is shaped into the kind of human who best meets the needs of a male-dominated society, in which women are defined in terms of what men want them to be. One of feminism's central arguments – one which has underpinned demands for education, property rights, political representation, reproductive choice, freedom from violence and more – is that women and girls are not just whatever men say we are. Claims that we are born to be subordinate, or that we enjoy serving others, or that we do not mind pain, or that how we behave when threatened, coerced or conditioned is no different from how we would behave without threats, coercion or conditioning, serve particular social and political purposes. If we were natural born givers, there would be no need to keep telling us that this is how we should be, or to

punish us when we fail to deliver the goods. There would be no need to write conduct guides, religious tracts, scientific analyses, sociological studies, all 'proving' that femininity is innate (while insisting that women and girls who appear not to be innately feminine are either in need of correction or are not proper women and girls at all).

If being a woman is natural, stop telling me how to do it

Throughout *There's a Good Girl*, Grabrucker is clear about the distinction between biological sex and socially constructed gender (at one point she considers masking her daughter's sex as a way of staving off 'the selective perception of what a girl or boy does or is allowed to do'). The problem is not that Anneli's sex has been wrongly identified, but that the world assigns her particular emotions, behaviours and motivations and a subordinate status because of it. This is gender as 'difference plus hierarchy', or 'difference used to justify hierarchy'. The assignment is not an inevitable consequence of being identified as female, but a consequence of patriarchy, which is not an inevitable state of affairs. It doesn't have to be this way, but in order to change things, we have to describe them as they currently are.

This understanding of gender is neither particularly complex nor rhetorically dazzling, but it has provided an effective means of questioning the various arguments – religious, scientific, moral, 'common sense' – that have been used to justify women's subordinate status. The precise terms that are used may have differed, but elements of Grabrucker's analysis are present in Mary Wollstonecraft's *A Vindication of the Rights of Woman* (1792), in which she takes on Rousseau for his

'ridiculous stories' regarding the natural disposition of girls. They're present when, ten years before Grabrucker's book was published, Robin Lakoff complained of the way girls are taught to be 'little ladies' and are 'chastised more severely for throwing tantrums or showing temper'. They're present in Deborah Cameron's 2007 book, *The Myth of Mars and Venus*, when she notes that 'whether or not women have any underlying disposition to behave differently from men, they are often obliged to be different because of other people's expectations'. They're present in Ros Ball and James Millar's 2017 work, *The Gender Agenda*, a diary of the couple's experiences raising one boy and one girl that was inspired by Grabrucker's original (in the introduction she provided, Grabrucker reflected that, despite formal advances for women in public life, 'comparing both diaries, obviously nothing had changed in turning a child of female sex into a "good girl" and a child of male sex into a "real boy"').

Kate Manne's *Down Girl* was also published in 2017. In it, she argued that the purpose of misogyny was to maintain the position of women as givers of 'feminine-coded goods and services' and men as receivers of 'masculine-coded perks and privileges'. As such, *Down Girl* offers a classic analysis of sex, gender and double standards. What makes it somewhat different – and more palatable in the age of JustBeKindism – is that Manne avoids addressing sex difference itself. Instead, she appears to define 'woman' circularly, in terms of whoever acquires the 'human giver' designation.

It is certainly possible to describe socialisation into the 'feminine' role of natural born giver without specifying which humans experience this or considering why. It is always possible to start an argument, even to argue well, but to never quite see it through to the end. This has become an increasingly common feature of the feminism of the past decade, which

strives to be inclusive by shying away from any precision regarding the categories 'male' and 'female', and hence from any clear structural analysis of who is doing what to whom. In 2023 the Barbie movie won plaudits for America Ferrera's monologue describing the impossibility of being a woman when 'the system is rigged'. There is a serious, searing feminist analysis trying to break out of this speech – why is it impossible? Who rigs the system? Who benefits? – but a fear of overstepping the mark has set in.

Right now, mainstream feminism is caught in a double bind. It is not that we have forgotten that it is sexist to insist that women are kinder than men. It's that it has suddenly become difficult to participate in roots-level discussions about what is believed about women, or how gender functions, without being called unkind ourselves. We contort ourselves to avoid causing offence, obeying the commandments of JustBeKindism in the very act of seeking to name the problem. The widespread misrepresentation of Simone de Beauvoir's famous 'one is not born, but rather becomes, a woman' is a case in point. If we switch off our critical faculties, we can pretend it means anyone can be a woman, regardless of sex, ignoring the fact that Beauvoir is describing 'the figure that the human female takes on in society'. Feminists butchering an argument about the impact of female socialisation in order to make it more inclusive may in fact be the perfect illustration of female socialisation.

It is as though we are still permitted a feminist interpretation of our predicament, but only providing the foundations have been quietly removed. We can discuss how terrible it is that women are required to come second, as long as we make sure we put others first.

Creating (and re-creating) the natural born giver

In his 1869 essay *The Subjection of Women*, John Stuart Mill argued that 'what is now called the nature of women is an eminently artificial thing – the result of forced repression in some directions, unnatural stimulation in others'. This is a critique of gendered socialisation which avoids taking a position on what men and women would 'really' be like without it. Instead, Mill simply says we cannot know. This pre-empts accusations of feminist 'blank slatism', whereby thinkers are accused of holding the delusional belief that the human mind is a blank slate at birth, with the only differences between men and women (beyond their reproductive role) being created by social conditioning.

The purpose of this book is not to make a case for men and women having precisely the same capacities for kindness, empathy and/or compassion, however we might define them. While 'innate' goodness is an interesting area of study (with some research finding, for instance, that men develop greater empathising skills given the right financial or sexual incentives), feminists have not relied on some imagined socialisation-free zone to make their case against the harms of specifically gendered socialisation. Instead, they have made several evidence-based arguments: that gendered socialisation under patriarchy exaggerates differences; that the differences that are claimed to exist between males and females vary, depending on what a given society wants from female people; that a system of rewards and punishments is in place to encourage differences which are nevertheless supposed to be innate; that the alleged evidence for these differences changes over time; finally, if feminists are wrong, why do so many women chafe at the restrictions placed on them,

and thrive when they are lifted? 'There would be little need,' writes the philosopher Jane Clare Jones, 'for the panoply of discipline and shame brought down on women when they fail to fulfil their sweet, compliant service function, if women came equipped as "natural" support humans simply by dint of being female.'

In recent years, much liberal commentary on gender has tended to treat 'the gender binary' as some weird misunderstanding, as though if only people could get it into their heads that pink *wasn't* just for girls (or those 'assigned female at birth'), we could all get on with experimenting to our heart's content. What this misses is that gender serves a purpose that outlives fashion – after all, girls were no more liberated back when blue was their designated colour. Stereotypes change, but the values which they serve to enforce do not. The conflation of femaleness with femininity and maleness with masculinity creates a social hierarchy in which female needs and female boundaries are less acceptable than male ones (and hence require formal recognition if they are to be recognised at all). Femininity binds together disparate characteristics such as masochism, superficiality, passivity, nurture and self-sacrifice into one neatly exploitable package. This is very useful to societies in which women's domestic, emotional and reproductive labour is undervalued, appropriated and/or coercively extracted. As Katrine Marçal points out, you do not have to treat a woman's work as 'economically relevant' if it is 'just a logical extension of her fair, loving nature'.

Of course, one should not forget that gender imposes a cost on men and boys, even if they have something to gain from its impact on women and girls. Unless you are a walking stereotype yourself (and who is?), sex-role stereotypes constrain everyone. This does not mean it is in the interests of everyone to abolish it entirely. If you are someone who benefits from a

system but also finds it constraining, you may prefer to keep making tweaks which minimise the costs to you while protecting your advantage.

Changing scripts

That gender norms are shifting and culturally contingent has sometimes led to the misconception that there is nothing inherently restrictive about gender. Yet even as norms change, there is consistency in which sex ends up at the bottom of the social hierarchy. Men's hair length or willingness to cry in public, for instance, is not clearly correlated to women being treated more favourably. What gender says about women's 'natural' position can remain the same, even as the precise script that justifies it may alter as men switch personal tastes and political preferences. When one script falls out of favour, another takes its place. Often, one script can co-exist with an earlier one. Traditionalist or religious justifications for women's natural born giver status rub up against 'progressive' or scientific ones, with those promoting them simply expecting women to pick a side.

The process for embedding a new script seems to be fairly consistent. First, find a new way of blurring the distinction between sex and gender (this could be based on neuroscience, religion, evolutionary psychology, some random observations you've made about your wife or daughter). Second, emphasise difference over hierarchy when it comes to your claims about men and women (perhaps by suggesting that those who still see hierarchy are behind the times and have mistaken your sparkling new findings for someone else's tired old sexism). Third, present femininity as neutral or even positive (ideally by implying that criticising femininity is no different from

attacking women themselves, which is logically coherent providing you haven't missed out step one). Finally, suggest that women who do not buy into your new script have missed the point and are in any case too biased to offer a worthwhile opinion on what women are.

As a young woman in the nineties, I felt very hopeful that traditional models for feminine conduct had been exposed as inaccurate representations of female people in all our diversity. I associated these models with religion, force of habit, a lack of imagination, and was confident that as we approached the twenty-first century, women had done enough to demonstrate that we were every bit as complex as men and were not some homogenous feminine server class. Then along came neurosexism, in the form of books such as John Gray's *Men are from Mars, Women are from Venus* (1992) and Simon Baron-Cohen's *The Essential Difference* (2003). Suddenly, it was acceptable to express the same ideas about women, only this time you could claim you were calling on cutting-edge science, not boring old patriarchal prejudice.

'Instead of being goal oriented,' wrote Gray, 'women are relationship oriented; they are more concerned with expressing their goodness, love, and caring.' While Gray used his work as a relationship counsellor to justify dividing men and women into ambitious Martians and nurturing Venusians, Baron-Cohen drew on his research into autism to popularise the idea that men (or people with a 'male brain') are systemisers while women (or people with a 'female brain') are empathisers. He was keen to assert that this was not in any way a value judgement on either. 'Society needs both of the main brain types,' he reassured us. It just so happened that when he listed jobs for 'people with the female brain' these tended to be lower-paid caring roles, while jobs for 'people with the male brain' were higher paid and more prestigious.

To me this looked like standard stereotyping, with little to no analysis of socialisation or hierarchy. Even so, it was very hard to challenge. Whenever I tried, I'd be told this stuff was apolitical. It was science. It was objective. Disagreeing with Baron-Cohen made you a flat-earther – you don't want people to think feminists are flat-earthers, do you? The whole thing made me paranoid. I did the quiz at the back of *The Essential Difference*, just to reassure myself that I had a male brain. I didn't really believe in the concept of a pink, fluffy lady brain but somehow I needed to make sure I didn't have one.

By writing about the 'female brain' rather than just 'women and girls', Baron-Cohen did of course provide himself with a get-out clause whenever accusations of sexism were made. There were, he insisted, several ways of thinking about and defining sex; alongside genetic sex (chromosomes), gonadal sex (hormones) and genital sex (penises and vaginas), one could also consider 'brain type' ('you are male if your systemizing is stronger than your empathizing, and you are female if your empathizing is stronger than your systemizing') and 'sex-typical behaviour' (male people's interests involved 'things such as gadgets, CD collections, and sports statistics', while female people's involved 'caring for friends, worrying about their feelings, and striving for intimacy'). You may feel, as I do, that caring about the football league results is not the same sort of thing as having a penis, and that Baron-Cohen is begging the question, already treating 'masculine' or 'feminine' behaviour as a marker of sex so that whenever a woman or girl exhibits more of the former he can simply suggest, not that female people are not all feminine, but that her 'brain type' may be male. It was, however, difficult to say this at the time.

When *The Essential Difference* was published, some female academics and journalists did point out that Baron-Cohen

was giving with one hand (expressly stating that not everyone with a vagina or ovaries had to be an empathiser) while taking away with the other (positioning empathising as a scientifically proven characteristic of femaleness, just as valid as having a vagina or ovaries). Deborah Cameron, Cordelia Fine and Natasha Walter produced robust rebuttals to neurosexism in *The Myth of Mars and Venus*, *Delusions of Gender* and *Living Dolls*, correctly noting that, as Cameron put it, the new discovery 'that women have a natural vocation to care' had appeared 'when older justifications will no longer wash'. Two decades on, the neurosexism of the nineties and noughties feels dated, its weaknesses and sleights of hand all too obvious. It, too, has been replaced by a new 'progressive', supposedly non-sexist script. Alas, this one has proved even harder to challenge. Rather than be accused of being an anti-science flat-earther, this time you risk being accused of being a bigot – and of being unkind.

The gender identity kindness script

In 2019's *Females*, the Pulitzer Prize-winning trans writer Andrea Long Chu defines as female 'any psychic operation in which the self is sacrificed to make room for the desires of another'. This sounds depressingly familiar, yet *Females* has not been denounced as yet another boring guide to why women love making sandwiches, wiping arses and generally putting themselves last. As was the case with *The Essential Difference* and *Men are from Mars*, we are not supposed to think of *Females* as a variation on the same old essentialist theme. Whereas that relied on claims to scientific objectivity and stories of hardwiring to ward off feminist critiques, this new narrative relies on three things – pornography,

queer theory and social justice rhetoric – so that any woman tempted to cry foul feels a little unsure of herself. Maybe it *is* different this time? Yet there are striking similarities between the two scripts.

Females – alongside other books by trans women writers, such as Julia Serano's *Whipping Girl* (2007) – tends to dodge criticism for its tremendously regressive view of women due to its positioning as a call, not for a return to traditional values, but for trans liberation. In this context, femininity, far from being a source of oppression, becomes a thing to be celebrated. 'No form of gender equity can ever be achieved,' writes Serano, 'until we first work to empower femininity itself.' It seems the problem is not that certain values are associated with female people, often relating to self-sacrifice and objectification, but that we look down on those values, and 'gatekeep' who has access to them. Nevertheless, at no point is it really explained why, if femininity is not something inherent to people with vaginas but can be desired and embodied by people with penises, we should be using the term 'femininity' at all. Just as Baron-Cohen could have written about systemising and empathising brain types without calling them male and female, Long Chu could have written about people who just love it when their 'self is sacrificed to make room for the desires of another' without calling such people female. What could be the purpose of choosing not to?

As was the case in *The Essential Difference*, this new gender essentialism problematises defining biological sex in order to conflate biological differences and sex-role stereotypes. This is made particularly clear in 'scientific' defences of trans activist beliefs about gender identity. Articles with titles such as 'Stop Using Phony Science to Justify Transphobia' and 'Here's Why Human Sex is Not Binary' adopt Baron-Cohen's tactic of repurposing 'typical' behaviours for one sex as

actual measures of sex itself. In the latter article, published in *Scientific American* in 2023, anthropology professor Agustín Fuentes tells us that the gametes our bodies produce do not 'tell us everything (or even most things) biologically or socially, about an individual's childcare capacity, homemaking tendencies, sexual attractions, interest in literature, engineering and math capabilities or tendencies towards gossip, violence, compassion, sense of identity, or love of, and competence for, sports'. All of this is true, yet none of it is evidence that, as Fuentes insists, sex is not binary. It is merely evidence that, say, the fact that my body produces ova and not sperm does not make me great at housework or terrible at maths, neither of which qualities would make me any more or less female.

What Fuentes, Long Chu and Serano are serving up is not a cutting-edge rethinking of sex, gender and inequality, but the same giving with one hand, taking with the other re-inscription of stereotypes we have seen before. However, any feminist who now attempts to follow the example of those who took on the neurosexists will receive an even harsher pushback than those women did. Whereas before she may have embodied the stereotype of 'the woman whose non-systemising brain can't do science', now she will be committing the norm violation of lacking empathy. Pressure to validate trans identities has meant that questioning the very idea of a 'feminine' brain or identity is recast as cruelly withholding femininity from trans women. Whereas the issue for feminists has typically been the harm done by gender, the priority for trans activists and allies is ensuring everyone is granted recognition of their true gender, with any criticism of gender itself instantly translated into a refusal to let people 'be themselves'. As Kathleen Stock writes, we are losing 'recognition that expected feminine social roles might be in any way regressive or worth fighting against'.

It is difficult to see how this marries up with the analysis of human givers and takers found in works such as *Down Girl*. Some feminists have sought to fudge things by suggesting that the only problem with gender is if it is wrongly assigned, hence if you do not wish to be 'sacrificed to make room for the desires of another', just don't identify as a woman. The trouble with this is that it would mean renouncing 'woman' as a political identity (and thereby making 'room for the desires of another' after all) while having no guarantee of not being subject to the expectations placed on female humans. Female people cannot sidestep gendered expectations so easily because femininity does not mean the same thing for the conscripts as for the volunteers. Just as there is a double standard of kindness, whereby 'being kind' can be passive for males (not hurting others, not taking from them) but must be active for females (giving, sacrificing, caring), there is a double standard of 'performing femininity'. Just like male authors of feminine conduct guides, male authors of paeans to a feminine gender identity fail to recognise that a male person's idea of how a female person feels about feminine self-sacrifice may not correspond to how a female person feels.

Added to this is the question of privilege. If a woman is a person with a feminine gender identity, but cis (biologically female) women have privilege over trans women, then the former are deemed to owe the latter a duty of care. To what extent the latter are themselves accommodating others, as opposed to fetishising the act of doing so, is never especially clear. Nonetheless, the message that *this* way of conflating femaleness with human giver status is politically acceptable, even if all the ones that went before it weren't, is incredibly powerful in 'progressive' circles at this point in time. According to this new narrative, women do not owe care to men simply because women are female, but the biologically

female subset of the category 'women' owe care to the male subset because they are privileged. But doesn't it end up amounting to much the same thing?

Human givers or human females?

In *The Subjection of Women*, Mill compares the woman who has experienced patriarchal socialisation to a tree that is grown 'half in a hothouse environment, half out in the cold', forcing some parts to flourish and others to wither. Men then look upon it, he writes, and 'indolently believe that the tree grows of itself in the way they have made it grow, and that it would die if one half of it were not kept in a vapour bath and the other half in the snow'. The idea that a woman who is allowed to grow and flourish without male control could be a very different person was anathema to many men of Mill's own era, but hugely important to women's rights activists.

More than 150 years after Mill, Julia Serano tells us that 'certain aspects of femininity (as well as masculinity) are natural and can both precede socialization and supersede biological sex'. It is not made obvious how this could be demonstrated, or what it would even mean if femininity has nothing to do with biological sex (why, then, is it femininity at all?) As was the case with Baron-Cohen's arguments, this maintenance of gendered definitions of what feminists have identified as 'subordinate' or 'human giver' traits offers a sneaky way of managing and even extending sex-based double standards while claiming this has nothing to do with biological sex. The same sexist coding is in place, but feminists who explicitly reject femininity as an oppressive social construct are now treated as a threat not just by the traditionalist, but also by the 'progressive'. When it was first published, a number

of well-known US liberal feminists showered *Whipping Girl* with praise. Jessica Valenti declared it 'a foundational text that will prove to be timeless', while Jennifer Baumgardner called it 'a 21st century feminist classic'. For my part, I think there is nothing whatsoever that is revolutionary about telling women, yet again, that femininity is innate.

What Mill asserted was, by contrast, revolutionary and remains so. One can see this in the way in which defining women purely as adult human females has, in the wake of the activism of Serano and others, quickly become taboo in 'progressive' circles. There are of course plenty of people who think both that only biologically female people can be women and that all women are innately feminine. One might call these people 'traditional' sexists. They are not the same, however, as people who believe that adult human females deserve a word to define themselves and around which to organise socially and politically, but that no other assumptions should be made about their 'true' natures. One might call these people feminists. The feminist position is as challenging as it ever was. If women are just adult human females, and not natural born givers, how can one justify their position in relation to men? How can one justify the fact that women do twice as much unpaid care work as men? How can one justify men's feeling of entitlement to women's time, labour, resources and even words? If we are simply human and female, neither creatures to be branded with 'Always Choose Kindness' T-shirts nor selves to be 'sacrificed to make room for the desires of another', then it seems that we are owed so, so much.

Women are still not permitted to imagine what we might be, or how we might feel, or how we might connect to one another, free of assumptions about what a woman ought to be or whose needs she ought to be serving. When we try to think of such a thing, there is always a way to tell us we are

at odds with the 'good' values of the day, be they justified by religion, science, nature or 'the right side of history'. There is always a way to tell us that we are unkind, whereas those attempting to box us in are simply trying to create the best of all possible worlds.

JUST BE GIVING

4

SEXUAL JUSTBEKINDISM

Instead of being physically violated, women are given
the privilege of giving literally everything away.

Mary Daly, *Beyond God the Father*

Women are there to feed an appetite, not to have any
of their own.

John Berger, *Ways of Seeing*

One of the grimmest sexual experiences I ever had was with
someone towards whom I felt obligated because he'd bought
me a jacket potato with beans. To be clear: I could have
bought the potato myself. I'm not even sure I wanted a potato.
It was just one of those situations where I couldn't find a way
to say no to one thing, then couldn't say no to the next. You
could call it an etiquette fail on my part. I don't know what
you'd call it on his.

Looking back, I think he would have known I didn't really
want it (the sex, not the food). As Deborah Cameron has

pointed out, 'most refusals do not even contain the word
"no". Yet in non-sexual situations, no one seems to have trou-
ble understanding them.' Using the example of the man who
claims not to grasp that a woman is asking for help with the
housework, Cameron notes that 'some "misunderstandings"
are tactical rather than real [. . .] The "real" conflict is not
about what was meant, it is about who is entitled to expect
what services from whom.' With my potato purchaser, I felt
I owed him. Perhaps I didn't think I deserved a potato for
nothing, that I wasn't the type of woman for whom you'd buy
one out of pure generosity. In addition, though, I think I just
wanted to do the right thing.

This was the late nineties, the height of lad culture and
so-called raunch feminism. We talked about women having
agency; we did not talk about women having sex to be nice or
polite or in order not to make the other person feel bad. We
had a narrative, or an excuse, which stated it was all about *us*
and *our* needs. We can be selfish! Just listen to the Spice Girls
on 'Who Do You Think You Are'.

As has since been noted – or as, to be honest, wiser fem-
inists were pointing out at the time – the trouble with a
positive consent narrative which is not supported by deep-
level social change is that it can have the effect of compelling
women to behave as though change has already happened,
as if that alone is what brings about change. In the context
of sex, behaving as though you are a member of the entitled
rather than the subordinate class can end up restricting your
choices even further. You don't complain because you're too
busy thinking, What would someone who actually wanted
this do? Don't you want to be that person? The pressure to
perform a kind of sexual selfishness chips away at one's ability
to name genuine sexual entitlement. Letting down a prospec-
tive partner becomes indistinguishable from letting the side

down. As one blogger put it, 'consent is sexy and sexy is mandatory'. You're a human giver saving everyone embarrassment by masquerading as a taker.

In *Feminism Against Progress*, Mary Harrington quotes the journalist Virginia Ironside recalling the sixties as 'an endless round of miserable promiscuity, a time when often it seemed easier and, believe it or not, more polite, to sleep with a man than to chuck him out of your flat'. Ironside is aware of how odd the term 'polite' sounds in relation to the act, yet it makes perfect sense to me. If the advent of the pill means you are deemed not to have a good enough excuse – if you fear, not pregnancy, but just unpleasant sex – then to say no constitutes an affront. Feigning desire serves the dual purpose of prioritising male feelings (caring for him) and saving face (caring for you). Yet it is a form of care that is ultimately harmful. Sex to which you nominally consent but do not want is not cost-free, or even just mildly inconvenient; it is not the same as politely pretending to enjoy a work of art, or eating an extra slice of cake when you are already full. It demands a particular form of effort to separate self from body, an attempted delusion that this makes you more, not less, of yourself.

'Should you fuck men out of politeness?' is not a question one should be asking of women, yet still, sixty years after the time Ironside describes, thirty years after my own experiences, we are asking it. Not only are we asking it, but – as some of the examples in the rest of this chapter show – the penalties for not complying are even graver than before.

Are we the incels?

In the spring of 2023, several news outlets reported the heartwarming story of a fourteen-year-old autistic boy who made

a poster and presented it to a female classmate, asking her to be his valentine. The girl said no, whereupon the boy's mother took to social media, recounting the tale and emphasising just how 'shy and socially awkward' her son was. The story got national attention and 'the next day at school, a number of [the boy's] classmates approached him with kind words and offers to be his valentine'. One girl 'presented him with a poster like the one he had made to ask the girl the day before'. He had become a high-status victim, at least for a day; the girl he had initially asked out, a heartless bully. Yet what exactly had she been supposed to do? Say yes when she didn't want to in order to spare him public humiliation?

The story illustrates many of the problems with 'just' being kind. In the eyes of some, the boy's autism elevated him above other boys who pressure girls to do things they do not want. His shyness and social awkwardness were problems the original girl could have solved simply by saying yes. Maybe she judged boys like him just because they were different. Her rejection became, not a simple expression of her desires – just as his choice to ask her, rather than another girl, had been – but a judgement on his worth as a human being, one which the rest of the world set about correcting. To some, the boy had a right to kindness and validation which the girl was withholding. But what of her right to have her needs respected? There's a suggestion that while all girls have a right to say no, it would make life a lot easier if they could train themselves not to, coupled with the old message that girls are better than boys at manipulating their desires – see how many of them were willing to approach the boy the next day! There's so much prejudice in the world, but if girls agreed to offer themselves to the boys who felt most left out, we'd have begun the work of removing it. Taken to its logical conclusion, this is incel thinking.

Men's rights activists have always made attempts to portray themselves as 'the new oppressed sex', but a particular subgroup of misogynist extremists, incels – a contraction of 'involuntarily celibate' – have been particularly adept at framing their predicament in terms which mirror popular social justice arguments. As Laura Bates reports in *Men Who Hate Women*, incels 'resort to railing violently against the unfairness of non-incel society (people they call "normies"), the selfishness of the most attractive men ("Chads"), the superficiality of beautiful women ("Stacys"), and the promiscuity of less attractive women who are still able to attract sexual partners ("Beckys")'. This positioning of oneself against a normative, privileged mainstream is not exactly unfamiliar. The idea that incels have a point – that, in fact, a more equitable form of sexual redistribution may be needed, particularly in light of violent acts such as 'incel hero' Elliot Rodger's 2014 killing spree – is something to which many pro-sex trade liberals have responded with horror, yet not, I suspect, without some degree of awareness of how it cuts into their own arguments (if sex is like any other commodity, why oppose it being given out for free?). It might well be the case that 'the problem with the incel community isn't a problem of lack of sex, it is a problem of power and entitlement and it will not be cured by sex', but why isn't that true about other groups of males (because we are always talking about males here)? Is it not somewhat convenient that, as *Vice* put it, '"Redistributing" Sex is a Toxic Conversation about Toxic People'? Who'd want to sleep with 'the toxic'? Yet 'toxicity' and 'entitlement' are hardly screening criteria available to the prostituted woman or child.

In her 1975 anti-rape polemic *Against Our Will*, Susan Brownmiller identified an ideological incompatibility between certain key tenets of the male-led sexual revolution of the

sixties and feminist resistance to sexual violence. Today many feminists – even those with the most 'sex positive' leanings – have been forced to admit that the clear sexual boundaries asserted during the #MeToo era are not a good fit with either the extreme liberalism of the Pornhub age, or the 'rights aren't pie', 'there's enough of everything for everyone' reassurances of social justice sloganeers. True respect for female dignity, boundaries and sexual freedom must defend the possibility that not all sexual fantasies can ever be indulged, and not all heterosexual male people can be promised the experience of sex with a female person. To many, however, that seems much too mean and absolutist. So begins yet another process of working out which women should be permitted to say no, which men have needs that should not be denied, which excuses are acceptable, which are not.

This has created a new uncertainty within feminism. When in early February 2023 *The Times* ran a piece claiming 'boys are being "triggered" by #MeToo and Everyone's Invited movements that have left many lost, insecure and traumatised', most feminists expressed outrage. The idea that boys were having their lives ruined over 'clumsy teenage fumbling' was not something with which many sympathised. At the same time, many of these same feminists were pushing for less, not more, punishment of more significant sexual crimes, and for a more, not less, liberal approach to the sale of sex. It is as though fussing over the minor incident has become a substitute for going hardline when the stakes are higher. Added to this is the way in which, in the name of kindness and inclusivity, many feminists have become anxious about the perception that women and girls 'hoard' and 'weaponise' victimhood, particularly in scenarios where male people are deemed to have a more legitimate or more high-status claim.

In 1987's *Intercourse*, Andrea Dworkin described how

sexual objectification is felt to carry with it 'the power to dominate men because men want the object and the sex [. . .] these trivial, mediocre things (women) have real power over men through sex'. In modern social justice circles, this resentment of the privileged yet lowly woman – who lacks the insight of the authentic victim, yet still believes she has the right to exclude – latches onto the stereotype of the spoilt white and/ or cis (that is, female) girl who selfishly puts herself first. As Phoebe Maltz Bovy wrote in *The Perils of 'Privilege'* (2017), 'the cliché of White Feminism converges quite neatly with misogynists' grievances against women, specifically against the kind of women whose romantic attention they believe they're entitled to'. She notes, for instance, that the men's rights activist blog Return of Kings features a post that, titlewise, would not be out of place on the Everyday Feminism website: 'Why Modern Feminism is White Woman's Privilege'. Only here it's about why white women – a subset of those 'trivial, mediocre things' with the 'real power' – should be shamed into sleeping with 'less privileged' men (is their privilege their whiteness, their femaleness or their ability to withhold sex? Does it even matter?)

Perhaps it shouldn't surprise us that incel narratives of entitlement and supposedly feminist analyses of privilege and inclusion run perilously close to one another. They have always been on that path, ever since certain feminists attempted to make the feminist position on rape, consent and boundaries consistent with a sexual liberalism that refuses to be 'judgemental'. Just as there are new, 'progressive' ways to impose the same stereotypes of self-sacrifice and submissiveness onto female people, as discussed in the previous chapter, there are always new ways of making female sexual refusal appear regressive, selfish and unenlightened.

Why can't you share?

When Kristen Roupenian's *New Yorker* short story 'Cat Person' went viral in 2017, this was due not least to its painfully accurate portrayal of reluctant, but not exactly coercive, sex. As main character Margot prepares to sleep with the older Robert, she realises she does not want to – she is repulsed – but sees no way of backing out of the situation. This would, Margot reasons, 'require an amount of tact and gentleness that she felt was impossible to summon'. She is not afraid that Robert will rape her, but that 'insisting that they stop now, after everything she'd done to push this forward, would make her seem spoiled and capricious'. This description resonated with many female readers (it certainly resonated with me, given the jacket potato scenario). It is such a common experience, yet by and large women have not discussed it – because we are either too kind or too ashamed.

The sense that it is 'better' to override one's feelings is a common feature of sexual JustBeKindism. Insisting that it is always possible to rationalise one's way into being more generous and giving creates a loophole for sexually entitled men. Rather than seek to close this loophole by being honest about the limits of sexual liberalism, some feminists have decided it is their duty to perform a kind of clean-up job. The problem with progressives starting to sound like incels isn't, it seems, a problem with progressive politics; it's that sounding like incels makes progressives look bad, which can be remedied by making the progressive case appear more intellectually sophisticated.

In 2018 the *London Review of Books* published Amia Srinivasan's essay 'Does Anyone Have the Right to Sex?', later reproduced, alongside other essays, in Srinivasan's book *The Right to Sex*. This was in response to the 'sexual

redistribution' debate that followed Elliot Rodger's rampage, and the uncomfortable impression that, if one accepted the most fashionable accounts of sex, inclusion, victimhood and gender, the incels seemed to have a point. Except the incels had to be wrong – they were sad, bad people – and the fashionable people had to be right, albeit without in any way changing their own position that is, one which resists any clear commitment to opposing the global sex trade, hardcore pornography, or regressive, femininity-based understandings of what women are. In her essay and book, Srinivasan acknowledges that there is a problem, yet somehow the acknowledgement seems to function as much as a defence as a critique of the politics that perpetuate it.

To be clear, Srinivasan is conscious of the risks of encouraging 'a discourse of sexual entitlement'. 'Talk of people who are unjustly sexually marginalised or excluded,' she writes, 'can pave the way to the thought that these people have a right to sex, a right that is being violated by those who refuse to have sex with them'. This is a thought she deems 'galling', arguing instead that even though some men are 'excluded from the sexual sphere for politically suspect reasons', they ought to be taking this up with 'the systems that shape desire' as opposed to resistant women themselves. While this makes sense morally, I would argue that the phrase 'excluded from the sexual sphere for politically suspect reasons' still retains echoes of incels complaining that 'Stacys' and 'Beckys' sleep with 'Chads' and other 'normies' but not with them. Nobody wants to be politically suspect, and those who fear this – most of all young women – are more likely to feel pressurised than any abstract systems of power.

This is not the only instance of problematic phrasing. In the midst of reassuring us that she does not believe the state should intervene to redistribute sexual services, Srinivasan

mentions that 'no one really wants a mercy fuck, and certainly not from a racist or a transphobe'. One does not have to be a racist or a transphobe – or indeed any sort of bigot – to read such statements and start to feel anxious. 'You just don't like me because I'm …' has long been a tactic predatory men will use to manipulate women into ceding boundaries (this is something which Gavin de Becker explores in *The Gift of Fear*). A man might not even have to be predatory, or have any desire to sleep with a reluctant woman, for her to feel she must demonstrate her 'goodness' by saying yes to him. If she believes it a good thing to question the legitimacy of her own desires, she may end up feeling morally compelled to do so. She might not *think* she's bigoted – but how can anyone be totally sure they're not?

'Racist or transphobe' can be read as an extension of the 'spoiled and capricious' label that 'Cat Person''s Margot fears. If, as the rules of social justice dictate, one cannot truly understand the depths of one's own privilege, one is always potentially saying 'no' for morally questionable reasons. If, in addition, biological sex ceases to count as a meaningful axis of oppression, it can become very hard for a 'privileged' woman to ever have a reason that is 'good' enough.

Progressive himpathy and the cotton ceiling

In *Down Girl*, Kate Manne coins the term 'himpathy' to describe 'the flow of sympathy away from female victims towards their male victimizers'. While she rightly notes that the most privileged men benefit from this in particular ways, I think there is such a thing as progressive himpathy. Male sexual entitlement is prevalent across all social strata and right across the political spectrum. It is not restricted to men

who are wealthy or identify as socially conservative, or even men who identify as men. Progressive himpathy provides a way for those who consider themselves progressive to direct 'the flow of sympathy away from female victims' who encounter predatory males who, somewhat irritatingly, fail to be lonely incels, boorish frat boys, Hollywood moguls or crusty right-wingers.

Manne's leading example of a recipient of himpathy is Brock Turner, who in 2018 was convicted of three charges of sexual assault. Turner's defence relied on the claim that, as a talented swimmer and student at Stanford University, he did not deserve to have his life ruined by having to deal with the consequences of his actions. Disgraceful though this tactic was, it is worth noting that it was roundly condemned by feminists and progressives. It is not difficult for those of us who move in such circles to feel profoundly unsympathetic towards Turner (who is also held up for judgement by Srinivasan in *The Right to Sex*). We single him out over other predators, ones at whom we might feel a little more uncomfortable pointing the finger. This suggests that sympathy redirection could be less to do with fixed criteria which mark a male person out as privileged, and more to do with how what has happened between a male person and a female person might impact on the values of one's social group. Turner, writes Srinivasan, was 'a perfectly bred specimen of wealthy white American boyhood', but what if he hadn't been? Her point is that those who pity him now no longer would – but what if others were to take their place?

As an example of the way in which sexually coercive male behaviour can be 'progressively' reframed so that perpetrator becomes victim, lavished with himpathy, one might look to the so-called cotton ceiling. This is a term used to describe the 'barrier' faced by trans women who identify as lesbians when

trying to have sex with actual lesbians. A variation on the term 'glass ceiling', which describes women's struggle to reach the top of the career ladder (they can see it, but they can't smash through), it uses cotton in reference to women's knickers. It is a standard term in trans and LGBT rights activism – in 2012, Planned Parenthood Toronto even ran a workshop going by the title of 'Overcoming the Cotton Ceiling: Breaking Down Sexual Barriers for Queer Trans Women'. A 2021 BBC article on the topic quoted the trans YouTuber Riley J. Dennis complaining that 'if you were to say that you're only attracted to people with vaginas or people with penises it really feels like you are reducing people to their genitals'.

While to many of us this may sound very much like a conversion therapist's argument (can't you lesbians just *make* yourself attracted to penises?), or even a bad seventies joke about being a lesbian trapped in a man's body, the cotton ceiling is taken very seriously by some modern social justice activists and liberal feminists. The BBC article, for instance, drew widespread condemnation not due to Dennis's comments, but for giving too much of a voice to lesbians who are only attracted to other people with vaginas (aka lesbians). Progressive sympathy went in the direction of male people, not female people such as Jennie, who described having 'someone saying they would rather kill me than Hitler [...] just because I won't have sex with trans women'. Feminists who had felt plenty of affinity for the fictional Margot had little to say about the real-life Chloe, who forced herself to sleep with a male person 'after repeatedly explaining she was not interested' and confessed to feeling 'very bad for hating every moment, because the idea is we are attracted to gender rather than sex, and I did not feel that'. Just as perfectly bred specimens of all-American boyhood can't be villains for the right, trans activists who compare lesbians to Hitler, or use

accusations of transphobia to coerce lesbians into sex, can't be villains for the left.

In her discussion of the cotton ceiling in *The Right to Sex*, Srinivasan argues that trans women 'often face sexual exclusion from lesbian cis women who at the same time claim to take them seriously as women'. It's a framing which redirects sympathy by positioning lesbians such as Jennie and Chloe as dominant, possessing both the structural privilege of cisness and the power to exclude. It also carries a suggestion of hypocrisy – why claim to take someone seriously as a woman if your actions indicate you don't actually mean it? Yet to me, this form of 'lying' hardly seems worthy of condemnation. It is possible that some 'lesbian cis women' do not think male people are women, or at least not in the same way that they are, but refuse to say so out loud. This is not because they are being deceitful, but because they are being nice.

Female niceness – that mixture of socialised subservience, genuine compassion and, sometimes, awareness of threat – is hardly an under-discussed topic. I doubt there is a woman alive who has not had the experience of being 'nice' to a man who has made her feel uncomfortable or towards whom she has felt some degree of sympathy, only to be accused of manipulation when she refused to allow things to go any further. When asked whether or not trans women are women, many female people have been generous enough to say something they may not believe to be true (and which may even come at great cost to their own self-respect) in order to prioritise male feelings. These women would be deemed pointlessly, needlessly mean were they to say no, on the basis that it would have no serious implications for them, yet when it turns out the implications are very serious indeed – a revision of the entire concept of 'lesbian', or the loss of female spaces and sporting categories – they are not supposed to complain. It is

a classic case of women being required to simulate emotions in order to please, then being punished for their fakery.

Once it is decided that male/female is not a meaningful axis of oppression, whereas trans/cis is, it becomes possible to cast lesbians as oppressors just for being lesbians. 'There is no entitlement to sex,' writes Srinivasan, 'and everyone is entitled to want what they want, but personal preferences – NO DICKS, NO FEMS, NO FATS, NO BLACKS, NO ARABS, NO RICE NO SPICE, MASC-FOR-MASC – are rarely just personal.' The list appears to be Srinivasan's own and it's one in which 'no dicks' sits rather oddly, suggesting the sexual rejection of male people by female people has the same historical resonance as the treatment of marginalised groups by more privileged ones. If anything, though, 'no dicks' is a rebellion against the very social norms which seek to keep the vulnerable in line. There is no history of black people trying to coerce white people to sleep with them. There is, by contrast, a very long history of people with dicks coercing people with vaginas to sleep with them. Whatever specific terms one chooses for penis people and vagina people, all those who question why some people with vaginas refuse to sleep with people with penises do so in a world that has been organised around facilitating male access to female bodies and dismissing female resistance.

Making female people feel guilty and ashamed of their rejection of male people – whether as individuals or as an entire sex – is not excusable on the basis that you are not literally forcing them to have sex. Progressive himpathy picks away all that we already know about female socialisation, male power and cultural coercion. All we are left with is 'But you smiled at me! You said I was a woman! You led me on!'

The kindest hate speech

If social prejudices shape our desires, then the multi-billion-dollar porn industry is where the two come together in the most horrific fashion. It's an industry that doesn't just sell racism, misogyny, homophobia, classism, rape culture, child sexual abuse – it depends on them. Strangely, though, in a world where feminist discourse can be conflated with violence, and trigger warnings can appear on the most benign of texts, there's a reticence about positing too much of a direct link between porn and prejudice. For instance, in her essay 'Talking to My Students About Porn', Srinivasan suggests 'anti-porn feminists are too confident in their assumption that images of sexual and racial domination on screen can do nothing but exacerbate sexual and racial domination off the screen'. 'The simplicity of this picture is undone,' she writes, 'not least, by the notoriously unruly unconscious: who can be sure what it will make of what the conscious mind deems "good" and "bad"?' Srinivasan is not denying that prejudice exists. Nonetheless, I can't help feeling that the relationship between porn and prejudice is treated as though it is far more complex and mysterious than it actually is.

I am often surprised by the mildness with which the porn industry is critiqued when set against the viciousness with which feminists themselves are checked for signs of moral impropriety. Then again, it is very difficult to know how to take on the porn industry in any meaningful sense. It can feel as though porn is just gonna porn, so women must dutifully attempt to limit the harmful impact. Even though one could argue that many early feminist objections to pornography have been proven right in the internet age, those same objections are often post-rationalised as blinkered, prejudiced and lacking in nuance – the pearl-clutching of unkind women

in league with the anti-sex right (which is not to deny some unfortunate alliances). There is something very frightening about thinking too long and too hard about what far too many 'nice' men like to watch or even participate in. It is easier to ask women to focus on their own behaviour, and there is something appealing about recasting a situation in which male sexual entitlement has – for now – won out over feminist complaint as one in which feminist complaint was too exacting and narrow-minded to merit a better response. What this fails to account for, however, is the degree of cruelty with which women are faced.

In May 2023, the journalist Helen Rumbelow wrote a report for *The Times* on hardcore pornography. She describes watching 'strangulation, gagging, binding and slapping [. . .] Real violence, humiliation and punishment.' 'It didn't help my brain,' she added, 'to know the suffering was for such a good cause: male pleasure.' Even when sites such as Pornhub are not implicated in cases of offline coercion and abuse, they legitimise misogyny. Women who point this out are not being simplistic or failing to notice the nuances. There is nothing complex or nuanced about it. Knowing that multiple people have been involved in creating this content is not something that can be un-learned. Rumbelow admits to wondering 'if this was another medium, say a wildly popular theatre show among teenage girls and women, that involved young men being humiliated, bound, in pain and sprayed with female body fluids, would we be having more of a conversation?' Of course we would. Yet when it comes to women and girls, not only do some feminists suggest that the link between pornography and real-life harm is too hazy to establish: for many, stifling 'anti-porn' thinking has become yet another 'progressive' cause.

Rather than question the mindsets of men who buy and

watch abusive content, women are encouraged to police their own responses to it. For her 2023 book *Porn: An Oral History*, Polly Barton interviewed a young woman who found that her boyfriend's recent browser history included 'pornhub. com forward slash eight person gang-rape or something'. As an abuse survivor, the interviewee is shocked and upset, but also finds herself 'hesitant to kink shame'. 'There are always pros and cons, aren't there?' she later reflects. 'One of the pros to increased access to porn is that the kink and fetish community might not be so marginalized.' She worries that her initial gut response to the eight-person gang rape search could mark her out as someone who judges those who enjoy watching that sort of thing, people who now constitute a marginalised class (perhaps occupying the space recently vacated by women).

In another interview, a woman in her mid-thirties muses on the relationship between feminism and pornography, arguing (not unreasonably) that 'criticism of pornography' was one of the things that led to feminism being 'vehemently hated and demonized' in the nineties. She is concerned about being associated with the 'Dworkinian position', the modern equivalent of which she considers to be 'a kind of TERFyness – radical feminism once again touching on a fascist position'. This speaker does not explain how or why criticising pornography – or thinking biological sex matters politically – touches 'on a fascist position'. Reading the interview, it is clear she has something to say about misogyny and power, but feels obliged to hold back, claiming it vital 'to square the positive and the negative aspects of power dynamics in your head, to remember that sometimes they're a positive thing which it's important for people to explore, that they're part of an activity which is vital and should be protected and understood'. It is as though wanking to vulnerable, possibly underage, possibly non-consenting girls being hurt can, if looked at from

the right angle, be classed as embarking on a complex explo-
ration of the depths of human desire; by contrast, having an
issue with people wanking to vulnerable, possibly underage,
possibly non-consenting girls being hurt is potentially fascist.
Kink (whatever it means) acquires a magical, untouchable
status. That the underlying politics of kink can be dull,
grubby, unimaginative, conservative, bigoted, a reinforcement
of dominance, is not an acceptable observation. Sympathy for
the female people in front of the camera must be suppressed,
and progressive himpathy directed towards the man who is
turned on by their pain.

Reviewing Barton's book for *UnHerd*, John Maier iden-
tifies a common thread, especially in the interviews with
women, whereby 'sincere, sound, and persuasive first-order
judgments about porn [...] are then swiftly crushed by
second-order deference to a sexual morality of nuance'. The
women will feel something is wrong, 'then will immediately
check themselves by noting that things are of course subtler
and more "complex" than that suggests'. This anxious self-
monitoring typifies the way women perform 'progressive
niceness', overriding their instincts while concocting excuses
for this being in some way different from passively tolerating
the worst of male entitlement. The empathy spotlight shines,
not on abused women and girls, but on male consumers of
porn, now claiming the role of the sexually marginalised,
forever threatened by the judgements of 'normative' society.
This is another way of ensuring that female compassion is not
'misdirected' towards other females, breaking the impermis-
sible 'closed circle' discussed in Chapter One.

Through the porn script, female degradation is granted a
context in which it is not just permissible, but in which it must
be defended against 'conservative' forces. The insufficiently
degraded woman – the woman who sees herself as more than

an object – becomes aberrant, or even (if one empties the term 'fascist' of all meaning) fascist-adjacent. This is a perspective that extends beyond sexual relations per se and into political interactions, because it informs men's expectations of where women should be positioned in relation to them. If you belong to a political movement which has made sexual liberalism one of its central pillars, you may think you stand in opposition to gender traditionalism and religious fundamentalism, but if you are fetishising femininity and female masochism, it makes little difference to women themselves. You are still absorbing the idea that women should be compliant creatures and view-ing your acceptance of this idea as proof of your own virtue. Right now, it is strange to see those who defend pornography against 'anti-porn' feminists pose as heroic opponents to traditional gender norms. Normative beliefs about women have always been sexualised to suggest we 'love it really', whether 'it' happens to be blowjobs, housework, dependency, pain, or having the life choked out of us. Describing histori-cal feminine conduct guides, Tabitha Kenlon notes that 'for men, physical prowess equates to virtue, and for women, the opposite is true – virtue is achieved through meekness and modesty, staying quiet and catering to the needs of others'. In the porn age, female virtue is achieved through berating your-self for over-reacting to your boyfriend's gang-rape videos, or overthinking the nature of power and misogyny, and de-ciding that, actually, it's not an issue when male orgasms are involved. Virtue is achieved through persuading yourself that unquiet women are basically Hitler.

People who would never dream of buying books about why women should stay in the home, or why men were born to rule, will nonetheless nod sagely while reading books which imply women get off on their own subjugation – that this is, indeed, part of what being a woman is. When, in *Females*,

Andrea Long Chu claims 'getting fucked makes you female because fucked is what a female is', we are not meant to see this as a sweary update to every religious text that has ever described woman as an empty vessel. When, in her much-lauded 2015 memoir *The Argonauts*, Maggie Nelson describes her trans man partner telling her, the pregnant cis woman, 'to be femme is to give honor where there has been shame' and 'you're just a hole, letting me fill you up', we are not meant to find this depressingly unimaginative. Objections to any of this are considered gauche, a sign you're not one of the initiates. If there are different scripts which seek to justify female subjugation – '"Nature",' writes Kenlon, 'slowly replaced religion as a justification for women's status (only to be supplanted by science in the nineteenth century)' – then the porn script is a particularly hard one to challenge because it is at once so obvious and so insistent that it is offering a break with social norms. In common with all good religious scripts, it can only be properly read and interpreted by a class of experts, one which rarely includes women, and never feminists.

Kindness and intellectual sophistication are the two qualities that we are encouraged to believe we will be demonstrating if we grant the sex trade and hardcore pornography our feminist approval. We will show we are not like those knee-jerk feminists of yore, with their childish prioritisation of women's desire to avoid pain. Assert your sexual selfhood by leaning in to self-abnegation! Or, if that's a bit much, do it by pushing other, more marginalised women towards it! Demonstrate your maturity and ethical nuance by not feeling anything so gross and basic as empathy for the women on Pornhub, and reserve it for the men who watch them! There is no generosity in this approach. We overthink and nuance ourselves out of humanity entirely.

The kindness of feeling nothing at all

In 1991, it became illegal for men in the UK to rape their wives. I was sixteen at the time and had not known I was growing up in a country in which spousal rape had been permitted. I remember telling my mother how shocked I was. How had I not known? Her response was to tell me the law change wasn't necessary because 'when you marry, you give yourself to your husband'. In her view, and that of all those who objected to the change in law, marriage constituted a form of unlimited consent, one which would not, in any case, be abused.

My mother had strong ideas about what women owed to men. She disliked the Human League's song 'Don't You Want Me' on the basis that actually, yes, having been rescued from working as a waitress in a cocktail bar, the female protagonist did indeed owe Phil Oakey a relationship ('It's just ungrateful'). I swore that when I grew up, I would not think this way. I would not give myself to any man. Unless, as it turned out, a baked potato with beans was involved.

Today's feminism is in a mess regarding the question of consent. It wants to be cleverer than my simplistic nineties feminism, cleverer than the feminism of my mother's generation, but it isn't. Because 'progressive' politics decrees that no one ever loses out when progress is made; this includes no man finding himself deprived of sexual entitlements. On the contrary, there should be more sex to go round, just as long as it is not distributed in any formal way. The invisible hand of kindness will sweep down and make sure no one gets left out.

One of the key ways in which earlier feminists sought to transform understandings of rape and consent was by making it clear that this was not just about the use of physical force. Rapists do not have to physically coerce victims; they can

rely on nothing more than the potential threat of force. They can rely on victims freezing; they can rely on victims fearing something worse. They can rely on victims feeling confused, that they have misunderstood the situation, that perhaps they have no right to say no. They can rely on victims being conditioned to believe that they have no other option than to submit. They can rely on victims not understanding what rape is, on them thinking this is normal and only what they deserve. They can rely on a broader cultural narrative which tells a victim that negative feelings mark her out as an unkind person, and that it's better for her not to think at all.

The effort to educate women out of these ways of thinking has been replaced by an effort to educate women right back into them. The emotional work required of a woman to reduce herself, or another woman, to an unfeeling object has been deemed so much less than the work it would take for a man to accept sexual exclusion. His needs are real and deeply human, whereas her resistance to self-annihilation is petty and capricious. While concepts such as himpathy have been used to challenge this framing, their application has been restricted to scenarios in which they are deemed politically useful in other ways. There is no base level acceptance that a woman's humanity should always take priority over a man's sexual pleasure.

In her 2018 article 'The Female Price of Male Pleasure', Lili Loofbourow described the way in which 'bad sex' can mean very different things for heterosexual men and heterosexual women. For men it may amount to 'a passive partner or a boring experience', whereas women 'tend to mean coercion, or emotional discomfort or, even more commonly, physical pain'. Loofbourow is not referring to violence or anything which might be formally identified as abuse. What she writes about are the accommodations women already make – the

discomforts they already accept – which are instantly forgotten when we discuss men, women and sex. 'Women,' says Loofbourow, 'are enculturated to be uncomfortable most of the time. And to ignore their discomfort.'

Just like women's unpaid care work, heterosexual women's prioritisation of men's sexual enjoyment at the expense of their own is not appreciated. It is, to use the sociologist Kathleen Lynch's expression regarding the former, 'defined as freely available from the nature of women, regarded as being produced without effort or work'. If we were to fully acknowledge it, we would see how profoundly odd it is to think now is the time to ask women to consider whether they may be being too bigoted and exclusionary in their sexual choices. Whatever their sexual orientation, women do not need to be told to be kinder. Any interrogation of our desires ought to start from the position that we need to be able to centre ourselves more. We can only do this, however, in an environment in which male entitlement is challenged rather than treated as something about which nothing can ever be done.

I do not want a return to the world my mother believed was the only one possible. Nor, however, do I think we can pretend to be all that far from it. There is no reason – none whatsoever – for women and girls to feel cruel for 'rejecting' potential sexual partners. There is no particular subgroup of women who should be required to apply extra scrutiny to their desires. The cost to some individuals of never getting to penetrate the body of another should be easily recognised as less than the cost to others of being reduced to penetrable objects. It is the opposite of connection and the opposite of kind.

5

EMOTIONAL JUSTBEKINDISM

Men expect women to adore what men shrink from
in horror – themselves.

> Valerie Solanas, *The SCUM Manifesto*

The poet, the mystic, the prophet, the so-called sensi-
tive man of any stripe, will still hear the wind whisper
and the trees cry. But to him, women will be mute.

> Andrea Dworkin, *Pornography*

In February 2022, following Russia's invasion of Ukraine,
the actress AnnaLynne McCord decided to share a video of
herself reading a poem. 'Dear President Vladimir Putin,' she
declaimed, 'I'm so sorry I was not your mother.'

If I was your mother, you would've been so loved, held in
the arms of joyous life. Never would this story's plight, the
world unfurled before our eyes a pure demise of a nation
sitting peacefully under a night sky ...

And so it went on. The performance was bizarre, and roundly mocked. Was McCord seriously suggesting that Putin's choice to invade was down to a modern-day version of refrigerator mother syndrome? And that if Putin had had enough cuddles, and been allowed to cry, and had his mind set 'quite free with the love only a mother can give', the geo-political situation would be quite different? Was there even any evidence that Putin's actual mother never held him 'in the arms of joyous life'?

As a mother of three boys, I confess to having felt quite relieved at the negative response. There are limits, it seems, to how far mothers of sons can be blamed for everything. Since my first child arrived almost two decades ago, there have been moments when I doubted this. From the start – and especially when my second child turned out to be male – I have been regularly reminded, as if I could forget, that boys are differ-ent, special and always potentially 'in crisis'. Ignore that, and who can blame them if maternal neglect leads them to do terrible things (up to, but apparently not including, invading other nation states)?

Back then, books I was advised to read in order to ward off failure included Steve Biddulph's *Raising Boys*, Nigel Latta's *Mothers Raising Sons* and Sue Palmer's *21st Century Boys*. Were I a new mum today, perhaps it would be Caitlin Moran's *What About Men?* and Ruth Whippman's *BoyMum: Raising Boys in an Age of Toxic Masculinity*. These books take different approaches, and offer different justifications for the 'boy crisis', including: a 'feminised' education system, a lack of male role models, a modern world poorly adapted to 'caveman' brains, feminism, pornography, a refusal to let boys be boys, the expectation that boys will be boys, a general sense that boys being boys is bad and/or good. The ideological approaches differ but what these books share is a

general message that, as Moran puts it, 'we've been neglecting our boys' (since Moran does not have any sons, I can't help reading that 'we' as more of a 'you').

Obviously I care a great deal about my own children's feelings and engagement with the world. Despite never having been one, I am conscious that being a male teenager is not easy. As a feminist, I also care more broadly about men's emotional lives. If feminists did not believe that men could change, what would be the point? And if we did not care for all men simply as fellow human beings, what kind of humans would we be? At the same time, there has long been a voice inside me – getting louder over the years – that wants to say 'Hang on! Is it really that much harder for boys than for girls to challenge gender norms? Have we really never talked about how impossible it is for men to express their emotions?' Because I can't help getting the impression that we've been talking about it for quite some time. Indeed, in 2013 Biddulph – having presumably exhausted his own niche market for boy troubles – produced *Raising Girls*, the blurb of which informs us 'today it is girls who are in trouble'. Not so fast, Steve! Crisis-ridden masculinity might no longer be your focus, but it's always someone's.

That masculinity is in crisis is routinely presented as a new insight, as though up until now feminists have been drifting along thinking men and boys, as 'the patriarchy', are doing just fine. Like Stereotypical Barbie in her Dreamhouse in the Barbie movie, it's as though we've been assuming the Kens don't have inner lives and needs of their own. I'll admit that the 'male tears' mugs and 'grant me the confidence of a mediocre white man' T-shirts haven't helped to dispel this myth, but (as argued in Chapter One) these do not represent the best that feminism has to offer. Serious feminism has long been engaged in analysing both the brutalising effect of gender on

men and in exploring men's difficult relationship with vulnerability and dependency. What I would suggest is that, as mainstream feminism has become increasingly absorbed into a broader, male-dominated 'progressive' project, and criticism of gender itself has receded, feminist analyses of the problem have been blunted. Having abandoned the analytical tools required to describe how gender itself harms men, feminists have assigned themselves – and hapless mothers of boys – the job of 'detoxifying' masculinity. Boys should still be boys, but a bit less so, in ways that unfortunately we can't easily define without sounding sexist.

As a mother, I consider my sons to be my main priority. As a movement, feminism's main priority should, I think, remain women and girls. The great masculinity clean-up starts to feel like yet more women's work, in lieu of there being any recognition of just how much time women spend tending to men's emotional lives. Our liberation depends on more than us fighting for a man's right to cry or wear a dress. If that had been all it came down to, the patriarchy would have fallen with the Romantic poets or Shakespeare. Alas, it did not.

Your mum might be a feminist, but feminism is not your mum

The world of men is brutal, whereas that of women is gentle and soft. This has been one of the traditional justifications for women tending to men's emotional lives without being permitted to expect the same in return. It's a way of thinking that underpins the middle-class 'separate spheres' ideology of traditional conduct guides, in which the angel in the house creates a sanctuary for when it is time for her husband to retreat from the harshness of working life. 'Woman's kingdom

of emotion, morality, sensuality and finely crocheted lace curtains,' writes Katrine Marçal, enabled her 'to balance a man's life through care and empathy and to put him in touch with the aspects of the human experience that he couldn't accept in himself.'

That was the thinking, at least. It was, of course, more fantasy than reality. Quite apart from the fact that most women have needed to engage in wage-earning work, it does not represent women's experience of themselves or their own potential as human beings. The stereotypes of domestic femininity – its sugariness, its superficiality, its passivity – are prescriptions, not descriptions. As Janet Radcliffe Richards puts it, 'the wish is the mother to the belief; much of what is believed about women stems from what is wanted from them'. In any society in which women are required to provide nurture to others, it is convenient to think that they themselves know nothing of brutality and harshness, creating a situation in which they, as pampered, unthinking creatures, 'owe' others particular forms of support.

The false binary imposed by the 'separate spheres' – between hard, independent, isolated man and weak, dependent, giving woman – has been an obvious target for feminist criticism. For many second-wavers, it was an example of gender as socially constructed difference deployed in the maintenance of a social hierarchy. It was not just the case that men and women were forced to play particular roles, but that the roles were not what they seemed. Femininity, feminists pointed out, might be coded as gentle, frivolous and over-emotional, but actual female socialisation could be violent and cruel, demanding specifically 'feminine' forms of physical and emotional restraint. The home might, for men, be a sanctuary compared to environments in which they were pitted against other men, but it could be less soothing to women

and children. To be 'liberated' from providing care was, for men, exclusion from an essential part of being human, and hence emotionally stultifying. Everyone lost out, because everyone was expected to settle for half the range of emotions. However, even though men were sad, too, if a feminist solution was to be found, it had, first, to avoid replicating the false dichotomy of brutalised man/soothing woman, and second, to recognise that while the current situation harmed men, it also helped to preserve their position of dominance.

Because many earlier feminists had a critique of gender which distinguished it clearly from sex, and were more interested in its abolition than its 'detoxification', they were able to examine the negative impact of masculinity on men without falling into the trap of reprising the 'feminine' role of doing a man's feeling for him. It is interesting to look at some of the ways they approached this, given the ever-recurrent message that feminists have not yet 'dealt with' the feelings of men and boys.

In 1983, Andrea Dworkin delivered a speech to the Midwest Regional Conference of the National Organization for Changing Men. She did not shy away from acknowledging that patriarchy hurts men, but went beyond the usual list of why women's tragedy is also men's:

> And I'm sorry that you feel so bad [. . .] And I don't mean because you can't cry. And I don't mean because there is no real intimacy in your lives. And I don't mean because the armour that you have to live with as men is stultifying: and I don't doubt that it is. But I don't mean any of that.

I find it strange to read that list from forty years ago because it maps so neatly onto all of the men's issues feminists

have, apparently, not talked about yet, or at least not until five minutes ago. Yet Dworkin lists them as though they will be obvious to everyone in the room, passing over them swiftly to get to her main concern, which is to draw a link between the brutalisation of men in war and that of women in pornography, and to ask that men stop raping women for at least twenty-four hours. She knows that men feel shame, but tells her audience that shame is not an excuse 'to keep doing what you want and to keep not doing anything else [...] How much you hurt doesn't matter in the end any more than how much we hurt matters.' The speech manages to be deeply empathetic while also insisting that men take charge of their own emotional responses. There is no mystification here – no encouragement to wallow in the unfathomable depths of tortured male psyche – but a recognition that clear choices already exist.

In 1976's *Of Woman Born*, Adrienne Rich noted that men were 'increasingly aware that their disorders have something to do with patriarchy. But few of them wish to resign from it.' She writes of men viewing the women's movement 'in terms of the mother-child relationship: either as punishment and abandonment of men for past bad behaviour, or as a potential healing of men's pain by women, a new form of maternalism, in which little by little, through gentle suasion, women with a new vision will ease men into a more humane and sensitive life'. This sounds to me like yet more angel in the house treatment, yet also very much like the role uncritically carved out for feminists in many much more recent texts. Reading Rich's words, I feel that we have gone backwards. Whereas half a century ago feminists were describing the harms done to male emotional lives as a starting point for exploring how men might help themselves – which is surely the only way forward – today it seems feminists are describing these harms

as though no one ever noticed them before, only to decree that they should be feminism's task to sort out.

Feminism, writes Deborah Frances-White, must 'fight for men who are being pushed into lonely desolation by the patriarchal pressures to conform to traditional masculine ideals'. Elise Loehnen, in 2023's *On Our Best Behaviour*, tells us that 'the resurgent energy of the feminine is required to bring our culture's toxic masculinity into balance'. In *No Offence, But . . .*, published the same year, Gina Martin complains that 'we don't let boys express the same level of emotion as girls, but we get confused when a grown man punches a wall out of anger instead of crying'. To be honest, I am not 'confused' when a grown man punches a wall; I am much more likely to be frightened. Overall, though, I am just very tired of these requests to tend to men and boys in the only movement that should be for women and girls. It is as though we are still the angels, feminism is the house, and the big, bad world is patriarchy, so it is only our duty to mop the brows of our poor, emotionally deprived menfolk while once again setting our own feelings to one side.

Progressive himpathy and the violent victim

Requests that feminists focus on the feelings of men and boys are often accompanied by the insinuation that if we don't, violence will follow. Frances-White argues that the result of men being 'discouraged from displaying their feelings' is 'shame, frustration and pent-up rage, which causes violence'. 'We are in a crisis of toxic masculinity,' writes Loehnen, 'and we must address what's happening to drive boys and men to murder children. It's clear that men have a problem, and it puts us all at risk.'

While I agree with the general principle that improved emotional health for men reduces violence, I find this framing deeply unsettling. Whereas Rich and Dworkin were pushing for men to cease justifying harm on the basis of emotional suppression – indeed, as part of overcoming the suppression itself – the current narrative has threatening 'keep him sweet and don't provoke him' overtones of the kind one might expect to find in lessons for obedient wives.

Much of the problem is that feminists are hamstrung when it comes to challenging two of the most significant forces – pornography and sex-role stereotyping – which prevent men from helping themselves. In *BoyMum*, for instance, Ruth Whippman claims that the group for whom 'gender expectations and norms [are] shifting at a much more glacial pace' than for others is 'cisgender boys'. But isn't that how the concept of 'cisgender' works, locating boys at the G.I. Joe end of a spectrum that has Barbie far away on the other side? 'Cisgender boyhood' is not subject to norms: it is a norm. Focusing on 'toxic masculinity' rather than gender wholesale – that is, maintaining the assumption that there is some pure, non-toxic 'masculine' essence that differentiates the 'real boy' from the child who just happens to be male – places restrictions on how far we can expect men and boys to change. It stops us letting go of the idea that there are some inner feelings that are inaccessible to 'real' girls or 'real' boys. In doing so, it keeps women and girls in a position of having to, in Rich's words, 'go on doing for men what men cannot or will not do for each other or themselves'.

It is worth pointing out that while male emotional suppression is real, discussions of it often validate 'separate spheres' thinking by implying this suppression is not a problem for women and girls, too. It is as though males alone are held back while females – as weepy, gossipy creatures – get all the

feelings. This ignores the level of emotional regulation and simulation in which women must engage in order to comply with the feminine standards imposed on us. We smile through the bad sex, tell ourselves not to be silly about our boyfriend's porn addiction, make sure we are not difficult or bitchy or just plain 'unlikeable' when going for the job. As the behavioural and data scientist Pragya Agarwal writes, there has been 'little research into the impact of emotional suppression and gender norms on women', something which she links to 'the stereo-typical narrative that women are more emotional than men':

> The view persists and percolates through academic atti-tudes as much as through popular sensibilities that women show their emotions freely, and therefore must not have any effects linked to emotional modulation and regulation.

Exaggerating women's emotional 'freedom' in relation to men's is a way of both ignoring their pain and naturalising their status (they cannot be unhappy, since unlike men they hold nothing back).

The impact of female emotional suppression might be less socially disruptive, but it is real nonetheless. Women and girls are more likely to starve, cut ourselves and/or be prescribed anti-depressants, but less likely to hurt others by committing violent acts. While male suicide rates are higher, women are more likely to make suicide attempts. The playing off of the silent, repressed, 'tells nobody his problems' male against the woman who cries and spills whenever she feels like it over-looks all of the adaptations and accommodations women make in order not to bother men (including forming their own support networks). When male violence becomes 'evidence' that men are more emotionally deprived than women – as opposed to evidence that the coping strategies men deploy

are different and more maladaptive – more pressure is placed upon women to, as Barbara Ehrenreich and Deirdre English wrote, 'make up for the world'. Be nice, be kind, and maybe he won't hit you. His socialisation under patriarchy makes it hard for him to control himself, whereas your socialisation makes you perfectly suited to compensate.

'Progressive himpathy' – introduced in the previous chapter as a means by which sympathy towards female victims is redirected towards male perpetrators, albeit for 'progressive' reasons – often comes into play in discussions of male violence against women which emphasise the status of men as victims of the patriarchy. Because liberal, self-styled-inclusive feminism has moved away from recognising sex as a meaningful axis of oppression, there has been an increasing tendency to envision male supremacy solely in terms of, as Laurie Penny puts it, 'a few white European men, usually the richest and most well connected'. The vast majority of men are, according to this line of thinking, beaten down and not really in control of anything. If they have power over women, it is only 'to make up for their lack of control over the rest of their lives'. This analysis ignores the way in which men of other cultures, races, classes and geographical locations have oppressed women without any need for stage management from the men whom it is more politically acceptable for white liberals to hate. It also suggests, somewhat discomfortingly, that most male power over and abuse of women – especially the violence which takes place in the home, which constitutes the majority of male violence against women – is not real power, but a kind of consolation prize for not having power over the humans who matter: that is, other men. It is, in Penny's words, 'a sop' for men who have 'almost no structural power, except over women and children'. I would argue that that is actually quite a lot of power. Of all structures, the patriarchal family unit is

surely the one that has done most to enable men of all races and classes to appropriate female reproductive and domestic labour. Feminist pity for abusive men lower down the male pecking order might feel kind and thoughtful, but is it kind and thoughtful for the women who live with them?

Most women who live with men who are marginalised are themselves marginalised. They may already feel under immense pressure not to disclose abuse in case this would be viewed as betraying their community. Progressive himpathy directs sympathy solely towards the marginalised man, whose marginalisation is extra-visible because it is understood to be an injury to his masculinity. The similarly oppressed woman lacks the same status as a victim; that she could also be considered *his* victim is simply too inconvenient. If she becomes the target for his 'pent-up rage', then that is his tragedy, not hers. 'The patriarchy' – which is not him – should not have worn him down. He should have been allowed to discuss his feelings more. She should have understood this.

This situation can be particularly extreme when abusive men do not identify as men. As Jenny Lindsay notes in *Hounded*, their female partners 'are frequently shamed and pilloried as a group for being unwilling or unable to embrace their male partners' identification as "women"'. If abuse occurs, these women are denied the language to describe it accurately without being regarded as bigoted. For those around them, there is status in sympathising with the male partner. The analytical tools to describe this in feminist terms, and the moral compunction to offer female solidarity, have been placed completely out of reach.

Men's feelings matter; everyone's feelings matter. However, the abuse of women by unhappy men – whatever the reason for their unhappiness – should not be seen only as a cry for help due to male disempowerment. As a particularly stark

example, when school vice-principal Alan Hawe murdered his wife Clodagh and their three children before killing himself in 2016, the act of violence itself was treated as evidence of his marginalisation in much of the reporting. As Colin Barrett wrote in his essay 'He Had His Reasons', Hawe's lack of any 'prior history of mental illness' was viewed as 'confirmation that Hawe was stoically suffering in a silence that eventually became unendurable'. As Barratt pointed out, male mental trauma, not domestic abuse, became the only story that mattered. 'The actual physical suffering of Clodagh Hawe and her sons Liam, Niall and Ryan,' wrote Barratt, 'is subordinated to the hypothetical mental suffering of Alan Hawe, their brutal demises repurposed as tragic collateral in the master narrative of Hawe's interior dissolution.' This is not a kind response to male violence, and certainly no way to prevent it.

'As a woman, I feel great'

In 2016 *Vice* published a report on 'The Men Who Transform into Living Latex Female Dolls'. One of its subjects, Goetz, a middle-aged man, transforms himself into a doll called Tessa as a way of overcoming the hardships of male socialisation. His father and stepfather told him boys didn't cry and would not console him when he was hurt. Being Tessa made him realise 'how different it could be'. 'As a man,' he says, 'you're expected to be tough. But as a woman, I feel great.'

Yet Goetz is not being a woman; he is dressing as a doll. That he conflates the two things is revealing of the way in which patriarchy's denial of subjectivity to women comes to be viewed as a perk of being female. We are smooth as plastic, untroubled by feeling; nobody roughhouses us. If we suffer at all, it is generally the form of suffering – a

sexualised form – which is misrepresented as desired or in keeping with our innate submissiveness (while boys are twice as likely to experience physical abuse in the home, girls comprise 80 per cent of victims of child sexual abuse). At no point does Goetz seem to consider whether his father and stepfather would have treated him any better had he actually been female, though neither of the men sound as though they would have been especially sympathetic. The girl Goetz never was is a void, the not-boy, the non-sufferer. Femaleness, even in latex form, is flight from the hell of being male. It is the imaginary retreat of the abused male child. How could any woman be so cruel as to take it away from him by asserting her own humanity?

JustBeKindism, for all its pretensions to challenge sexism, falls back on a belief in female privilege. Just as conduct guides insisted, women owe men softness, compassion, empathy, care and uncomplaining tolerance because female socialisation, whatever its inconveniences, is less painful than the male equivalent. Only now, not only should women, protected from the 'harsh realities' men endure, 'create a sanctuary' – we should be willing to become one, our own selves becoming a space into which men, envious of our pampered inferiority, might identify. We are not serious humans; we are not required to deal with the serious side of life. The very least we can do is serve as mirrors, vessels and mannequin models for others.

The expectation that women and girls prioritise male emotional lives because, first, that is what women and girls are there for, second, our own needs are already being met, and third, we do not have quite enough intellectual depth to be bothered by the human condition, has found new life in the left's embrace of queer theory and trans activism. If all female people genuinely felt the way men who fetishise femininity

believe us to feel, the latter would be absolutely right to accuse those of us who stick to the 'adult human female' definition of 'woman' of unkindness. Here we are, drowning in entitlements, and we are unwilling to even acknowledge it, let alone offer some of our riches to others. Women have all the fun stuff and none of the existential crises. When we are accused of having unacknowledged cis privilege – of failing to realise how lucky we are to identify with the femininity that has been handed to us, or to even notice that we identify with it – there is a coming together of several strands of the JustBeKindist matrix: the left's obsession with rooting out the taint of privilege; the overlap of 'social justice' virtues with the feminine virtues women are expected to embody; patriarchy's positioning of femininity as a kind of luxury non-subjectivity; and the porn script's ramping up of the idea that women enjoy pain, so that even being oppressed is a form of indulgence. If being a woman was so bad, it is implied, why would anyone identify into it? If femininity wasn't life on the easy setting – if you didn't love it really – why wouldn't you just opt out of being female?

The story of transition from man to woman is – like that from man to doll – often pitched as a story of withdrawal from the harshness of life. In *Females*, for instance, Andrea Long Chu recounts the story of Gregory Lazzarato, a competitive diver who transitions to become Gigi Gorgeous, a human who looks like a doll. Describing an earlier image of Lazzarato, Long Chu describes him as 'cold, alone'. By contrast, Gigi Gorgeous 'has sanded her personality down to the bare essentials': 'She laughs at what is funny, she cries at what is sad, and she is miraculously free of serious opinions.' If women really were as trivial as Gigi – regardless of the script that decrees this, be it religion, neurosexism or porn – I would think we owed a great deal to those denied this status. That we are in fact full,

living, breathing subjects, managing our own complex needs while tending to others, is the problem with this narrative. The 'exclusionary' woman who openly rejects the concept of cis privilege commits the age-old sin of reminding men that there is nowhere to which one might flee. There is no state of untroubled, latex-skinned, depth-repelling semi-humanity to which one might transition (providing women cease to hoard it for themselves). There is no angel in the house, or of the porn script. That is a fantasy, and women cannot spend their lives being blamed for the fact that the fantasies men have built around us turn out not to be true.

Nobody is alone

There is hope for men and boys, as there is for women and girls. None of us are alone. Nonetheless, many men's perceptions of themselves as heroically independent can be so deeply ingrained it is mistaken for reality. If femininity – which we are no longer allowed to critique in its entirety, only in 'toxic' droplets – is coded as relationship and dependency, masculinity is coded as isolation. Yet few human beings live like this. We can, however, tell ourselves the same story so many times it feels like the truth.

Just like women, men are highly dependent on other humans, starting with their mothers. The masculine code is not so much 'be independent' as 'don't recognise your own dependency'. Dependency is a woman thing. Acknowledging your inevitable human dependency aligns you with actual, non-doll, flesh-and-blood women; it is shaming. This mode of thinking does not reduce the emotional demands men place on women. On the contrary, it becomes another way of not seeing women's work. The truth is, the vast majority of

women, feminists included, are not sitting around swigging from 'male tears' mugs but putting an enormous amount of thought into ensuring the men around us feel supported. We hold our tongues; we tiptoe; we decide our own needs are less important. Unfortunately, because this work cannot be acknowledged, it does nothing to assuage the feeling of deprivation. We will patch up the wound, and it will be self-inflicted again.

Humans give and take from one another all the time but, as Jane Clare Jones writes, the idea of patriarchal invulnerability makes it difficult for men 'to negotiate the vulnerability of their needs in an ethical way'. The old-new advice served up to mothers of boys and feminists – 'Have you considered men and boys might be vulnerable too?' – does not necessarily help to resolve this. We already know it. We've always known it. Validating the delusion of male invulnerability and resolving to put our womanly skills to solving it risks being just another way of replicating it (the academics Angelica Ferrara and Dylan Vergara recently coined the term 'mankeeping' to describe 'the labor that women take on to shore up losses in men's social networks and reduce the burden of men's isolation'). Here, it is our kindness that risks becoming toxic.

In *What About Men?* Caitlin Moran claims that men have not been solving their own problems so 'as usual, muggins here – a middle-aged woman – had to crack on and sort it all out'. There is some justification to this. Because the cost of masculinity is so bound up in its benefits, one could argue that it is much harder for men to be invested in addressing it, or even that the act of addressing it is itself 'unmasculine'. Yet there have been male writers, men's groups and male support networks that seek to do so. Like many feminists, I feel a degree of anxiety around this because of the occasionally fine line between men working to challenge gender

norms and anti-feminist men's rights activism. However, anti-violence training organisations such as Michael Conroy's Men At Work and anti-loneliness support groups such as Men's Sheds perform a valuable role in genuinely challenging gender norms. Years ago, I might have thought associating men with sheds was too much of a reinforcement of stereotypes; now, I think a far more ingrained stereotype – that men cannot admit vulnerability – is worth tackling using a lesser one. It is in some ways irritating for feminists to know that men's emotional problems are indeed our problems, but we cannot just sort them ourselves. It has to come from men.

We cannot keep telling men and boys that feminism will grant them emotional liberation at zero personal cost and without their own active involvement. 'We infantilize men and deceive ourselves,' wrote Rich, 'when we try to make these changes easy and unthreatening to them':

We are going to have to put down the grown-up male children we have carried in our arms, against our breasts, and move on, trusting ourselves and them enough to do so. And, yes, we will have to expect their anger, their cries of 'Don't leave me!', their reprisals.

We will have to expect to be called unkind. There is, I think, no other way.

6

REPRODUCTIVE JUSTBEKINDISM

... in a very real sense, nature is unjust to men. She includes and excludes at the same moment. It is an injustice, however, which male praxis might reasonably be said to have overcorrected.

Mary O'Brien, *The Politics of Reproduction*

Women's reality is not the dominant ideology, and women's view of the world is overruled by men's view. Motherhood in a patriarchal society is what mothers and babies signify to men.

Barbara Katz Rothman, *Recreating Motherhood*

Patriarchy is the most successful reproductive rights movement the world has ever known. It found a way to correct the biggest, most intractable injustice of all: female reproductive biology being allocated to those lesser beings, the females. Thanks to some solid, millennia-spanning challenges to the exclusionary nature of the female body, men have clawed back the status and entitlement privileged womb owners sought to keep for themselves. Well done, men! Talk about

showing the world that rights aren't pie and biology isn't destiny!

I jest only a little. There are, I think, enormous parallels between traditional patriarchy's appropriation of female reproduction and modern-day 'progressive' attempts to redistribute its spoils. In both cases, from a male perspective the womb owners have something you don't. You can't just take it from them – it's not tangible in that way. So instead you find ways to claim that what is theirs is also yours, only on some deeper, more meaningful level. You acknowledge that a difference exists – after all, you can't miss it – but that their form of ownership is inferior in nature, even a little grubby. They are containers for something that, in an ideal world, ought to be yours alone.

The most hardened feminist would struggle not to be impressed at how effectively old-style patriarchy appropriated female reproduction. Not content with convincing us that men made babies while women simply incubated them, it then told us that this was emblematic of women's uncreative, receptive nature. The intrepid sperm – a fully-formed mini-human in waiting – did all the work, with the womb functioning as a dark, gloopy waiting room. Women, as Beauvoir put it, furnished 'only passive matter while the male principle contributed force, activity, movement, life'.

Today, nobody seriously believes that this is how pregnancy works. We know, too, that women have resisted their broader designation as the passive sex, existing only to nurture the creations of men. Women are people, and men can be nurturing too. At least we say these things, yet it is also true that men – even the most pro-choice among them – have never fully relinquished their sense of entitlement to the reproductive process. As Helen Gibson, founder of Surrogacy Concern, points out, we can always find new ways of 'convincing

women that the child they grow from their own body and blood isn't theirs'.

Many of the harms of JustBeKindism – the double standard of gender non-conformity, the push for greater female emotional self-regulation, the misrepresentation of men's increased emotional demands as brave declarations of vulnerability, the dismissal of female embodied experience – find intense expression in the 'progressive' reinvention of reproductive, familial and nurturing relationships. We forget that patriarchy has never been solely focused on offloading care work onto women, but on redefining biological and social relationships to make it look as though when men take from women, they are actually doing us a favour. When men today say they are being denied the 'right' to care, or when women are told the dismantling of 'mother' as a particular role and status would be for their own good, we need to be a little suspicious. Are men wanting to share the load? Or are women, once again, just being asked to make way for the true owners of the child? Reproductive rights matter. It is good and kind to fight on behalf of those who need them most. But just whose reproductive rights is JustBeKindism defending?

The exclusionary politics of pregnancy

The experience of pregnancy is completely closed off to half of the human race. The feeling that it ought to be shared out more equally – at least in terms of cultural status, if not physical pain or risk – is a cornerstone of patriarchy. It underpins narratives which make the process of reproduction a male creative act, and legal and social norms which inscribe male ownership of women and children (naming conventions, custody biases, abortion restrictions, the intense regulation

of female sex lives). It is fundamentally patriarchal to seek to 'reassign' reproductive authority to male people. This is a problem for those who claim that feminism takes nothing away from men. Many men would like to retain a central role in a biological process which excludes them, only in ways that are less scientifically untenable and socially inconvenient than before.

As Mary O'Brien pointed out in 1981's *The Politics of Reproduction*, however much wanting babies is cast as a 'woman thing', men are obsessed with paternity. To deny it, she writes, 'is to make nonsense of centuries of strenuous masculine activity to negate the uncertainty of fatherhood'. In a reversal of the myth of penis envy, second-wave texts such as O'Brien's or Gena Corea's *The Mother Machine* (1985) emphasised men's natural position as one of alienation from the reproductive process and any assurance of biological lineage. A pregnant woman is never in any doubt as to whether the foetus is really inside her body and not someone else's; without a number of measures which limit women's sexual freedom and other men's access to her, a man can never be absolutely certain that the same foetus is connected to him and not another man.

'Man's nullity as a parent appears unbearable to him,' wrote Corea. '[. . .] His assertion of a right to the child must be supported by ideologies of male supremacy and by a host of social structures.' In any culture that still encourages women to view their reproductive potential as a liability, such assertions may seem strange or even hysterical. *They* envy *us*? But the structures, myths and rituals exist. Look at forced marriage. Look at the right's obsession with female sexual purity. Look at the paternity tests that were a staple of nineties talk shows. Look, if you dare, at the left's new-found obsession with claiming men can get pregnant, too, or even that humans

can change sex as easily as clownfish. Female bodies are not meant to do something that male bodies can't. If you cannot stop them doing it – and especially if you still require them to do it – you must take it upon yourself to define and control what pregnancy is and, by extension, what women are.

There is a degree to which modern reproductive technologies have sought to get around the mean, exclusionary nature of pregnancy. As yet, however, no human being has been gestated to term outside a female body. Even if this were to become a possibility, there remains only one type of body that can do this without any form of external intervention (beyond impregnation itself). To many, this doesn't seem fair. It didn't seem fair to men in the past, and it does not seem fair to those now insisting that kindness, empathy and the complete denial of competing rights are the solution to all injustices. There must, it is felt, be some way of rearranging things so that anyone who wants a baby all of their own can have one. There must be some way of solving the problem of female people not sharing their femaleness. Why can't pregnancy – like woman, like man – be whatever we want it to be?

The answer to this is simple and frustrating: because pregnancy just isn't like anything else. As the sociologist Barbara Katz Rothman has argued, this very uniqueness has been a problem for patriarchy, but it has also been a problem for liberal feminism, which has rebelled against the things men have done to counter reproductive alienation without necessarily grasping that female reproduction is not itself to blame. In her 1989 book *Recreating Motherhood*, Rothman noted that both patriarchal ideology and liberal feminist thinking had 'come to the same conclusion about what to do with the problem of the uniqueness of pregnancy: devalue it. Discount it so deeply that its uniqueness just doesn't matter'. The liberal feminist devaluation of pregnancy Rothman identifies – rooted in a

tendency to blame *any* recognition of reproductive difference for women's oppression rather than men's chosen response to said difference – has played a role in distorting social justice-based approaches to pregnancy, especially in light of the two trends which have become far more dominant since the time at which she was writing. The first is that of denying the social and political salience not just of pregnancy, but of biological sex in its entirety. The second is that of validating individualism (the so-called 'true' self) at the expense of accepting the contingent, relational nature of our identities. The very beginnings of human life show that relationality is not an add-on to personhood. 'Just be kind' politics cannot tolerate the singularity of pregnancy, its sex-specificity, its mixture of fuzzy edges and firm boundaries. And if your politics cannot tolerate pregnancy – and you will not change your politics – you will reach a point at which your politics cannot tolerate the class of humans who get pregnant.

In *Full Surrogacy Now*, self-described cyborg feminist Sophie Lewis dismisses O'Brien's *Politics of Reproduction* by describing it as 'trans-exclusionary' and 'romantically gynocentric'. Wasn't that the Ancient Greeks' issue with pregnancy too? Hasn't that always been everyone's issue with pregnancy, with womanhood itself? It's all far too womb owner-focused! Women need to stop being so gynocentric and trans-exclusionary and give someone else a turn at being them. There is a connection between the ancient devaluation of female reproduction and the current moral panic over female people existing as women at all. Somewhere between the two lies feminism's own misplaced anxiety over biological essentialism. In seeking to free ourselves, there are ways in which we have ended up tightening our own restraints.

Saving us from our reproductive selves

Pregnancy is profoundly important and only women experience it. Not all women want children, not all women can have children, and those who do retain other capacities, interests and purposes. Both of these statements can be true. In order to defend the second, however, many feminists have felt it necessary to reject the first.

I think almost every woman – whether or not she wants or has children – has feared being negatively defined by maternity, her personhood boiled down to just one thing: *Have you had babies? If not, why do you even exist? If so, then that is all you are.* In my late teens, I remember reading Jeanette Winterson's *Oranges Are Not the Only Fruit.* It's a novel I still love, but at the time, one scene became very fixed in my mind. Towards the end of the story, the main character Jess meets a former lover, Melanie, who has stayed behind in their home town. Melanie is pushing a pram and, Jess notes, 'If she had been serene to the point of bovine before, she was now almost vegetable.' Melanie has nothing of interest to say, discussing only 'the weather and the roadworks and the soaring price of baby food'. Those particular words made a deep impression on me: *pram, bovine, vegetable, baby food.* There was so much more going on within the text, with its complex analysis of maternity, sexuality and forgiveness, but as an isolated (though clearly straight) teenager I found myself reaching for one reading only. Don't ever become like Melanie, her capitulation to maternity bound up in her capitulation to everything that is bad and conservative! (I suspect my response was so narrow and visceral because even then I knew that I quite wanted children – and what would that make me?)

Men denigrate the enormous significance of female reproductive experience because it does not include them; feminists

do it because it includes them all too much. The most privileged among them – and I include myself here – often go along with this right up until we have babies of our own, then immediately start asking why 'no one' has ever mentioned what a big deal this is. (Lots of women have, of course; it's just that we wanted them to keep it to their bovine, vegetable selves.) There is nothing dehumanising or reductive about pregnancy and motherhood. It does not rob us of other human qualities or capacities, however much it is felt that this would even up the score. There is nothing about the validation of female reproductive experience – as an exclusively, uniquely female experience – that demands we sacrifice other aspects of our humanity, or that all women be forced to bear children, or that men cannot be involved in later acts of care. Yet we are surrounded by messages telling us the opposite, and these have a tendency to make us afraid.

Nowhere has this fear been weaponised against us so effectively as in the drive towards using 'inclusive' language to describe the people who get pregnant and give birth. As noted in Chapter Three, when feminists assert that women are simply adult human females – our potential held back by us all being forced, as Mill put it, to grow 'half in a hothouse environment, half out in the cold' – we are told that this is dehumanising women by reducing them to their body parts. We are supposed to favour the liberation of a word (no more shall 'woman' be associated with the brood mares, the walking wombs) over that of actual people. Female people will continue to exist, but the word 'woman' will no longer be sullied by association with us. The patriarchy has treated women as reproductive vessels, but that's all been rectified – henceforth only actual reproductive vessels (who used to be called women but aren't any more) will be treated as such.

This leads to a situation in which feminism continues to

express concern for the people who get pregnant – abortion rights have not been, and indeed cannot afford to be, dropped as a feminist interest – but cannot describe them as a coherent class (one that includes female people at other life stages, some of whom never get pregnant) called 'women'. It is a situation in which any analysis of the relationship between pregnancy and women's oppression founders. We rarely get beyond 'right-wing men don't want pregnant people to have abortion care because they want to punish assigned-female-at-birth sex-havers for having sex'. The supposed punishment for having sex is then slotted into power analyses which might consider race and class, but very rarely female reproductive biology in and of itself. That pregnancy has an inherent value which men of all political persuasions might wish to appropriate is overlooked. After all, there is no longer a linguistically identifiable class of people who get pregnant, so whom would they even target? Just the uterus owners, but who are they?

That so many women end up supporting this erasure is not because they are stupid (necessarily) or selfish (again, necessarily). Our exploitation has been so effectively conflated with our femaleness that we can feel grateful if someone offers to take it off our hands, or at least politely pretend not to see it. The feminist insistence that our bodies should not determine our social position becomes an insistence that our bodies should not determine our physical and social relations in any way. If you want to avoid being barefoot and pregnant, stop thinking your body makes you anything special.

The gatekeeper's dilemma

For many of us who came of age in the aftermath of second-wave feminism, it seemed self-evident that greater male

involvement in childcare could only be to the benefit of women. The entire problem, we were led to believe, was that nurturing had been considered the responsibility of women alone, on the spurious grounds that the ability to give birth also made one better at the practical work of raising children. This in turn had led to the undervaluing of care work, to the detriment of society as a whole. Everything would get better once men were equal parents – assuming women allowed them to be, and why wouldn't we? It wasn't as though having a uterus made sleepless nights, potty training and the fiftieth reading of *Thomas the Tank Engine* any less soul-destroying.

In the 'Revolutionary Parenting' chapter of 1984's *Feminist Theory* bell hooks presented men's greater involvement in childcare as something women could only expect in exchange for no longer seeing 'the mother/child relationship as unique and special because the female carries the child in her body and gives birth'. She was critical of feminists who asked for men to contribute more while maintaining a 'willingness to glorify the physiological experience of motherhood as well as an unwillingness to concede motherhood as an area of social life in which women can exert power and control'. Although writing at the same time as O'Brien and Corea, hooks took a very different position, and it is one I cannot help finding unfair (and wonder if hooks would too, given the way in which this 'conceding' is beginning to play out right now). Why shouldn't women 'glorify the physiological experience of motherhood'? Why must we pretend that male bodies are equally significant and contribute just as much to the creation of new lives when we can see that this is not true? It is not as though denial of female reproductive significance made men of the past more willing to prioritise child welfare. We cannot give up the uniqueness of the maternal relationship as part of

a deal with men; it will still exist, and it will still be unique and special.

Gendered double standards already ensure that female care is accorded a low value, whereas the male version benefits from the rarity perception. Many of us will have seen the cartoon of the 'good, fun father' and the 'bad, lazy mother', both of whom demonstrate these qualities by buying their children the same takeaway pizza. The issue is not just that the bar for fathers is lower, but the rewards are higher. 'The "good father",' wrote O'Brien, 'is admired on ethical grounds, and rewarded with domestic power [. . .] The "good mother" is merely natural, though family law provides safeguards to ensure that she stays so.' The belief that men just need to be 'allowed' to be better fathers (and in return will have 'earned' the right to deny motherhood any special status) is not altogether dissimilar to the belief that men just need to be 'allowed' to cry (and in return will have 'earned' the right to even more female emotional labour). It ignores the fact that men are *already* exerting a significant degree of control over women in the context of familial and interpersonal relationships. As with additional emotional labour, additional maternal erasure risks disappearing down the black hole of male entitlement, unnoticed and unappreciated, doing nothing to lessen men's sense that women are ignoring their need for recognition and inclusion.

One of the problems of discussing men's involvement in childcare relates to the way in which, even though gendered beliefs about care have led to mothers being exploited, what one does for one's own child cannot be thought of solely in terms of 'work'. As is stressed throughout this book, feminists have sought to challenge the categorisation of women as innately selfless human givers in relation to helplessly selfish male takers. In relation to motherhood, however,

it would be inaccurate to characterise women's liberation solely as liberation *from* caring. Women have also had to fight *to* care for their own children on their own terms. In many societies, the patriarchal nuclear family is one in which, until relatively recently, mothers had few rights. As Corea writes, 'it was not until 1886 in England that, under certain rare circumstances, a woman could get custody of her children'. Today, there is a commonly held belief that family courts are and always have been biased towards mothers, one that is exploited by men's rights activists and abusive ex-husbands, who will claim that there is a sexist bias limiting their 'right to care'. Yet maternal custody rights are not 'traditional'; they have been hard won.

This is not to say that the arguments used to win maternal rights could not be 'traditional' or reliant on a degree of biological essentialism. As discussed in Chapter One in relation to campaigns for girls' education and women's suffrage which emphasised supposedly feminine virtues, it can be difficult to distinguish a sincere belief in sex-role stereotypes from strategic essentialism. Even so, the fact that stereotypes have historically been used to argue for maternal rights does not mean that any rights specific to the role and status of mothers are in and of themselves sexist. In 1995's *The Neutered Mother*, the legal theorist Martha Albertson Fineman argued that by eagerly embracing the gender-neutralising of parenting, liberal feminists – many of whom took past gains for granted – had paved the way for the fathers' rights movements of the eighties and nineties, which allowed men to pose as progressive while agitating for a return to past assumptions of male privilege and the emptying of the term 'mother' of any significance that might empower women themselves. (Thirty years later, there are times when I feel that yesterday's angry, Batman-costumed divorcee has simply morphed into today's

sex-denying, Mumsnet-hating, feminist gathering-protesting middle-aged man.)

It is possible to look at Fineman's work, and that of maternal theorists such as O'Brien, Corea and Rothman, and see in it a kind of paranoia about the relinquishing of female specialness. They are indeed, as Lewis would put it, 'romantically gynocentric'. My younger, pre-children self would certainly have been reluctant to identify with a feminism which centred maternity to such an extent. 'Sure,' I would have said, 'some female bodies do things no male bodies can, but maybe it's worth not making too big a deal about it, lest it means all female bodies be defined solely in relation to that one capacity.' Given how many men simply do not take enough responsibility for the practicalities of childcare, and the tremendous social and economic consequences this has for women and children, arguments such as 'men's participation in nurture emerges from the exercise of proprietary right' can feel abstract and elitist. In 1991's *Feminism Without Women*, Tanya Modleski even took issue with the film *Three Men and a Baby*, arguing that it shows 'it is possible [. . .] for men to respond to the feminist demand for their increased participation in childrearing in such a way as to make women more marginal than ever', granting themselves 'more options than they already have in patriarchy: they can be real fathers, "imaginary" fathers, godfathers, and, in the older sense of the term, surrogate mothers'. Before the emergence of commercial surrogacy as the left's latest cause, I would have found such claims ridiculous. Now, I think 'men's participation in nurture' – like women's freedom from violence or the right to an abortion – is being leveraged to reassert old entitlements in new ways. If men's greater involvement in care work will help women, why can't we wait for it to do so before deciding the status of mothers should be deboosted even further?

What we have, as is so often the case, is liberation as a game in which women are expected to go first and show their hand, trusting that men will follow and play by the rules. You give up this, and I'll give you that. Give up your sexual boundaries and I'll give you your abortion rights. Give up the word 'woman' and I'll stop imposing sex role stereotypes on you. Give up any recognition of the political salience of the female body and I'll stop viewing female people as inferior. It is not a fair game to begin with, predicated as it is on the idea that a man's offer to stop doing something harmful is equivalent to a woman sacrificing another element of selfhood. It would be unjust even if men kept up their half of the bargain, but all too often they don't, and they never, ever go first.

It is an enormous ask to expect women to abandon any recognition of women's specific role in reproduction and the raising of humans, both now and throughout history, on the basis that maybe – if we're lucky – men might change a few more nappies and book the odd dentist's appointment. To empty motherhood of all significance is both impossible – it cannot be insignificant, because whatever we think or say, the same bodies make new bodies – and dangerous, given the extent to which men's appropriation of female reproduction has relied, first, on attempting to deny this very significance, and second, on telling women that any significance eventually granted must be accompanied by their acceptance of a lower status.

Recognition of reproductive difference does not make it inevitable that women are subordinate to men. In the matrilineal communities described by Angela Saini in her 2024 book *The Patriarchs*, no one pretends not to know that only one category of human can get pregnant. However, in communities such as that of the Khasi in north-east India, a child is understood to belong to her mother, whereas in that of the

Kerala, men participate in raising the children of their sisters as opposed to those of the women with whom they have had sex. A society without the patriarchal appropriation of female reproduction and in which men care for children does not have to be one in which reproductive difference is invisibilised, devalued or progressively erased via 'inclusive' language. Another world is possible.

Unfortunately, what men in matrilineal societies do not have is something which many 'progressive' men in patriarchal societies cannot imagine relinquishing. Even if their commitment to engage in more caring work is genuine, it is rarely proposed that this should run alongside an acceptance that they cannot ever be assured of having a child that is biologically 'theirs'. That would be unfair. They will insist once again that rights aren't pie, claiming female reproductive labour cannot possibly be a finite resource wholly reliant on the consent of female human beings. Woman-as-vessel has been around for so long it is unimaginable that she could ever cease to exist.

Extreme babysitting

In 2023 the US organisation NARAL – standing for National Association for the Repeal of Abortion Laws – became Reproductive Freedom for All. Under the new branding, they pledged to campaign for 'abortion, contraception, gender-affirming care, and more'.

It is absolutely right that the feminist focus on reproduction should not be restricted to arguing for abortion rights. Reproductive liberty, as law professor Dorothy Roberts explained it in *Killing the Black Body*, 'must encompass the full range of procreative activities, including the ability to bear a

child, and it must acknowledge that we make reproductive decisions within a social context, including inequalities of wealth and power'. This is incredibly important. No one should be forcibly sterilised, or have their babies taken away without just cause, or be forced by poverty to care for other people's babies at the expense of their own. When abortion rights organisations broaden their remit, one can see, poten tially, a nod towards this wider mission.

NARAL's name change can be understood in terms of a broader commitment to reproductive justice. However, the organisation's accompanying drive to gender neutralise their terminology and take on 'gender-affirming care' also points to something else: a move away from centring women and their reproductive lives. Reproductive justice is not just about femaleness – it is about race, class, sexual orientation, poverty – but femaleness should matter. As soon as it does not, we risk finding ourselves back on the side of that other, more successful reproductive rights movement: patriarchy.

Commercial surrogacy – a $14 billion industry, forecast to grow to $129 billion by 2032 – has sought to insert itself into the reproductive justice narrative. A 2020 *New York Times* article on 'The Fight for Fertility Equality' lauded the arrival of 'a movement formed around the idea that one's ability to have a baby should not be determined by wealth, sexuality, gender or biology'. One might consider 'biology' an interesting addition. After all, wasn't traditional patriarchy similarly fixated on correcting (or over-correcting) the perceived injustice of biological reality? If we now treat reproductive biology in the same way as wealth – as something which unfairly advantages one group over another – it becomes obvious whom we must consider the new dominant class: female people (young, fertile female people in particular).

In October 2022 the *Guardian* published a piece in which

men in the US complained about health insurers refusing to pay for surrogates. The headline ran '"We are Expected to be OK with Not Having Children": How Gay Parenthood Through Surrogacy Became a Battleground'. The photo to illustrate the article showed two male hands clasped in front of a pregnant (non-male) belly. A feminist response to this should surely be: yes, gay or straight, male or female, if you do not have the capacity to gestate a biological child of your own, you have to be 'OK' with not having one. The fact that so many social institutions and cultural practices have prioritised heterosexual men's refusal to be 'OK' does not make the refusal any less entitled when it comes from gay men.

To the JustBeKindist, however, pointing out that a fertile female body is not a resource to which every human being on the planet must be assured access is something only mean old traditionalists would do. 'Patriarchal man,' wrote Adrienne Rich, 'impregnates "his" wife and expects her to deliver "his" child; her elemental power is perceived more and more as a service she renders, a function she performs.' What better way to get rid of such a crude, restrictive, transactional set-up than by dispensing with all that traditional marriage nonsense? The trouble is, one can have different perspectives on who is most harmed by the situation Rich describes. The wife whose body, emotions, work and relationships are devalued? Or the bystander who feels excluded from getting his (or her) chance to play the role of patriarchal man with a baby-making machine all of his (or her) own? Whose problem do you want to fix – that of the victim of patriarchal man, or that of the wannabe patriarch?

Commercial surrogacy offers, at first glance, a progressive pushback against narrow-minded views regarding how families should be formed. Its proponents would even argue that there can be no sexism involved because commissioning

parents need not be men; women (whether in relationships or not) also pay other women to gestate babies they will claim as their own. In recent years, many famous women, such as Kim Kardashian, Rebel Wilson, Paris Hilton and Sarah Jessica Parker have acquired babies via the surrogacy route. Nonetheless, it will hardly need pointing out that no woman of similar rank has taken time off to work as a commercial surrogate. Rather than grant all women true reproductive liberty, what surrogacy does is grant a few women access to patriarchal man's entitlements. Indeed, when the commissioning woman's own eggs are used, we see the real extent to which modern medicine can turn women into men: by enabling the most privileged to use the bodies of those lower down the social hierarchy to continue their own genetic lineage. To paraphrase Rich, the female celebrity impregnates 'her' surrogate and expects the surrogate to deliver 'her' child.

A superficially feminist politics which denies the specificity of female reproductive experience, far from liberating all women from being treated as vessels, prevents the vessel from being treated as a woman, let alone a mother. Corea points out that the language used to describe surrogate mothers is intended to emphasise their dehumanised status: 'The women are referred to as inanimate objects – incubators, receptacles, "a kind of hatchery, rented property, plumbing" – and they have come to speak of themselves in this way'. The writer Arlie Hochschild visited a surrogacy clinic in India where the women, all extremely poor, are encouraged 'to think of their wombs as carriers, bags, suitcases, something external to themselves'. 'To get paid,' Hochschild writes in *The Outsourced Self*, '[the surrogates] had to agree to terms that severely limited their say over various aspects of their pregnancies, which, in turn, whittled down their autonomy, their selfhood, and, because of this, their capacity and desire to

relate to the baby they carried.' As is the case with sexual and emotional JustBeKindism, an entirely one-sided emotional regulation is being demanded. On the one hand, wealthy, usually white people are not expected to imagine their way into being 'OK' with not becoming biological parents. On the other, impoverished, usually black and brown women are commanded to brainwash themselves out of recognising what is happening within their own bodies. Imagine your womb is a suitcase! Convince yourself that kick, that second heartbeat, is nothing to do with you! The relationship desires of the privileged trump the real relationships of the marginalised. Like the prostituted woman or the wife of the abusive-but-marginalised male, the surrogate is expected to flip a switch on her own emotional responses.

JustBeKindism relies on a one-dimensional view of any complex situation. Rights aren't pie, we are told, because whenever we come up against competing rights, one person's 'rights' turn out to be undeserved entitlements. Given the choice between two possible readings of commercial surrogacy stories – a triumph over bigotry and old-style conservatism, or a redistributative project in which the relatively privileged transfer their exclusion from the reproductive process onto poor women – we are meant to favour the former. But why can't we see both things at once? We only see 'erasing mothers' as conservative paranoia because we have forgotten just how deeply 'erasing mothers' – their significance, their status, their unique bond – has been embedded in the heterosexual nuclear family. As Katha Pollitt wrote in 1987 regarding the rise of commercial surrogacy (with particular reference to wealthy heterosexual couples exploiting poorer women), 'it is a means by which women sign away rights that, until the twentieth century, they rarely had: the right to legal custody of their children, and the right not to be bought, sold,

lent, rented or given away'. Not only that, but a woman who signs a surrogacy contract is 'promising something it is not in anyone's power to promise: not to fall in love with her baby'.

Biological mothers are not just metaphorically out of the picture; in many cases, they are literally so. Post-birth photos shared on social media by commissioning parents often ape those of birthing mothers. The commissioner is lying on his or her back in a hospital setting, smiling exhaustedly and clutching the baby to his or her chest. It is very hard to view such photos without knowing that somewhere off-camera, there is a post-partum woman who is bleeding, that she will bleed for weeks, that within a few hours she will experience afterpains, that in a few days her milk will come in, which she may or may not be contractually obliged to hand over, that the feelings she will experience are not something she has been able to sign away, that her body and mind are changed forever. It takes effort not to know this, but this is the effort that JustBeKindism insists will make us sophisticated, enlightened, released from the bigotry of low-level, knee-jerk responses, which are all a bit *Daily Mail*. It's the same kind of effort that rescues the interviewees of *Porn: A Social History* from fretting about sex trafficking and gang rape videos. It is a conscious withholding of empathy in the name of 'kindness'.

In Lewis's *Full Surrogacy Now*, one gets the sense that the privileged woman who feels a little too much for the exploited woman is rather ridiculous: breathless, hysterical, prone to exactly the type of 'Won't somebody please think of the children?' pearl-clutching that is a cover for prejudice. Hers is a suspect kindness, 'disgust and paranoia,' writes Lewis, '[. . .] dressed up as righteous feminist rage and as pity'. I have thought a lot about this. Am I, in fact, just paranoid because prostitution and surrogacy make me insecure about my own experiences of sex and motherhood? Do I need to think other

women are exploited in order to reassure myself I haven't invested meaning in things which can be meaningless? And I'd say the answer is no, because that would just be weird. I don't think I am better or purer; I know I am more privileged, but I don't believe that this gives me some extra-special, refined response to intense human experiences that less privileged women lack.

The 2002 film *The Magdalene Sisters* features a scene in which Rose, a Magdalene laundry inmate who has had her baby taken from her through forced adoption, struggles with the pain of postpartum breast engorgement. We are permitted to feel pity for Rose, but not the modern-day contractual gestator. The latter's pain is paid for, or perhaps she is contracted not to feel that, too. Yet an absence of pity for the surrogate does not come naturally. Lewis mocks critics of surrogacy for their supposedly rose-tinted, romantic vision of pregnancy as 'the very pinnacle of wholeness and self-realization'. Have we not even noticed that 'sometimes mothers die; sometimes they don't love their babies; sometimes they abort them, abuse them, abandon them, divorce their co-parent, or even kill'? My god, how basic are we? Only we have, in fact, noticed. This was never a justification for the atrocities of the Magdalene laundries, and it is not a justification for the deliberate, pre-planned commoditisation of impoverished women's right and capacity to be emotionally attached to their own babies.

The parallels between reproductive and sexual objectification are made particularly clear in the 2023 reality TV show *Facelift*, billed as offering 'an insight into the lives of Dr Darren McKeown and husband Tom as they navigate a big year running a cosmetic clinic, building a luxurious cosmetic hospital and having their first child'. Here, women have two roles: either as candidates to be cut up and remodelled into

more visually appealing objects, or as containers for Darren
and Tom's future child. Interestingly, in an interview fol-
lowing the birth of the child, McKeown makes much of the
surrogate's capacity to feel. She is, he says, 'the most kind
human being we have ever had the good fortune of meeting',
since 'carrying a baby for another family for nine months has
to be one of the most selfless acts a human being could do'.

'Selfless' is one way of putting it (although any selflessness
involved in the three previous pregnancies which ended in
miscarriage is not mentioned). McKeown emphasises that 'the
surrogate is not genetically related to the baby. She basically
babysat our daughter inside her womb for nine months.' In a
similar fashion, the UK surrogacy agency Brilliant Beginnings
promotes its services as 'extreme babysitting' ('Brilliant
Surrogate Tracey [is] talking about her "extreme babysitting"
journey ... Could you be an extreme babysitter?'). If only
Aristotle had thought of it: man provides the life principle,
woman does the extreme babysitting.

Current campaigns to liberalise surrogacy in countries
such as the UK, so that those seeking rentable wombs are
not 'forced' to look elsewhere, are campaigns to restrict the
rights of surrogate mothers to change their minds – a kind
of legally enforced emotional regulation. This is what people
mean when they complain that UK laws are more restrictive
than those in certain US states: that women still retain (for
now) some scope to keep their babies. It's important that
the narrative surrounding surrogacy focuses on 'gifts' and
'selflessness' and masks this demand for what is, in essence,
a return to patriarchal authoritarianism. For a brief moment,
at the start of Russia's invasion of Ukraine, the barbarity of
unregulated surrogacy was laid bare for all to see with parents
who had 'commissioned' babies from impoverished Ukrainian
women seeking to 'liberate' their babies (but not the women

who had just given birth to them, or any of their other children). Then people forgot, because distinguishing between the goodies and baddies in a story this complex is too much like hard work.

Feminist warnings about the toxic combination of 'progressive' sex denialism and commercial surrogacy suffer from feminism's Cassandra syndrome: if something sounds that terrible, we must be being alarmist (see also: porn). If one describes the process in the starkest terms – redefine 'woman' in line with the scripts of patriarchal femininity and pornography, rename the group formerly known as 'women' in line with reproductive function (gestator, menstruator, uterus owner etc.), legitimise the right of wealthy men and women (both of whom can be biologically male) to rent out the bodies and acquire ownership of the babies of poor 'gestators' – where we are heading sounds completely dystopian. It sounds like racist, classist, capitalist patriarchy pushed to its absolute limit. It sounds insane.

How could the right side of history, the good guys, support this? No one kind could advocate for something so unkind, therefore the feminists must have got it wrong. If womanhood is femininity, and femininity is masochism and self-objectification, then it is surely an impoverished woman's privilege to be nothing, feel nothing. We are meant to think this isn't dehumanisation. Anyone who thinks otherwise simply isn't un-empathising hard enough.

They tried to convince us you weren't really like us

Pregnancy is an act of physical self-sacrifice and generosity, whatever the desires and emotions of the pregnant woman

herself. It is a deeply intimate, exclusive relationship. It is risky and changes the body forever; it might even kill you. To show due respect for all of these aspects of pregnancy is difficult. We are supposed to deny its uniqueness in order not to be bound by it, but it remains unique. It doesn't matter if people with those bodies come to be viewed, as Marina Strinkovsky puts it, 'like unwanted and egregious Amazon packaging'. Even if you tell them to view themselves that way, even if you make it their job to do so, that is not what they will be.

A 'progressive' culture that wishes to make female bodies available for everyone without openly appearing misogynistic needs to believe some women feel nothing. In such a culture, prostituted women and women in surrogacy are viewed as completely different from those miserable wives whom old-style patriarchy subjected to bog-standard sexual and reproductive exploitation. The feminist who protests that no woman can will herself into temporarily performing the role of vessel will be regarded as suffering from some quaint, conservative delusion that all women are governed by embarrassingly traditional responses to sex, pregnancy and birth. Because myths about female distaste for sex and an over-emphasis on 'maternal instinct' have been used against us, we are now expected to welcome the total denial of involuntary emotional responses (I use the term 'we', but it is largely privileged women like me who get to do the theoretical welcoming, whereas the most disadvantaged women are expected to engage in the practical side of emotion denialism).

What I am advocating here is not a return to a one-size-fits-all nuclear family model. This works for some and has caught the imagination of a burgeoning 'reactionary feminist' movement, but if we truly desire better, more caring structures, women raising children without the involvement of men need to be centred and valued far more. 'Progressive' politics

might find the idea of male nurturance more interesting and novel but in the real world, 90 per cent of single parents are female, bearing the brunt of government cuts and high childcare costs. If we care about resource redistribution – resources such as food, money and warmth, not female bodies and female emotions – we could do worse than to focus on them. Yet as Fineman writes, 'the existence of unstigmatized mothers successfully mothering outside of the traditional heterosexual family calls into question some of the basic components of patriarchal ideology'. A truly progressive left should not be weaponising female poverty to enable women to 'choose' to hand over exactly the same resources that old-style patriarchy has coercively extracted through violence, ritual and tradition. Single motherhood, argues Fineman, remains 'deviant simply because it represents the rejection of the primacy of the sexual connection as the core organizing familial concept'. It should not be that wealthy people commissioning babies on demand are considered more 'progressive', more interesting, more deserving of woke applause, than a woman parenting alone.

In his 2005 novel *Never Let Me Go*, Kazuo Ishiguro tells the story of a generation of clones raised to provide organs for 'normal' people. In order to justify this, the latter tell themselves that the organs appeared from nowhere. It is not a belief based on any particular evidence, but on what needs to be true to make the exploitation palatable. The possibilities provided by the clones – a far longer, far healthier life, cures for diseases which would once have killed – are just too tempting. As one former teacher of the clones tells her ex-pupils, by the time people started to gain knowledge of the clones' own origins and subjectivity, it was too late: 'How can you ask a world that has come to regard cancer as curable, how can you ask such a world to put away that cure, to go back to the

dark days?' As with clones in a dystopia, so, too, with female bodies under patriarchy. We know that babies do not come from nowhere. We know that they are not ready-made proto-humans implanted in the potting soil of the female body. But can we go as far as knowing that women are human, that women feel, that women exist in relation to others? If it is inconvenient for a clone to be a person, one can choose not to call them a person; if it is inconvenient for a surrogate mother to be a woman, one can call her a gestator or a uterus owner. The dehumanisation of others is a response to what needs to be done to and taken from them. As the teacher in Ishiguro's novel says, 'they tried to convince themselves you weren't really like us. That you were less human, so it didn't matter.'

It is not altogether surprising that the surrogacy script has come along to replace other reproductive scripts. What people – men in particular – would otherwise be being asked to relinquish is tremendous. At the same time, you can only dehumanise something you already know to be human. The 'ordinary' people in *Never Let Me Go* fear the clones – not the harm they might do, but the humanity they might exhibit – because some part of them already knows their entitlements are based on an injustice. When Darren McKeown describes his baby's mother as 'selfless', it is a literal expectation: she should have no self, no connection, no interdependency. We want to think everything can be sheared away. Babies grow in bags; cloned organs emerge from nowhere; anyone who claims otherwise is spoiling the illusion.

JUST BE INCLUSIVE

7

A MALE ALLY WALKS INTO A BAR

Self is incrementally expanded as the parasite drains self from those not entitled to it. To him it is given, by faith and action, from birth. To her it is denied, by faith and action, from birth. His is never big enough; hers is always too big, however small.

Andrea Dworkin, *Pornography*

A male feminist walks into a bar, because it was set so low.

Anon

'This is the future that liberals want.' Thus went the caption of a popular meme – at least if you were a liberal – in 2017. It accompanied a photograph of two people sitting side by side as they rode the New York subway. One was a glamorous drag queen, long legs spread wide, the other, a woman in a niqab, only her eyes visible. The image, along with the caption, had originally been shared on Twitter by someone who believed it to show, in the words of the *New Yorker*'s Ian Crouch, 'some kind of debased and terrifying dystopia'. This was met with

widespread ridicule. 'Twitter users,' notes Crouch, 'pointed out that the sight of two very different-looking people riding the train was neither remarkable nor futuristic – such things happen every day, right now.' One of the first responses was simply a man tweeting 'awesome!'

The way the phrase was picked up was funny and clever. Like 'sounds gay, I'm in!', it took an attempt at shaming others for not conforming and turned it into a source of pride. *Buzzfeed* ranked the image third in its '38 Great Memes That Defined 2017' (behind Distracted Boyfriend and Blinking White Guy). In an interview with the publication, the drag queen pictured, Gilda Wabbit, said, 'I won't speak for all liberals, but my goal is for everyone – white, brown, drag queen, soccer mom, cisgender, trans, heterosexual, queer, working class, middle class – to be able to exist as they choose without judgement or fear.' These are lovely, warming sentiments. Everyone should be able to move through a world that feels safe and welcoming. Yet the picture also felt like one of those trick drawings in which you can see two different things – the old woman or the young woman, the rabbit or the duck. Look at it one way, and you can see diversity and difference; look at it another, and it's hierarchy and sameness. You can, for a while, only see one version, but once you've seen the other, it is difficult to unsee it.

It's a photo of two people who freak out someone who wants everyone to dress and think a particular way – someone who is, one imagines, particularly hostile to Islam, immigration and gender diversity. It's also a photo of a man wearing whatever he likes and taking up plenty of space, and a woman who is covered up, barely seen behind an item of clothing associated with patriarchal norms and the male gaze. Clearly one can't presume to know why the woman in the photo dresses as she does. Nonetheless, as long as some women

still suffer physical violence and imprisonment for failing to submit to 'modest' dress codes dictated by men, there is something uncomfortable about 'liberals' looking at that image and thinking only 'yay, difference!' In terms of relations between the sexes, the scenario is very normative. The same person as always is reaching out and grabbing more attention, more space; the same person is adapting and shrinking. Is this really the future the liberals want?

My feeling is that it isn't, but that sometimes – because of that tendency to see gender only as difference, not difference plus hierarchy – it can be the one that they are endorsing anyway. This misunderstanding of how gender functions means some men can be expanding the boundaries of male territory, forcing women to budge up even more, while honestly believing they are defying norms and that anyone who objects is therefore being mean.

In his book *Against Empathy*, the psychologist Paul Bloom uses the metaphor of a spotlight to describe empathy's limitations. 'What you see depends on where you choose to point the spotlight,' he writes, 'so its focus is vulnerable to your biases.' If you are empathising only with one subject, and everything else is in darkness, then there is no complexity to any situation. There are no other tensions, no other subjectivities, no other power imbalances. There is the empathy that you, a kind person, feel for the norm-breaker who attracts the hostility of the bad people. The very idea of alternative perspectives becomes a fabrication aimed at justifying cruelty.

JustBeKindism does not merely stifle debate and restrict expressions of compassion to certain types of people. It shores up male power and validates male identities at a time when many men feel both are fragile. The double standard of kindness, whereby 'being kind' is seen as exceptional in men but taken for granted in women, means that the space, resources

and validation that women have already gifted to men are not factored in when women are asked to 'just' be kind. What women are already doing isn't kindness; that's just everyday life, in which everyday women can afford to give a little bit more. Doesn't everyone want a world in which men – sorry, people – can do whatever they like while women – sorry, good liberal allies – cheer them on?

The stunning bravery of doing whatever you want

In 2021 John Lewis produced an advert for home insurance which fell very much into the category of 'liberal if you look at it from one direction, depressingly conservative if you look at it from another'. A boy of around eight or nine dances his way round an expensive-looking dwelling, leaving destruction in his wake. He kicks his shoes against a lamp and a light fitting; he smears paint down the banisters and knocks a picture off the wall; staring disdainfully at his sister, who is painting at a table, he smashes a vase with an umbrella then tips all of her paints onto the carpet; he then takes his paint-smeared hands and slaps them onto the kitchen walls, before spinning a pan around, causing the handle to break a glass, while his mother – working on a laptop – looks on rather anxiously. The closing caption is 'let life happen'.

There are several responses to this advert. Boys will be boys, amirite? They're just naturally boisterous and aggres-sive! Boring old Mummy and sister will have to deal with it – isn't that what female people, life's supporting characters, are there for? A more feminist response might be to con-sider the boy to be a bit of a bully, particularly towards his sister. The little girl is being good – because that's what little

girls are conditioned to be – only to be treated as dull and worthy of mockery by the sex whose right to self-expression is sacred. A third option is to see the boy as a brave warrior taking a stand against gender norms. He is, after all, wearing lipstick and a dress. *PinkNews* approvingly described him as a 'one boy tornado' who 'throws his heart and soul into his performance'. 'The star of the ad,' wrote Victoria Richards in the *Independent*, 'is a role model for so many boys who wish they too could copy their sisters without condemnation, wear a tutu and princess dress and heels and strut to the strains of Stevie Nicks.' Only the boy isn't copying his sister. His sister isn't trashing the place (nor is she, for that matter, dressed like a princess).

The advert was pulled shortly after its release. This was not due to the diversity of responses it provoked, but on the basis that it gave viewers the wrong idea about John Lewis home insurance, which does not cover your child smashing up your home. A *Guardian* piece reporting the advert's demise noted that the advert had been 'attacked as everything from a crass cultural lecture to a treatise on sexism', describing it as 'the latest front in a seemingly never-ending culture war'. What was noticeable about the different responses was the way in which those defending the advert didn't engage at all with those who criticised its sexism. The assumption seemed to be that no one *really* felt empathy for the girl or the mother and that this was just something bigots were faking in order to mask their real anxiety, which was to do with boys in dresses. Only if you are not the sort of person who finds boys in dresses remotely remarkable, how could you fail to notice the sexism? The scenario is all too familiar.

This was a classic case of the male child 'finding himself', exploring his identity, testing boundaries, while the female child exists as a kind of supporting character/shock absorber.

It is something Marianne Grabrucker returns to several times in *There's a Good Girl*, as she compares the reining in of her daughter Anneli's self-expression with the liberties accorded to a male playmate, Schorschi. When the boy hits Anneli, 'Schorschi's father makes fun of her for crying and puts her in her place [...] Not a word to Schorschi to be more careful or to stop messing around.' When Anneli rushes to climb a fence and Schorschi follows, then pushes her out of the way, 'no one tells Schorschi he ought to let Anneli over first'. Instead, Schorschi's mother worries about the cost to her son's 'personal development' of not having been first to the fence to begin with. Grabrucker notes that 'we don't discuss the problem of the boy taking over the girl's idea [...] We don't bother about how the girl's personality may be damaged by this.'

In 2018's *Rage Becomes Her*, Soraya Chemaly describes witnessing a similar dynamic at her daughter's nursery. A male classmate regularly delights in destroying the elaborate castles Chemaly's daughter builds. For weeks, his parents offer a variety of excuses: '"He's just going through a phase!" "He's such a boy! He loves destroying things," and, my personal favorite, "He. Just. Can't. Help. Himself!"' Chemaly's daughter becomes increasingly distressed but does not retaliate. When Chemaly tries to persuade the boy's parents to take the situation more seriously, she finds that they view it as her daughter's responsibility to adapt to the situation. 'They were perfectly content to rely on her cooperation on his working through what he wanted to work through,' she writes, 'yet they felt no obligation to ask him to do the same.'

One-boy tornadoes have always been excused; little girls have always been expected to adapt. The little boy in the John Lewis advert behaves no differently from Schorschi, or the boy at Chemaly's daughter's nursery. His self-expression and growth must come at the expense of the female people around

him. A little boy's right to be his 'true self' must override a little girl's right to space, creativity and comfort. Yet to some viewers, far from reinforcing masculine norms, the boy in the advert is helping to combat them. He is a beneficiary of the double standard of gender non-conformity, whereby any male person who breaks any of the arbitrary cultural rules that other male people impose on him is considered to be doing women and girls a favour – even if all he is doing is whatever the hell he likes.

It is true that feminists do not tend to like gender stereotypes. This has led some male people to mistakenly believe that they are doing their bit for the feminist cause whenever they reject one, regardless of whatever else it is they are doing at the time. It is as though they think refusing to be a bit inconvenienced by certain dress codes deserves the same amount of credit as rejecting the right to appropriate resources and spaces. They might quote Judith Butler and tell you that gender is a construct, or boast about their rejection of patriarchal masculinity. All this is fair enough, but this doesn't actually mean they believe the usual masculine-coded perks and privileges should no longer be theirs for the taking. They just think they shouldn't have to pay the price of denying their 'true selves' in order to acquire them, and not only that, but women should be so grateful to men like them for rejecting cis heteronormative patriarchy that we will be more than happy to keep on giving.

An important point made by Kajsa Ekis Ekman is that 'differing roles are not in and of themselves a sign of oppression'. 'What actually characterises patriarchal systems,' she writes, 'is the fact that men are free to break the rules, while women are punished both when they comply and when they resist [...] The core of patriarchal ideology, as with all exercise of power, is not the rules but the double standard.' One example

she cites is the man who 'dares to show his feelings' being applauded in a way a woman never would be. In a similar vein, Shani Orgad and Rosalind Gill argue that 'expressions of vulnerability by women can be readily dismissed as sub-scribing to narratives of "victimhood", while similar accounts by men may betoken a highly valued "sensitivity"'. Being able to bend the rules is a manifestation of privilege, forcing those surrounding the privileged person to adapt. Such adaptation is forced upon the little girl who learns not to make a fuss about the 'expressive' boy who hits her, or the 'helpless' boy who destroys her castles, or the 'glamorous' boy who throws her paints on the floor. Rewarding male people for appropriating female space in a way that is only superficially unmasculine becomes a socially acceptable way of reasserting the mascu-line, space-stealing norm.

The association of femaleness with inferiority means male people who 'lower themselves' by rejecting stereotypical performances of masculinity are stigmatised in some com-munities, but not all, and particularly not those which pride themselves on their 'progressive' values. In his 2013 article 'A Very "Gay" Straight?', Tristan Bridges explores the way in which some straight men 'co-opt elements of gender culturally coded as "feminine"' without actually subverting inequality. Rather, these men 'capitalize on symbolic sexual boundaries to distance themselves from specific configurations of hegem-onic masculinity, but not necessarily the associated privileges [...] By framing themselves as gay, they obscure the ways they benefit from being mostly young, mostly white, heterosexual men.' In this context – if we are to understand heterosexuality as being attracted to someone of the opposite sex – I think it is worth looking back on the situation of lesbians expected to consider trans women potential sexual partners, as discussed in Chapter Four. We are not supposed to think that a trans

woman is expanding the performance of 'straight masculinity'; we are meant to think the trans woman who identifies as a lesbian is completely outside it, neither masculine nor heterosexual. The underlying hierarchy, however – which person's self-assertion is treated as sacrosanct, and which person just needs to adapt – is completely unchanged. It is, I would suggest, an extreme version of the situation Bridges describes.

In *Care and Capitalism*, Kathleen Lynch notes it is 'quite common for well-educated White middle-class men to differentiate themselves from "traditional" men by highlighting their gender-aware ideologies, tastes and behaviours, while simultaneously retaining and protecting their male power in the gender hierarchy'. Lynch suggests that 'borrowing some "soft" feminine symbols and practices' can be a way to 'conceal male power by giving it a symbolically acceptable face'. Here I find myself recalling many of the anti-feminist protestors I have encountered at conferences and feminist gatherings in recent years. There is a belief that if you are playing cheesy disco music to drown out the testimony of a rape survivor, or dancing a 'queer joy' conga to stop women from entering a public space, or wearing a T-shirt which features death threats against feminists, but is also pink and shows a kitten holding a kitchen knife, this cannot be toxic masculinity. Even if what we have, when all the extras are stripped away, are more male people demanding female people take up less space and rein in their self-expression so that boys can be not just boys but anything they want to be, all of the time.

The power of style to override substance makes it difficult for feminists to critique this dynamic without being dismissed as miserable opponents of other people just 'being themselves'. The fact that one person's expanding 'selfhood' requires the constriction of another person's – that it means women cannot, to quote Dworkin, 'feel a whole range of feelings,

express a whole range of ideas, address our own experience with an honesty that is not pleasing to men' – is simply not noticed. The underlying hierarchy is the air we breathe; we only notice difference, and the 'difference' of a superficial rejection of one form of masculinity is enough to distract us from that which remains the same. Any feminist failure to get on board with the 'fun' of a boy in a dress destroying his sister's possessions, or a man in lipstick leading a woman's march, falls into the category of old-style feminists once again being bitter and humourless, if not actively hateful.

The truly gender non-conforming woman – gender non-conforming in her resistance to male entitlement – comes off poorly in comparison to the 'fabulous' male who embraces every feminine norm bar that of being situated lower down the social hierarchy. She is sour-faced; he is joyous. She is limitation; he is freedom. It is not surprising that many 'progressive' men (and women) not only decide to throw their lot in with him but convince themselves that this is the way to create a brighter, shinier, kinder world for everyone. If only some women (and little girls) would stop making so much of a fuss about keeping their paints, their castles, and indeed anything of their own.

Budge up, bigots!

In early 2024, the writer Freddie deBoer published an article on sex and gender which is a masterpiece of the kindsplaining genre. Literally called 'I Think You Should Be Kind', it presents itself as an argument for trans inclusion. The argument is convincing, providing one is willing to ignore multiple feminist analyses of gender, sex and power, and to trivialise issues such as flashing ('every man who's regularly changed in

a locker room has been forced to see some old guy's dangling balls'), the trauma of female adolescence and the fundamental power that male people – regardless of declared identity – continue to hold over female people. Gender roles, he grandly informs us, 'are not fixed by biology or society but emerge from the lived experience of each of us'. It would appear no critic of gender identity has ever thought of this. Germaine Greer, hang your head in shame.

That women and girls' 'lived experience' of gender roles tends to involve an awful lot of being told to be nicer, to be quiet, to hand over more of their possessions, to put the emotional lives of male people first, is not mentioned anywhere in this call to empathise with all those who suffer deeply at being denied the right to express their true feelings and desires. Like so many men calling for more kindness towards those who do not fit into neatly gendered boxes, deBoer does not seem to see feminists who defend female-only toilets or sporting categories as women who have an 'identification with a gender other than that assumed by society', regardless of what a norm violation such behaviour constitutes. There is, it is implied, little difference between gender-critical feminists and conservative men whose transphobia is rooted in an attachment to gender stereotypes. They are all considered unkind. Being unkind is unacceptable, regardless of whether you are male or female, and regardless of whether the fact of your sex means your kindness costs you more.

On the subject of male people demanding inclusion in female-only sporting categories, deBoer is dismissive of what he calls 'a controversy without a problem'. Lia Thomas, a male swimmer who competed against and shared changing facilities with female competitors, 'became an internationally-known figure,' he writes, 'precisely because transwomen competing at the highest levels of women's sports is so

remarkably rare'. This apparently means it is no big deal. Were male people competing in female sporting categories ever to become a real problem, the reader is assured that 'we as a society will come together and find some equitable, just solution that respects everyone's rights and personhood, a solution which takes as a core requirement that transwomen be treated with dignity'.

As documented by UN Special Rapporteur Reem Alsalem in her 2024 report on violence against women and girls in sports, Thomas is not such a rare example. Due to having to compete with males, writes Alsalem, 'by 30 March 2024, over 600 female athletes in more than 400 competitions have lost more than 890 medals in 29 different sports'. Yet even if that were not the case, why doesn't deBoer conclude that the amount of distress caused to female competitors is sufficient to require that Thomas be the one to show kindness? DeBoer already acknowledges there is at least one real conflict here, not a potential one. Some female competitors have already lost out. How many losing a place on the team and/or feeling discomfort is too much? Are female feelings always trumped by male ones? And if so, where's your 'gender roles aren't determined by society' now? These are of course rhetorical questions. The answer is already presented in deBoer's piece, in which Thomas's claim on female resources and boundaries is made into an issue of 'personhood' and 'dignity'. Male people are entitled to female people's stuff because what is at stake is never just male people having more stuff. It's their very selves. For them, it is of existential import. Female people, on the other hand, are not in any way diminished *as* female people by having to budge up. As Grabrucker pointed out with regard to Anneli and Schorschi, there is little attention paid to how much the requirement to take up less space affects a girl's self-perception and emotional growth.

The priority must always be the male person's 'personal development'.

One should, perhaps, be grateful that deBoer thinks trans women on every Olympic podium *might* be enough to merit concern. In 2019, the sports writer Jonathan Liew wrote mockingly of the fears of female competitors regarding male intrusion into female sporting categories:

> They're coming! Over the horizon, they're coming! They're coming for your medals and your trophies and your endorsement contracts. They're coming, with their giant bulging muscles and enormous flapping penises, to ruin everything pure and good.

I am not aware of any female athlete concerned about male people competing in female-only categories writing or speaking about the problem in this way (though there is a long history of men using such a tone to caricature feminists). Later in the piece, Liew announced that even if male people did come and take every single piece set aside for female people, he wouldn't mind:

> Why would that be bad? Really? Imagine the power of a trans child or teenager seeing a trans athlete on the top step of the Olympic podium. In a way, it would be inspiring.

Liew acknowledges that there may be some who still do not share his view, but to them he says 'sport isn't fair. Never has been. Genetics isn't fair.' It is an odd sort of argument. One should accept that biology isn't fair, unless it's the kind of biology that puts you in the male category when you want to compete in the female category, in which case, screw biology.

The switch around from 'just be kind' to 'suck it up' on

this topic in particular can be breathtaking. One might recall that when it comes to biological capacities in which female people have the upper hand, such as getting pregnant, there is no such 'life's not fair'. As discussed in Chapter Six, the whole world must be reorganised to compensate men for *that* injustice. Then again, asking a surrogate mother to deny her entire physical and emotional bond with her baby is no big deal. It's not like asking a male person to forgo the essential self-affirmation that comes with joining the girls' swimming team.

When it comes to gender and sporting categories at school level, we are frequently reminded that these are 'just' children who 'just' want to play, as though expecting a male child to suppress his own desires would be especially cruel. The female competitors required to move aside for them are supposed to be mature and understanding. Every place taken by a male competitor edges out a female one, but she is not viewed as a victim of exclusionary policies. She is the privileged cis girl who needs to accept her limitations and learn her supporting role. Granting the male child 'true selfhood' at the expense of female self-realisation thus becomes a way of restoring his masculine status, albeit recast as a gender-neutral human right. After all, to be masculine does not mean to exemplify all of the arbitrary cultural trappings of red-blooded manhood per se; those are just one way of asserting one's dominance. Masculinity is a relationship to femininity – the One versus the Other – and it can be acted out from within categories formerly set aside for women and girls alone.

It is worth noting that female inclusion in sport has long been controversial because it places patriarchal definitions of what women are – passive, non-competitive, their emotions directed solely towards meeting the needs of men and children – in question. The version of femaleness it presents to the world is completely unlike that found in traditional conduct

guides or porn-inspired modern-day treatises on womanhood as femininity. When England's Lionesses won Euro 2022, Lucy Ward wrote in the *Guardian* about the joy of seeing goal-scorer Chloe Kelly's shirtless celebration because of the contrast it struck with images of women designed for the male gaze: 'Here instead is a woman thinking about herself, her sporting skill and her team: looking out, even as she is being looked at.' Kelly is not playing the object; far from being a hollowed-out fantasy figure, she occupies herself. This version of womanhood is far more controversial and fear-inspiring than the hackneyed, hyper-feminine version of gender non-conformity that Liew and deBoer have convinced themselves the less enlightened masses are worried about.

Today's sportswomen are not underrepresented in coverage and prize money because earlier generations of women showed no interest in football or athletics, or because earlier spectators were not interested in watching women compete. As Rachel Hewitt documents in 2023's *In her Nature*, men in positions of power chose to drive them out, introducing restrictions following periods during which sportswomen had been making significant gains. Hewitt associates the pushback at the turn of the twentieth century with a raft of measures imposed 'in reaction to the burgeoning success and authority of women in the public domain'. She quotes Pierre de Coubertin, founder of the modern Olympic Games, declaring that women's role should be 'above all to crown the victors, as was the case in the ancient tournaments'. This desire to drive women out of sports is very explicit, and clearly linked to marking territory in order to reinforce gender norms. 'Key to sport's capacity to boost male strength,' writes Hewitt, 'was the exclusion of femininity and effeminacy from its spaces.' One way of reinforcing sport's relationship to masculinity is to deny women any sports at all; another is to

recast the female sporting category not as a space for female physical excellence, but as one for lower-achieving 'feminine' people, who will never achieve the speeds of male athletes, not because they are biologically different, but because they lack that magic masculine touch. The re-categorisation of female sports as feminine sports thus excludes women and girls on two levels: first, by male people taking the literal places and prizes of female competitors, but second, and perhaps even more significantly, by redefining them not as true sports, but an inferior, feminine imitation (which is, I suspect, how some male sports writers and commentators have always thought of them anyway).

Although women have managed to claw back status in areas such as football, they are still, as the football journalist Carrie Dunn points out, treated as interlopers, 'expected to demonstrate their gratitude for everything they receive, no matter how little, particularly as they [...] begin to take up spaces and resources – spaces and resources that [...] are still given to men and boys without question'. Their male counterparts, meanwhile, 'are hailed and praised as "allies" for doing the bare minimum, for recognising the existence of women's football [...] when true allyship would be using their platform to genuinely promote and support the game and its participants'. The double standard of kindness – the lowest of bars for men, the highest for women – is already in place in the sporting world. If female players are assumed to have a debt of gratitude to pay, it is a short step to recasting this as privilege and entitlement. By intruding on the 'male' sphere of football, the interlopers are seen to have something which doesn't belong to them (despite having been robbed of it in the early twentieth century, when the FA introduced what would become a fifty-year ban on women's football). Rather than say any of this out loud, the 'progressive' male sports writer can

call these women exclusionary and fantasise about the 'inspiring' day when a better type of woman has claimed it all back.

Should one require proof that male inclusion in female categories is about prioritising one sex over another (as opposed to prioritising gender over sex in an area where one sex just so happens to lose out more), one might look at US Rowing's 2023 trans inclusion policy. This decrees that it is fine for any number of male-bodied people to compete as women in women's events, but not fine for more than 50 per cent of a mixed rowing crew to be male bodied. That is, trans inclusion is the priority and sex is irrelevant when female rowers might lose out as a consequence, but not when it might lead to male rowers being disadvantaged by a mixed team having a greater proportion of male competitors than their team does. As Olympic rower Mary O'Connor commented, 'this policy destroys fair competition for girls and women, but it protects it for boys and men'. For some reason, everyone agrees that a trans woman's 'personhood' and 'dignity' isn't quite as important when a man might lose out on a trophy. After all, one must think of the man's personhood and dignity, too. There's only one group for whom personhood and dignity are apparently of no consequence at all.

What is a man?

'What is a woman?' has, in recent times, earned the status of the hardest question in the world. Politicians hate it, while Judith Butler has built a decade-spanning career making people vaguely anxious, but also strangely smug about not knowing. 'What is a man?' does not invoke fear in quite the same way, but this was not always the case.

In the immediate aftermath of feminism's second wave

there was great anxiety, not over 'the woman question', but over its male counterpart. If women gained equal rights in the workplace and full reproductive autonomy, and if manual labour declined, what would there be left for men to do that women couldn't? As one *Los Angeles Times* article from 1993 fretted, hadn't modern reproductive technology 'allowed radical feminists to reduce men to sperm donors'? Well, not quite, and certainly not now. We do not tend to hear men referred to as sperm donors – or penis havers, ejaculators, testicle owners or similar. Men are just men. As for the sex class formerly known as women – menstruator, bleeder, chest feeder, gestator, uterus owner, cervix haver ... Anything goes (my personal favourite was the Welsh government's rather dramatic campaign for 'people who bleed across Wales'). Just as long as it's not 'women'.

Man, wrote Beauvoir in *The Second Sex*, 'is the Subject; he is the Absolute'. Woman, meanwhile, is the 'Other'. It is remarkable just how effectively the 'kind, inclusive' language argument has been used to bolster this relationship. The more women become the 'only include' class, the more men's definitional boundaries become inviolable. Insisting that anything and everything may be shoved into the category 'not man' has the effect of reinforcing 'manhood' as a fixed category with fixed borders. No one tells men this makes them exclusionary. On the contrary, men such as Freddie deBoer can boast that 'not once have I ever been confronted about using language that suggests a gender binary. Not once!', without seeming to realise there could be a reason for this other than everyone else being hysterical. That men are gaining and women losing out is rendered invisible by the very ideology being promoted, which refuses to recognise the relationship between biological sex and gender as a social hierarchy. It is, from a man's perspective, win-win. He gets to reassert his status as 'the

Subject' and if 'the Other' complains, he can tell her to just be kind.

As Germaine Greer wryly observed, 'a good-hearted woman is not supposed to mind that her sex is the catch-all for all cases of gender ambiguity'. It is not accidental that 'woman' has become the catch-all and 'man' has not. Gender self-identification does not have an equivalent impact on both sexes, regardless of whether it is nominally possible for women to identify as men. Campaigns to raise awareness of female cancers reduce women to 'cervix owners' and 'uterus havers'; meanwhile, Prostate Cancer UK has a March for Men, and November continues to be rebranded 'Movember', with men encouraged to grow a moustache for male cancer awareness. No one accuses men's charities of being exclusionary because, well, men's cancer is a serious matter. It's no time to be compromising on clarity when male lives are at stake. Only one half of the human race is in need of rebranding, regardless of whether it puts their lives in danger. We were starting to become too solid, too clearly defined in our own right to serve our familiar purpose of assuring men that they exist, too.

If Progressive Man was facing an 'am I just a sperm donor?' crisis in the nineties, JustBeKindism has offered him the perfect solution. No longer is he torn between embracing crass stereotypes of red-blooded masculinity and feeling unmanned. Now, he can just replace the word 'red-blooded' with 'cis'. Hey presto! No longer does he have to think the only things that differentiate him from mere women are his sperm donating and jar opening abilities. As Agustín Fuentes assures him in 'Here's Why Human Sex Is Not Binary', 'ova don't make a woman and sperm don't make a man'. Special manly manliness makes a man. The not-men wouldn't understand it.

There is a certain type of man who clearly loves this new

way of understanding manhood because it allows him to re-
affirm his own masculine borders while lecturing women on
the need to make 'woman' an even more open category than
before. I am sure he does not notice the imbalance here. He
may well tell himself that the solution to injustice that he is
promoting works both ways. If male people can identify into
female-only refuges, sporting categories, prisons, changing
rooms etc. then female people can do the same in reverse,
without any risk to their personal safety. If male people can
take places on female-only shortlists, female people can
identify their way into male privilege ... somehow or other.
It takes about five seconds' thought to see why none of this
would work, but this man doesn't have five seconds to spare.
He's too busy lecturing female people on inclusion.

A prime example of this misconception can be found in
Times journalist Kenny Farquharson's 2023 piece 'How the
Trans Row Will End in Compromise'. 'Surely womanhood
in all its glory,' he opines, 'is capacious enough, generous
enough, diverse enough, to accommodate and perhaps even
to welcome a small number of people who did not start life's
journey as women?' Reading this, I cannot help hearing
echoes of the surrogate mothers in Chapter Six, encouraged
to think of their bodies as containers, or of Andrea Long Chu
defining femaleness as the state in which 'the self is hollowed
out'. What are women anyway, other than empty vessels,
bags, collections of holes? Stuff it all in, we can take it!

I could quite easily write a similar piece demanding that
'manhood in all its glory' accommodate those who 'did not
start life's journey as men'. I am sure plenty of nice male allies
would nod along then proceed to do no 'accommodating'
whatsoever. What would it even look like? As Kajsa Ekis
Ekman points out, 'a woman cannot say: I am a man now,
let me be prime minister! Or: I may have a vagina but I am

nevertheless a man so don't rape me! Neither of these are defi-
nitions of man which men are expected to adhere to.'

Farquharson goes on to suggest that in twenty years' time,
'we will wonder what all the fuss was about' because 'trans
rights will be as uncontroversial as gay rights are today'.
The comparison with gay rights is a frequent one. The title
for Jonathan Liew's article is 'Why the Arguments against
Trans, Intersex and DSD Athletes Are Based on Prejudice
and Ignorance'. One might argue there is nothing prejudiced
or ignorant about believing female people deserve a sporting
category of their own, but apparently this is just a cover for
'an irrational fear of the other'. In Freddie deBoer's piece, this
fear of the other is directly compared to homophobia. To all
of these men, it is seemingly unimaginable that female people
might genuinely want things of their own – prizes, spaces,
words, categories – without there being any ulterior motive.
All female desire is filtered through the lens of what it might
mean to their male opponents.

Certainly there are superficial similarities between trans
activism and campaigns for gay rights, and trans activists
have done an excellent job of piggybacking onto the latter. If
one imagines objectors to either cause as essentially feeling
a bit funny around people who transgress arbitrary social
norms relating to sexuality and gender, they do appear closely
aligned. This argument even works for LGB people who claim
trans activism is homophobic (in relation, for example, to the
cotton ceiling), since one can merely say these people have
achieved a heterosexuality-adjacent respectability and want
to pull up the ladder behind them. Trans activism is not the
same as gay rights activism, though. It is not simply about
ensuring the absence of discrimination and the recognition
that one's feelings and desires are real. It is, as Jane Clare
Jones points out, 'a movement committed to a fundamental

reconceptualization of the very idea of what makes someone a man or a woman'. This idea of reconceptualisation is often deliberately fudged, as though 'a woman can have a penis' is of the same order as 'a woman can love other women' or 'a woman can be good at maths'. But these are different things. In the second two statements we are making declarations of possibilities for female people as women. In the first, we are denying that female people need to be identified as a group at all. Female people, as the oppressed sex class, ought to have some say in this.

By dismissing as bigoted any woman wishing to define herself as an adult human female, men are able to offload any shame at their own prejudices and phobias onto her (she is presumably 'capacious enough' to contain these, too). Male disgust at non-conforming males, their fear of being 'emasculated' by category ambiguity, and their desire to keep their own category 'clean' – all of which have been associated with men's bigotry and violence towards other men – are conflated with women's legitimate fears of male physical and sexual violence, and their legitimate desire to have resources and words of their own. In the UK, early concerns about any negative political consequences to gender reassignment were pitched in male-default terms, with Lord Lester declaring in a 2010 debate that trans people are 'the most vulnerable people of all because they touch on the fears of ignorant people and they need protection'. But whose ignorant fears would these be? Are all trans people vulnerable in relation to all non-trans people, or might it not be worth considering who is most vulnerable – a male-bodied human or a female-bodied one – regardless of gender identity? Men can feel incredibly proud of themselves for having overcome irrational fears which women never had in the first place. Our fears may be perfectly rational, yet the 'kind' man is

incapable of grasping this, thinking only, I suppressed my discomfort – why can't they?

As discussed at the start of this chapter, an easy way to silence women's concerns about male entitlement and theft of space is to look at an image and see it from only one perspective. *She just doesn't like what they're wearing. She just finds him too flamboyant. She's just a bigot pretending to care about something else.* It is a way of discrediting any female testimony which causes political inconvenience or contradicts a male perspective on what constitutes kindness and inclusion. The woman who feels discomfort with the easy answers of JustBeKindism may well empathise with those she challenges, but there is no empathy for her.

I think *you* should be kind

At the front line of the battle over how to make 'exclusionary' women share their resources, one thing tends to be forgotten: rape crisis centres shouldn't exist in the first place. Women's refuges shouldn't exist. Instead, men could stop raping, assaulting and excluding women. Go on, lads. Give it a try. #JustBeKind. Even if you still can't bring yourselves to care about how women feel, at least we'd no longer have something to 'weaponise' in order to mask our 'fear of the other'.

I am conscious that such a suggestion will sound ridiculous. As the parents approached by Chemaly might have said, the violent male 'Just. Can't. Help. Himself'. In the meantime, it would apparently be unreasonable to expect other male people to place limits on their own personal development, self-expression and dignity just to grant women a little more space for growth. As soon as there is a serious request for men to make room, there is horror. It is the Other, not the

Subject, who has to shrink. Men such as Freddie deBoer and Kenny Farquharson may counter that they are not demanding women be kinder than men, but they refuse to acknowledge just how much is required of men to reach the same starting point as women, or the degree of control men maintain over any concessions they make. Even after men have decided to be 'inclusive', the nature of male power means that such inclusion is in name only.

'Being inclusive' does not require men to give up any of their masculine-coded perks and privileges; it does, on the other hand, force women to offer up more feminine-coded goods and services. In the very rare cases where gender self-identification would lead to a tiny degree of inconvenience for men, moves have been made to mitigate or prevent this. This was the case for US Rowing's mixed category and is the case for hereditary peerages in the UK, whereby transition does not affect the favouring of male offspring – apparently sex is not so randomly assigned when it comes with power so directly attached. Many feminists might say this is just typical, but I do actually find it surprising. I would have expected men to be more invested in not making the double standard quite so obvious. That so little effort has been made by those preaching inclusion to cover their own tracks makes the imbalance start to feel less like an oversight and more like trolling.

There is a reason why women did not get the vote, access to education, equal pay legislation, the criminalisation of rape, abortion rights, public toilets, maternal custody rights, political representation etc. simply by telling men to be kind. Too many men, including those who call themselves feminist allies, do not feel any particular compulsion to be capacious, generous and accommodating towards women. It is an absolute gift to them to be able to pretend that refusing to

acknowledge sex difference grants both sexes equal access to one another's resources.

A meaningful gender politics should work from the premise that men should cede ground, not take more. Women cannot force this, and everyone knows it. A starting point, however, would be to direct the moral shaming where it needs to go. No man is so special or non conforming as to be owed even more from women. When Jonathan Liew writes 'the burden of change [...] is on the rest of us', the 'us' here should be the human takers. I think *you* should be kind.

8

BOUNDARIES ARE FOR BIGOTS

It is very tempting to take the side of the perpetrator. All the perpetrator asks is that the bystander do nothing. He appeals to the universal desire to see, hear, and speak no evil. The victim, on the contrary, asks the bystander to share the burden of pain. The victim demands action, engagement, and remembering.

Judith Herman, *Trauma and Recovery*

So once again the girl is put under pressure for reacting the way she does, even though the boy is the cause of it. She isn't to cry when he hurts her. Nor does he have to stop hurting her.

Marianne Grabrucker, *There's a Good Girl*

For years I didn't know that Medusa was a rape victim. I just thought she was a monster and had always been one. 'There are many ancient variations on Medusa's story,' writes Mary Beard. 'One famous version has her as a beautiful woman raped by Poseidon in a temple of Athena, who promptly transformed her, as punishment for the sacrilege (punishment to

her, note), into a monstrous creature with a deadly capacity to turn to stone anyone who looked at her face.' Not being much of a classicist, I'd managed to miss that part. I'd seen images of Perseus, holding aloft her snake-haired head, and thought Medusa deserved everything she got. Imagine being so angry, so hate-filled, so hideous. Upon learning her back story – or one of them – I needed time to recalibrate before being able to direct any pity her way.

It took me even longer to learn that the transformation of rape victim into monster is a common one, and not just in mythology. There might be perfect victims, but usually they are dead (and sometimes, not even that can prevent their monstering). Rape may be terrible, but its aftermath is socially and politically inconvenient. All too often, the shame of it is projected onto victims, their trauma and rage recast as malice and hate. The stereotype of the victim as 'ruined' – made ugly, unclean, unfeminine – confirms her status as a problem for her community. She spoils the stories, desecrates the temple. No one knows what to do with her.

Like every other iteration of patriarchy, today's 'progressive' version has its own problem with rape victims. The understanding of rape that rose to prominence during feminism's second wave – that it is related to male supremacy, that boundaries matter, that rape victims are not monsters – has fallen out of favour. Many of the central principles of JustBeKindism – in particular, sex denialism, a decontextualised veneration of 'inclusion', and the demonisation of anything deemed 'exclusionary' – are simply incompatible with a serious, victim-centred analysis of sexual violence. This does not mean anti-rape activism has ceased, or that all rape crisis centres have closed. What it means is that the people whom you might expect to be arguing your corner – from feminist academics to the CEOs of women's refuges – might think you a Medusa, too.

What follows explores the way in which the 'progressive' obsession with inclusion has offered a new means of monstering female victims of sexual violence, in ways that are anything but compassionate and empathetic. I would like to think this is unintentional, the unfortunate side-effect of complex, nuanced debate, but the pattern is dreadfully familiar. If female subjectivity is a problem for your politics, you can deny the female subject. No one needs to be kind to monsters. Feminism must be kind to women, but Medusa stopped being a woman. It owes her nothing at all.

Only include?

'Feminism,' writes Deborah Frances-White, 'has always been a request, or demand, for inclusion.' This is partly true. Women have demanded the right to be included in spaces, institutions and activities from which men have excluded us. We have fought for the right to vote, the right to an education, the right to participate in public life at all levels. We have requested the right to be in the places where men have claimed we do not belong. We have asked to be included in the ranks of the fully human.

Men, it should be added, never had any issues with defining what a woman was when it came to excluding us from particular spheres. There has never been any hand-wringing over just who needed to have the door slammed in her face. As Kajsa Ekis Ekman has pointed out, that only happened when 'woman', as a linguistic tool, fell into the hands of the feminists. As soon as women were in a position to create spaces and resources for themselves, definitions became fluid and questionable.

This is because feminism is also about exclusion. It has

involved the setting of boundaries around women's sexual and reproductive lives, and the creation of physical spaces where only women can go. To certain men, this has always seemed unjust. A movement which simultaneously demands that men make room for women *and* that men get out of areas where women do not wish them to be? Isn't that hypocritical? The feminist answer to this has been no, because these are not the same sort of spaces. The identification of spaces specifically for women is a condition of women's inclusion in public life. A public toilet is not the same sort of thing as a polling booth. A vagina is not the same as a male-only networking club. Resources which mitigate disadvantage and recognise particular vulnerabilities are not the same as those which ringfence privilege. It is not as though women have ever campaigned to take away men's toilets, or to remove their right to consider their penises a part of their own sovereign selves. If men do not notice that these particular entitlements remain intact, it is because, unlike women, they have been able to take them for granted.

Until relatively recently, griping about selfish women refusing to include men in everything we do was understood to be the province of men's rights activists (MRAs). So, too, was calling women Nazis for saying no to predatory men and prioritising female experiences of sexual violence in our analyses of sex, gender and power. The argument for both inclusion and exclusion seemed to have been accepted by the mainstream. This was before inclusion was positioned as the ultimate, unquestioned good. All of a sudden saying that some things are not like other things is viewed as churlish, proof that, deep down, feminists don't really believe in equality. The spectre of the 'exclusionary' feminist is no longer something only MRAs call upon.

To be clear, alongside a male critique of feminism as

exclusionary – because it excludes men, or more accurately because it centres women – there is a legitimate feminist argument that the movement has excluded particular women while centring others. It is the case that certain feminist campaigns and approaches exclude women whose experiences of intersecting oppressions mean that they cannot take advantage of gains that benefit more privileged women, who perceive themselves to be the default feminist subjects. Not only have women with the greatest proximity to power, who tend to be white, heterosexual and/or wealthy, prioritised gains which are modelled around women like them, but *Lean In*, glass ceiling-breaking feminism has led to privileged women relying more heavily on less privileged women to support their advancement. This form of exclusion – that of a movement which claims to represent all human females while promoting some and not others – has required some unpicking, and will continue to do so. Feminism is for all women, and the ability to keep checking when and where it has limited its focus is a strength, not a weakness.

Unfortunately, this legitimate critique of an exclusionary feminism has caught the attention of those who harbour MRA-style resentments against feminists but, due to their own 'progressive' positioning, have not always been able to articulate them in a socially acceptable manner. This also comes at a time when certain academic theories of inclusion and exclusion have started to present themselves as 'feminist', and position feminism's actively chosen 'exclusionary' practices (the refuges, the refusals) as unsophisticated, naive, and perhaps even racist. Once the idea of 'exclusion' is stigmatised wholesale – that is, once a necessary prerequisite for women's participation in the world of relationships starts to be seen as morally suspect – vital feminist gains are undermined.

Over the past decade we have seen an increasing conflation

of feminism's legitimate exclusions with illegitimate ones. In some instances this conflation has been accidental, but not, I think, all. If you are in any way uncomfortable with women fighting for their rights, threatening them with being perceived as 'exclusionary' is a useful tactic. It makes us unsure of our choices, since most of us fear that we do exclude in ways that we probably shouldn't. Without careful consideration of different factors, how can we ever be certain that 'legitimate' exclusions are not in fact illegitimate? In an interview for the podcast *Philosophy Bites*, Amia Srinivasan declared that 'a feminism that isn't inclusive is just not a very good feminism, politically or morally speaking'. But what does that even mean? How have we reached the point of describing feminism as 'inclusive' without being very specific about what is included and what is left out – that is, if anything can now be left out at all?

'Being exclusionary' has been successfully tied to a feminism that is not just privileged, but out of date. Working towards a feminism that is more inclusive of all women necessarily involves taking an inventory of past sins, but this has led to the idea that one should question *all* ways in which past feminists were 'too exclusionary', particularly in their attitudes towards sex and violence. An exclusionary approach to tackling rape (for example, one that fails to consider the specific needs of the most marginalised women) has begun to be seen as no different from an 'exclusionary' attitude towards pornography, the sex trade and the accommodation of the most extreme male sexual demands. If everything bad is exclusion, the answer is only include.

Rather than focus on the social, cultural and economic practicalities of inclusion, certain 'progressive' activists have invented a number of slurs, usually ending in *-erf*, to shame women whose feminist beliefs are deemed to be 'exclusionary'.

The -*erf* stands for 'exclusionary radical feminist' (though the person using the slur, perhaps sensing that they are starting to sound a little like men who used the term 'feminazi' in the nineties, will intermittently insist that 'they're not actually feminists, or radical'). The function of these slurs is to recast evidence-based feminist political analyses as exclusionary impulses, rooted in a pathological desire to keep out the other. An understanding of sex as a reproductive classification system and gender as a social hierarchy makes you a terf (trans exclusionary radical feminist); opposition to pornography and the sex trade makes you a swerf (sex worker exclusionary radical feminist); critiques of womb rental make you a serf (surrogacy exclusionary radical feminist). It's all a bit babyish (some feminists joke about what comes next: misogyny exclusionary? Penis exclusionary?) Indeed, one can take almost any feminist insight and find a way of *erf*-ing it. This does not make the practice of doing so any less powerful. As Sarah Ditum wrote in a 2014 blog post, 'How "TERF" Works', the term is 'a misogynist's dream', ensuring women distance themselves from each other to avoid 'any association with a tainted form of feminism'.

What is especially worrying is the degree to which the stigmatisation of feminism – not a particular form of feminism, or particular feminists, but feminism per se – as exclusionary has gained status and credibility among people who consider themselves the opposite of men's rights activists. A convoluted anti-feminism masquerades as a newer, brighter, better, more inclusive feminism, shorn of all the nasty, bitter (old) exclusionary bits. This pseudo-feminism is viewed as an improvement on the past. The past was when feminists excluded; the future is one in which they learn the error of their ways.

(Anti)feminism without borders

There is something I have come to think of as reverse feminism – a kind of anti-feminism developed by those who feel politically and/or professionally obliged to identify as or align themselves with feminists, but who do not particularly like female people or being associated with them. The reverse feminist will claim she is not anti-feminist; she is merely refining or improving feminism, stopping it being so blunt, so unsophisticated, so horribly gynocentric. Because it requires a great deal of contorted logic and slippery language to make anti-feminism look like feminism, reverse feminism has an air of cleverness. This may not hold up to close scrutiny, but it does not really need to, since this form of anti-feminism demands very little in terms of activism or even thought. You can just let it wash over you, and rest assured that it feels right. (Which it will, because it feels familiar. It's the same old sexism, only claiming to be its opposite.)

A leading proponent of this kind of feminism is, I would suggest, Judith Butler, queer theorist and author of *Gender Trouble* (1990) and *Who's Afraid of Gender?* (2024). In the latter work, Butler complains that 'TERFs' do not really deserve to be considered feminists (she uses the term 'TERF' freely, claiming that the alternative 'gender critical' would not be deserved because gender-critical feminists 'have misunderstood and distorted the history and meaning of "critique"'). 'For better or worse,' she notes, 'a wide range of positions can be called "feminist," and it makes no sense to allow one faction, censorious and rights-stripping in its aims, to lay claim to the term'. I would agree with this, though not with Butler's follow-on claim that what she calls 'transphobic feminism' might still be considered feminism but 'it should not be'. To my mind, the censoriousness and rights-stripping

impulses – and indeed the anti-feminism – are being identified in entirely the wrong place.

There are, it is worth noting, plenty of statements made by Butler with which one might reasonably agree before things veer off course. A generous understanding of Butler might suggest that she simply does not feel we should be boxed in by gender norms or make assumptions about others because of them (so, not all that far from J. K. Rowling when she tweeted 'dress however you please' etc.'). In *Who's Afraid of Gender?*, she argues that 'the critique of the gender binary' is not a claim 'that "women" and "men" are over and done with' (though I am unsure whether anyone has really been suggesting this):

> On the contrary, it asked why gender is organized that way and not in some other way. It was also a way of imagining living otherwise. The critique of the gender binary turned out to give rise to a proliferation of genders beyond the established binary versions – and beyond the gender hierarchy that feminism rightly opposes.

Imagining living otherwise is fundamental to feminism. What is not altogether clear is why Butler clings to 'a proliferation of genders' as opposed to, say, a proliferation of personalities or ways of being which are no longer coded in relation to masculinity or femininity at all. As argued in Chapter Three, insisting on the former makes it far more difficult to undermine the hierarchy that is mentioned (briefly, and without much explanation) in the passage above. Nor is it clear why, if we wish to understand 'why gender is organized that way and not in some other way', radical feminist arguments which relate this organisation to the (unnecessary, chosen) exploitation of one sex class by another are so quickly

dismissed. As Clare Chambers has pointed out, 'one puzzle for Butler's account [of the gender binary] is that it seems to posit an infinite regress [...] Something must come first; there must be some pre-political difference that politics can get its teeth into'. Nonetheless, it might be possible to allow this to remain hanging – not all feminism has to explain everything, all the time – and simply embrace the 'imagining living otherwise', were it not for the way in which Butler's understanding of how biological sex does (or does not) relate to gender and power leads to political claims which are, to my mind, inimical to increasing the security and freedom of women and girls. One cannot live 'otherwise' unless it is safe to do so (and single-sex spaces, for instance, are a necessary prerequisite to women's full involvement in public life).

A common criticism of Butler's work has been that it is too opaque or difficult to read (she famously won the journal *Philosophy and Literature*'s 'bad writing award' for 1999). This has meant that the reader can glean from it the things that are uncontroversial (it is bad to impose norms on people because of their sex!) while giving the things one does not quite grasp – more questionable, but thereby more intimidating – the benefit of the doubt. I think a bigger issue, though, is that Butlerian 'feminism' operates in a field where pinning things down and insisting on precision are easily associated with regression, conservatism and the dreaded 'binary'. Vagueness and abstraction function not just to boost intellectual status but as a political defence. This is especially the case with regard to concepts such as inclusion, bodies and borders, all areas where feminists have identified a need to be precise.

Feminist resistance to rape culture and reproductive exploitation relies on the insistence that not only is the female body definable, but that it has tangible borders, an inside and an outside. Feminists have pointed out that patriarchy

is obsessed with borders: maintaining those of men by transgressing those of women. Woman, wrote Andrea Dworkin, is 'human by a standard that precludes physical privacy, since to keep a man out altogether and for a lifetime is deviant in the extreme'. Here, Dworkin is attacking men's obsession. Yet to read Butler's attack on 'TERFs', one would think the obsession is being created and perpetuated by the person who notices it: that is, the feminist.

It is not inherently anti-feminist to ponder the nature of interiority and exteriority. What matters is how it is done, and what conclusions are drawn. 'What constitutes through division the "inner" and "outer" worlds of the subject,' writes Butler in *Gender Trouble*, 'is a border and boundary tenuously maintained for the purposes of social regulation and control.' This 'tenuous maintenance' is, ostensibly, something in which all humans engage. It is an interesting concept to explore in different contexts, but only if we are able to make specific as opposed to blanket value judgements regarding it. As we saw in Chapter Seven, 'man' maintains his borders and boundaries, not just but *especially* when demanding a queer theory-inspired breaking down of inner and outer divisions; 'woman', not so much.

As far as the body is concerned, 'for inner and outer worlds to remain utterly distinct,' Butler notes, 'the entire surface of the body would have to achieve an impossible impermeability'. Obviously, this is literally true. If we didn't have pores or eat or sweat or defecate, we'd die. But where are we meant to go with this? Even if our sense of physical stability is illusory and must be 'determined in large part by cultural orders that sanction the subject and compel its differentiation from the abject', how does this affect our understanding of sex, gender and power in practical terms? When feminists talk about a woman's right to decide what does and does not enter her

own body, or who does or does not get to enter female-only spaces, we are not indulging in some paranoid right-wing fantasy of total repulsion of the Other. We're just saying women are subjects, too. Butlerian analyses of dangerous attempts to control boundaries – and the internal impulses and anxieties from which they arise – can usefully inform understandings of racism, homophobia, misogyny and/or xenophobic border policing. I do not think they are helpful when deployed in the context of women understanding their own bodies, first, as meaningfully different from male bodies, and second, as having physical points of entry – the mouth, the vagina, the anus – that should not be transgressed without their consent. Female bodies are not plots of land.

In *Who's Afraid of Gender?* Butler asserts that 'when TERFs claim their gender is appropriated, they concede, in effect, that they think of their sex as property, something stolen from them'. It is a very odd argument, namely because this is just not what feminists who think sex is politically salient and/or view gender as a harmful social hierarchy are claiming or thinking. No one believes that being denied the right to describe herself or organise on the basis of sex makes a woman any less female; it does, however, make it harder for her to resist oppression. Yet by recasting feminists, not as people resisting male intrusion on female spaces, movements and bodies, but as obsessive guardians policing 'sex as property', Butler grants herself the right to make extreme comparisons between feminists and far-right actors who do wish to control the bodies of others:

> Like Trump, Orbán, Meloni, the Vatican, and all others on the Right who refuse self-determination as the basis for sex reassignment, trans-exclusionary feminists argue that gender mutability is an illegitimate exercise of freedom, an

overreach, an appropriation [...] The Vatican thought it
was God's creative powers that were being stolen by gender
advocates; the trans-exclusionary feminists think that their
own sexed bodies are being appropriated by nefarious
actors.

It is a ludicrous claim, but Butler's repetitive insistence – un-
supported by any quoted evidence – that 'trans-exclusionary
feminists maintain that their rightful property, their sex, is
being taken from them' operates to align feminism with big-
otry. It is a view of female experience which does not centre
those immersed in it, rather those who view it as a commodity
to which no one should be granted exclusive access. It ought
to have no place in debates surrounding sexual violence, but
here we are.

'No' means 'fascist'

In *Full Surrogacy Now*, Sophie Lewis is damning of what
she considers a feminist 'fixation' on 'the inside of a woman's
body', as though this is a weird fetish for which women should
be shamed. Meanwhile, in *Me, Not You*, her 2020 book de-
crying 'the trouble with mainstream feminism', gender studies
professor Alison Phipps argues that 'trans-exclusionary and
anti-sex-work feminism amplify the mainstream movement's
desire for power and authority, and pursue it by policing the
borders of feminism and womanhood'. When the issue be-
comes the border – as opposed to whose border, and whose
purposes are served by erasing or transgressing it – an entire
feminist analysis of sex and power can be turned on its head.

Me, Not You claims to explore mainstream anti-rape activ-
ism in a way that 'centres race, giving an additional reading

of the movement at a time when white supremacy is being violently reasserted'. There are legitimate arguments to be made about racism within anti-rape activism, particularly in terms of the failure of white women to recognise that different communities have different relationships to the criminal justice system. Race has been a sensitive subject in this regard; the 'Question of Race' chapter of *Against Our Will* proved to be its most controversial, with both bell hooks and Angela Davis suggesting that Brownmiller was siding with white women as potential rape victims over black men as potential victims of false accusations. Phipps, a white woman, does not simply acknowledge these critiques, but takes things further. Her book, she writes, is not just an attack on 'white feminism' but 'is based on the concept of political whiteness, which describes a set of values, orientations and behaviours that go deeper than that. These include narcissism, alertness to threat and an accompanying will to power.' Translated out of reverse feminism, these include caring about yourself as well as others, expressing a legitimate fear of sexual violence, and wanting to set your own boundaries. Understanding why such things matter to female people under patriarchy is simply incompatible with a sex denialist, Butlerian position on inner and outer spaces.

Like Butler in *Who's Afraid of Gender?*, Phipps takes ideas which are helpful when applied to understanding xenophobia, racism and the guardianship of misappropriated property, and puts them to use in analysing how feminists should and should not respond to male assaults on female bodies. Also like Butler, Phipps aligns 'trans-exclusionary' feminists (she does not use the term TERFs) with a form of conservative border policing. Anti-racist arguments are merged with arguments against any form of feminism which maintains the importance of biological sex, in ways that are deeply

worrying. Who wouldn't be against 'narcissism, alertness to threat and an accompanying will to power' when considering white supremacy? But what do these mean when addressing rape culture, not least in terms of understanding legitimate fears and asserting legitimate boundaries? To be clear, I am not suggesting that one should not consider how such fears and assertions can be appropriated by racists or expressed in racist ways. What I would claim, however, is that thinking biological sex matters to a political analysis of rape is not the moral equivalent of fearing a racialised Other. To claim otherwise is to go beyond an analysis of racism within anti-rape activism, and to start rooting out any recognition of the salience of sex within such activism on the spurious grounds that it is an extension of or equivalent to racism.

In *Me, Not You*, Phipps determinedly lumps together anything to do with borders, boundaries and fixed definitions to demonstrate that these things are all bad in much the same way. At one point she tells us that 'hoarding and defending resources means reasserting borders': 'It also means reasserting white supremacy, class privilege, "abled" bodies, masculinity and binary gender. Women are women and men are men; Brexit means Brexit.' This has similarities with Butler's insistence that 'TERFs' see sex as 'their rightful property'. It is certainly true that some political actors will use phrases such as 'women are women and men are men' in an attempt to enforce gender norms, but this is not the same as feminists insisting on the immutability of biological sex, or requesting resources and making political arguments which centre adult human females. As with Butler, Phipps glides from making good, liberal arguments with which it is hard to disagree towards inviting us to ignore feminist fundamentals. '"Taking our country back" and "making it great again" means closing our doors against, expelling

or assimilating anyone who dares to produce, reproduce or think differently,' she writes:

> It means reasserting geographical and ideological borders: defending the normatively gendered, cis, white, enabled and 'economically productive' capitalist body against those on the outside. It means emphasising reproductive (hetero)sex.

That all sounds bad, doesn't it? Only, what does 'emphasising reproductive (hetero)sex' actually mean? Thinking sex difference matters at all? In a book about responses to rape – one in which the author shows herself to be explicitly against the notion of female-only rape crisis support – this is not an idle question.

Phipps is right that white supremacists have treated women as property to be protected from defilement in order to further their own interests – 'the white and bourgeois rape victim has been a key motif in colonial expansion,' she writes, 'as well as "law and order" and anti-immigration agendas in richer countries which protect the "haves" from the "have nots"' – but this does not make us property when we assert ourselves. Nor does it make us actors in the exploitation of our trauma. There is an emphasis on complicity and self-indulgence throughout *Me, Not You*. 'White feminist narcissism has no truck with the idea that we are anything but victims,' Phipps claims at one point, later stating that 'the power of "white tears" still reflects privilege even when – as in the case of #MeToo – those tears are shed over real experiences of trauma'.

In a 1991 article, Catherine MacKinnon described the white woman – 'the white man's image of her', at least – as 'effete, pampered, privileged, protected, flighty, and self-indulgent'. Bourgeois white rape victims, claims Phipps, might

feel vengeful, but do not exact revenge themselves; 'instead, we ask the "Angry Dad" or "White Knight" of the state or institution to do it for us' (how such an infantilising image compares to *any* woman's feelings about reporting rape I find hard to imagine). A long-standing feminist insight – that privileged men weaponise the abuse of 'their' women – is twisted out of shape, then presented to an audience desperate not to be 'bad' bourgeois white women themselves. As Jane Clare Jones has pointed out, this is not to dismantle, but to validate the patriarchal position. Portraying the rape victim as a participant in men's exploitation of her trauma 'is to deny that women have their own experience of the world apart from male symbolic projections [...] what rape means to women is not the same as what rape means to racist patriarchal right-wing men'.

The extreme reaches of queer theory might seem to be of relevance only to those engaged in an academic vs radical feminist turf war. Nonetheless, these arguments are already influencing diversity training and the rape crisis movement. In *Me, Not You* – which has already been used in 'inclusion' training for organisations such as Oxfam – Phipps is clear that the targets of her criticism are not just the -*erfs*. 'Mainstream feminist activism against sexual violence,' she writes, 'is shaped and communicated by the woundedness of white bourgeois femininity.' You can attend your anti-rape march waving a 'Sex Work is Work' or a 'No TERFS on Our Turf' banner, but you may still be found guilty of 'the systematic privileging of bourgeois white women's wounds at the expense of others'.

Despite its intersectional posturing, reverse feminism is not a critique of racism (or transphobia, or sexual shaming) as it is transmitted through feminist rhetoric regarding sexual boundaries. Because it adheres to a politics which does

not even permit women to recognise other bodies as male, it ends up becoming a takedown of the feminist theory of rape entirely, hoping that if enough attention is paid to other oppressions, no one will notice. Yet if we jettison our entire analysis of sex, violence and power in the name of 'inclusion', there is no feminism. We are left with a more explicit version of patriarchy, shorn even of the pretence that most rapes aren't really rapes. We know they are; it's just we no longer care.

Unclean, unkind victims

In 2021, Mridul Wadhwa, a trans woman who was chief executive of Edinburgh Rape Crisis, was interviewed by Deborah Frances-White on the *Guilty Feminist* podcast. On the subject of female rape survivors who may want female-only support, Wadhwa expressed the view that 'sexual violence happens to bigoted people as well'. Were these 'bigoted people' to bring 'unacceptable beliefs' into the environment in which they were seeking support, Wadhwa said, they should 'expect to be challenged on [their] prejudices'.

Despite criticism from many feminists (though not Frances-White herself), Wadhwa doubled down on this position when participating in a virtual meeting in Sheffield, entitled 'Building Intersectional Inclusion in Rape Crisis Services'. Participants were informed that Edinburgh Rape Crisis Centre, as an inclusive space, 'had to really wash and clean its history of the perception of rape crisis centres not being inclusive of trans people'. It is a striking choice of words, one with, as Jean Hatchet writes, 'horrific connotations'. Wadhwa could have stressed a need to change perceptions, or to make more options available in future, but chose instead to use an image evoking uncleanliness. The reference is to the history of the

rape crisis movement, not to rape survivors themselves, but what is being suggested is a moral taint, as though a legacy of providing female-only support is dirty and shameful. As Hatchet writes, 'women built Rape Crisis. Our movement doesn't need "cleaning".'

There is a broader association of rape responses with uncleanliness, which makes Wadhwa's language especially distressing. Shame and blame are projected onto survivors whose testimonies are inconvenient to their communities. A woman or girl who accuses a family member, or a member of her church, or a political ally, risks being disbelieved or held responsible for what happened to her. It is easier to dismiss her as 'ruined' or 'dirty' than to deal with the social and moral upheaval that comes from recognising the wrong done to her and seeking redress. Since many victims already feel misplaced shame, they are primed to accept this further humiliation. They are taught that they asked for what happened; that they were to blame; that they are the ones who need scrubbing clean. If your rape leads you to seek out female-only spaces, could this not also be seen as a mark of your moral degradation?

The rape victim as 'bigoted person' is a variation on the theme of the rape victim as monster. In *Trauma and Recovery*, the psychiatrist Judith Herman described how, because the rapist 'often enjoys higher status than his victim within their shared community', the victim can end up isolated, possibly even 'driven out of a school, a job, or a peer group'. This rejection can be extremely distressing. A high proportion of women do not disclose experiences of sexual violence because they already know how the narrative will play out. Symptoms of trauma will be used against the victim, held as evidence of mental instability, untrustworthiness or antipathy towards men in general. In a *Prospect* magazine

piece on Donald Trump's sexual misdemeanours, Charlotte Kilpatrick notes that 'female Trump supporters often look on women who claim they have been sexually assaulted not as victims, but as troublemakers, screaming harpies who dared to step a toe out of line of what is expected of them and their gender'. But isn't this true of anyone who feels a victim's testimony threatens their most cherished beliefs?

Most rape survivors know their attacker. We do not know how many people of our own acquaintance, in our own communities, have committed rape. One thing we do know, however, is that the vast majority of rapists are male and the vast majority of their victims are female. If the rape accuser is already a social and political inconvenience, she causes particular difficulties when those from whom she seeks help are invested in denying the social and political salience of biological sex. Should she require a female-only space in which to heal, she places in question the insistence that sex is not binary and that gender identity trumps biology. She poses a challenge to 'inclusion' as the greatest of all goods. She undermines the claim that cis women have privilege over trans women and must centre the latter at all times. Like the sex abuse victim who points the finger at the priest, her accusation risks shaking the very foundations of the religion. As far as those who wish to keep the faith are concerned, she requires a very particular sort of shaming. Her trauma must be turned against her in a very particular way.

In an article for the website Everyday Feminism, one contributor responds to the question of 'what's the matter with women's spaces' by explaining that 'most of the time, "women's space" is code for "cis women's space," which is a problem'. It is not in fact code. There is nothing strange or sneaky or manipulative about the use of 'women's spaces' to mean spaces for female people. Nor is there anything morally

suspect about wanting them to exist. For those who are committed to prioritising gender identity over sex, however, the woman who wants such a space must be positioned as untrustworthy, saying one thing when she means another. Don't listen to her! Who knows what else she might be lying about? In order to maintain the illusion that biological sex is irrelevant, female trauma in the aftermath of sexual assault cannot be permitted to manifest itself in a legitimate desire to exclude male people. Should this occur, the trauma response must itself be vilified and discredited. Following the patriarchal tradition of dismissing female rape victims as either mad (hysteria, borderline personality disorder) or bad (attention seeking, pathological lying), rational fear becomes an irrational phobia, while justified anger becomes the rage of the bigot. 'Prejudiced' victims must, in the words of Wadhwa, 'reframe their trauma'. As ever, the rape victim's 'treatment' takes the form of moral cleansing – for her, not the perpetrator.

Recent years have seen a spiralling of punishments inflicted on rape victims who have been 'tainted' – that is, made hyper-alert to the salience of biological sex – by their experience. One woman, still managing the trauma of a past assault, saw her essential surgery cancelled after requesting female-only aftercare. Dead rats have been pinned to the door of an 'exclusionary' (female-only) rape crisis centre and women's shelter in Vancouver. A Brighton-based survivor of sexual abuse who campaigned for one female-only therapy group – to run alongside multiple mixed-sex groups – was subjected to vicious online abuse (plus the darkly amusing suggestion that if exclusionary women really wanted resources for themselves, they should consider setting up a movement just for themselves). In addition to dealing with the original problem of male sexual violence, women have had to organise

to re-create female-only resources, then respond to attacks for having done so. The women running Vancouver Rape Relief and Women's Shelter issued a statement denouncing 'Discrimination Against Women in the Name of Inclusion'. In response to those who compared her position to racism, the Brighton campaigner pointed out, quite reasonably, 'black people don't commit over 90 per cent of sex crimes. No race does. But males do.' Racism-by-analogy is used to smear any woman whose rape trauma undermines the 'progressive' position on female accommodation and inclusion. She, too, becomes one of the 'screaming harpies who dared to step a toe out of line of what is expected of them and their gender'.

One does not have to present the rape victim as a snake-haired monster to imply that her experience has impaired her capacity for moral judgement. It is even possible to suggest this while claiming to have the victim's best interests at heart, as though by doing so one is actually offering her a better hope of recovery. For instance, in the midst of arguing against a female rape victim's right to female-only support, Butler assures us that 'violent crimes are real':

Sexual violence is real. The traumatic aftermath is also real, but living in the repetitive temporality of trauma does not always give us an adequate account of social reality. In fact, the reality of the trauma we suffer makes it difficult to distinguish between what we most fear and what is actually happening, what happened in the past and what is happening now. It takes some careful work for those distinctions to emerge in a stable form for clear judgement.

Hence it might be understandable, in the aftermath of rape, to want spaces free from male intrusion, but such feelings are not to be trusted. 'One might see someone who is reminiscent

of the person who has done the violence,' writes Butler, 'but is it not up to us to ask whether that new person should be bearing the burden of our memory, our trauma?' (To which I would say, if that 'new person' is male, then no – it is up to that person to take the victim's feelings into account.)

An ultimate objective may well be to restore the victim's ability to feel safe amongst people of both sexes. However, what Butler seems to miss is that restoration of trust is not the individual responsibility of the victim, but the collective responsibility of a community. If victims are to understand that not all male people are a threat, it is important for them to know that if they wish to have a female-only space, the vast majority of male people will respect that, and those who do not will be subject to moral censure. There is nothing reassuring in being told that 'the violent desire [to rape] does not arise from the penis', but from 'a social desire for absolute domination' that most often happens to be found in penis-havers. It is true that fixating on penises rather than domination itself would be a mistake. However, it is also true that one expression of said desire for domination lies in the fact some male people find it intolerable for female people to have any space whatsoever in which those in possession of a penis may not enter. Butler claims that 'calling for segregation and discrimination can only seem "reasonable" when [the] phantasmatic construal of the penis as weapon is organising reality'. I would counter that treating the exclusion of all male people from a tiny minority of spaces as 'an alibi for forms of discrimination that can end up in fascist forms of targeting' is far more unreasonable. In yet another of her stopped-clock moments, Butler correctly points out that 'the framework for understanding why some men rape is surely widespread masculine domination, which includes rights of access to bodies they seek to control'. That being the case, why does

she overlook this desire for domination and control in those who, knowing that some women want just one space in which to heal, refuse to grant them even that? How can she possibly think those who do this are disidentifying from, as opposed to reinforcing, the most regressive masculine norms?

A rape crisis centre ought to be the one place where a woman can be sure that she will not be judged. However, when centres take the line that 'trans women are women', a victim finds herself in the position of having to hide any awareness of sex difference (even if she is prepared to recite the catechism). If the sound of a male voice in group therapy shocks and disturbs her, she must not show it. Other people's perceptions must be prioritised over her own. This is a perversion of the purpose of therapy, seeking to educate the distressed woman into compliance rather than ease her distress. In her book *Defending Women's Spaces*, Karen Ingala Smith, who has spent decades working directly with victims of male violence, points out that abused women experience further harm when they feel pressured to deny their own sense of reality in order not to be rejected by those from whom they seek help. The role of supporters is to help these women regain trust in themselves and others, 'not to replace the doubt in their heads about their perception with a false reality, and not to make them feel bad about themselves by accusing them of bigotry'.

In a 1987 speech, Dworkin described the way in which women are encouraged to believe victimhood is 'a state of mind': 'It's not that something happened to us; instead, we have a state of mind that's bad. And feminists are responsible for this state of mind, because we make women feel victimized.' The -erf – the feminist who still insists sex matters or that the sex trade is harmful – is the modern-day bearer of responsibility for this 'state of mind'. She disturbs the natural

order of things by making other women think they exist and matter as independent beings. Couldn't women just not think this? Kind, inclusive women learn not to feel. They watch their boyfriend's torture porn and feel nothing; they sell sex and feel nothing; they have babies for other people and feel nothing; they can surely be raped and feel nothing, too. In the end, we are left with women being told, as Dworkin put it, 'forget about rape, forget about it, don't have a bad attitude'.

Telling women to be kind and inclusive after rape is a way of blocking resistance to rape. Not only does it seek to rob us of the linguistic tools we need to organise and the physical spaces in which we need to heal, it seeks to keep us silent, blaming ourselves. We are not dirty, damaged goods. The shame is not ours.

You, too

In September 2023, the actor Danny Masterson was sentenced to thirty years to life in prison for raping two women. The assaults had taken place two decades earlier. It has been claimed that one of the reasons it took so long for Masterson's accusers to be believed was that both he and they had been members of the Church of Scientology. Victims have alleged that the church leaders conspired to cover up Masterson's crimes and to harass and discredit them. This is something the church has denied, stating it has 'no policy prohibiting or discouraging members from reporting criminal conduct of anyone'.

Masterson's sentence struck me as very long – not in the sense that his crimes seemed small, but in the sense that most men who do what he did face no punishment whatsoever. And how long would have been enough? There is no amount

of time, nothing that could ever undo his actions. Hence it starts to feel random, almost completely detached from any meaningful, collective position on sexual violence and male power. There is a game, and most of the time abusers win. This time, one lost.

The sentencing came at a time when feminist anti-rape activism has been under attack for being supposedly in thrall to the criminal justice system, obsessed with the idea, as Phipps would have it, that 'criminal justice represents protection, not oppression' and that 'we "take back control" by ceding control to the punitive technologies of the state'. I do not think this is an accurate representation of feminist priorities. What I do think, though, is that one can approach the topic of rape from any angle, as a member of any team, any religion, any political group, and as long as you take the side of the victim, you will be called a traitor. You are offending the church; you are in league with the state; you are an apostate; you are a bigot. Either way, it is inconceivable that your priority is simply the victim herself. The rape accusation is always an attack on those who are better and purer – closer to God, or closer to true social justice – than you or her.

The problem of men raping women and girls will not be solved by the criminal justice system. Contrary to the claims of reverse feminists, drawing on the spectre of the vengeful harpy, I do not think there is a feminism that, as Srinivasan claims, 'sees the punishment of bad men as its primary purpose'. Most feminists know that most rape accusations, though in all likelihood true, cannot be proven beyond reasonable doubt, and that the weaponisation of sexual violence to play off one group of men against another is all too real. The only way we end this problem is through prevention, and consent lessons are not enough. We need to change the world.

A world in which men do not feel entitled to rape is one

in which the idea of a woman is not defined by religion or pornography. It's one in which female inner lives matter, in which the boundaries of female bodies are respected, in which women are not shamed or called phobic and bigoted for prioritising their own desires. It's one in which there is no right to sex, or to porn, or to the bodies of prostituted women and abused girls. It's one in which women and girls are not expected, as a matter of course, to suppress their own emotions in order to facilitate male self-realisation. It's one in which incels don't call women bitches, and academics don't call them fascists, for saying no. It's one in which you would never dare tell a raped women to 'reframe her trauma' or force her to lie to prioritise the feelings of others. It's one in which it is understood that once you make 'problematising' female refusal or female rage at violation into a social justice cause, you are part of rape culture. You are not asking for rape to end; you are telling victims to matter less.

Realistically, there will be no end to rape in my lifetime or yours. Even so, an end to the demonisation of victims, at least within the confines of feminism, should be entirely achievable. In *Men Who Hate Women*, Laura Bates recounts the history of the anti-feminist National Coalition for Men, mentioning that it has 'filed court cases seeking to force the defunding of women's domestic violence shelters, unless they admit men'. Compare this to Phipps, who argues that 'in future, abolition politics might require us to refuse increased funding for women's services if this requires trans-exclusionary admissions policies'. It's the same mindset, except the first is rightly recognised as anti-feminist activism, the second treated as 'feminism'. We can do better than this, and we should.

The fetishisation of 'inclusion' is eroding women's hard-won right to spaces of our own, and it is happening fast, not least because the 'exclusionary' woman is another version of

the unfeminine woman, that actual breaker of norms whom everyone – 'progressives' included – is primed to reject. The exclusionary woman has become such a monster, a modern-day Medusa, that we forget that what she is requesting is so, so small. She is not trying to turn men to stone, or to deny anyone's right to exist. 'It seems,' writes Marina Strinkovsky, 'such an innocuous thing to ask: just leave us these small spaces':

> Go on with your lives, think, write, organize, work alongside us, ally with us, but respect our demand for some spaces where we would like to be alone. I mean, put like that, it seems completely incomprehensible to refuse, doesn't it? Who else but women would be denied a small private space to discuss their experiences of childhood sexual trauma, for example?

Who else but women – the containers, the vessels, the selves that exist to make room for the desires of another? Isn't it time for others to reframe their understanding of us?

JUST BE PERFECT

9
KINDNESS LESSONS FOR MODERN GIRLS

KATHERINE:
Why are our bodies soft, and weak, and smooth,
Unapt to toil and trouble in the world,
But that our soft conditions and our hearts,
Should well agree with our external parts?

William Shakespeare, *The Taming of the Shrew*

LADY MACBETH:
Come, you spirits
That tend on mortal thoughts, unsex me here,
And fill me from the crown to the toe topfull
Of direst cruelty!

William Shakespeare, *Macbeth*

'A girl's best friend is her attitude.' So says *Take a Look at Yourself*, a twenty-four-page booklet published by the National Dairy Council. Every girl in my class was given a copy during the 'period talk' at our primary school in the

mid-eighties. I still have mine, fluorescent green and baby pink, dayglo suffragette branding. On the cover is an image of a thin, pretty girl with long hair. Only it's not even a drawing of her, but her reflection in a mirror.

'To look and feel well,' the booklet begins, 'you don't have to have a filmstar face and the latest kind of fashionable figure. What's important is your attitude – a frame of mind based on a simple desire to make the best of yourself.' There then follow sections bearing titles such as 'Care of your skin', 'Hand and nail care', 'The life and soul of your feet', 'The look of your eyes', 'Simple guide to healthy hair' and 'You are what you eat' (dairy is good, funnily enough). '"Weighty" problems' – which I returned to again and again – depicts a plump girl on a set of scales, a thought bubble over her head showing cakes and burgers. ('If you have eaten correctly from an early age, slimming shouldn't be necessary.') As far as I know, there was no equivalent booklet handed out to pubescent boys (for all that we'd have appreciated 'The life and soul of your testicles').

This booklet used to obsess me. I thought that if I did everything it told me, I could leave behind the failure of an unfeminine girlhood and grow into the right kind of woman: desirable, untainted, compact. Someone whom puberty could not ruin. As long as I had the right attitude, I, too, could gaze endlessly at my own perfect reflection.

Take a Look at Yourself was a feminine conduct manual. I see that now, though at the time I would have thought it something much more modern and far less sexist. What was being asked seemed trivial, doable, a perpetual low-level fussing over every inch of your external self. There was nothing on sexual relationships or becoming the perfect wife. Yet if, to quote Tabitha Kenlon, the conduct manual 'helped women rehearse for the daily performances required of them', insisting

that 'women should not only be good, but should also be seen to be being good', then *Take a Look at Yourself* did fall into that category.

As Kenlon documents in *Conduct Books and the History of the Ideal Woman*, this is a genre that is constantly being updated, as more media and scripts emerge through which to present feminine ideals. 'The definition of womanly behavior might have expanded since medieval writers put quill to parchment,' she writes, 'but there are rules nonetheless, and the consequence for violation can be immediate, public and long-lasting.' John Gray's *Men are from Mars, Women are from Venus*, already mentioned in Chapter Three, is included as an example of a nineties guide. For twenty-first-century women, social media starts to play a role, as popular hashtags, videos, forums and viral campaigns instruct them on how to present themselves and what to care about now. These are often the same things women have always been taught to care about, albeit presented in a slightly different manner.

Right now, I believe the pressure on adolescent girls and young women to 'just be kind', particularly as it is transmitted through certain social justice and 'feminist' narratives, constitutes its own form of feminine conduct guidance. As was the case with the conduct manuals of years gone by, the message is infused with regressive ideas about the relationship between femaleness and femininity, and reels in its subjects at an age when they are especially vulnerable and deemed to be in need of 'shaping' for adult womanhood. It might feel original because it deploys a great deal of feminist, anti-objectification, pro-gender nonconformity rhetoric – and because it is highly conscious of mental health concerns and terminology – but it creates and feeds many of the same anxieties as before, and seeks to replace girls' trust in themselves (their minds, their bodies) with deference to a higher authority, whose

perceptions of reality trump their own. The demographic JustBeKindism targets the most is also the target market for conduct manuals – relatively privileged girls whose identities are bound up in the idea of being 'good'.

This chapter looks at the psychological and developmental cost of JustBeKindism on these girls. Recent years have seen a dramatic rise in the reporting of low self-esteem and poor mental health among teenage girls and young women. This tends to be portrayed sympathetically, with some acknowledgement of a political context, but I am not sure it goes far enough in exploring the impact of all the new ways in which girls are encouraged to suppress their own sense of self. In 1987's *Hunger Strike*, an unashamedly feminist study of anorexia, the therapist Susie Orbach argued that for the young woman of the eighties, 'developing femininity successfully requires meeting three basic demands: deference to others, anticipating and meeting the needs of others, and self-definition through others'. To Orbach, the consequences of meeting these requirements frequently meant that women were 'unable to develop an authentic sense of their needs or a feeling of entitlement for their desires'. Translated into the language of JustBeKindism, one might say that today's good feminine subject must listen and learn, she must be a good ally, and she must describe herself using terminology which prioritises the self-definition of others. The impact of these demands can be very similar to that on women four decades earlier, affecting not just their ability to identify their own needs, but their understanding of their relationship with their female bodies – what being female means, the obligations it imposes, whether they really want to live in/as those bodies at all.

There's a part of me that remains shocked that my own generation of girls was handed such direct and, the more I

think of it, brutal guidance on what 'becoming a woman' meant. Here you go: you'll be real women soon. Soon you'll get hips and breasts. Soon you must shed any absence of self-consciousness, becoming an observer of yourself as other. *Take a look at yourself!* Then again, this was a tiny booklet. It wasn't like now. The messaging wasn't everywhere, rules being constantly updated and transmitted via a device in my pocket. 'The world gets harder and harder,' wrote Hilary Mantel in 2004. 'There's no pleasing it. No wonder some girls want out.' It is even more difficult now. The same old rules are revised, and even feminism no longer seems to offer you an exit route. You can never escape scrutiny, not least because when puberty hits, you cannot escape yourself.

Always look your best

'Women,' wrote the art critic John Berger, 'watch themselves being looked at.' Objectification shapes not just our relationship to men, but our relationship to ourselves. We observe ourselves constantly, are encouraged to do so, but are also shamed for it. My own teenage obsession with weight and starving away every inch of flesh seems, on one level, ridiculous – vain, narcissistic, even selfish and arrogant. Women and girls' complicity in rituals regarding appearance – even when taken to the furthest extremes – is often turned against us, used as evidence of our triviality and moral inferiority.

In this context, inner goodness can be presented as a superior alternative, something that both elevates us from the dehumanisation that comes with being reduced to an object and which allows us to contribute to the world in a meaningful way. 'Beauty,' as one popular meme puts it, 'isn't about having a pretty face. It's about having a pretty mind, a kind

heart, and most importantly, a beautiful soul.' Forget about your thighs – concentrate on being a nice person!

Alas, it is never quite that simple. The problem is not just that having a pretty mind, a kind heart and a beautiful soul actually sound like quite a lot of effort (more effort, I would say, than skipping breakfast or buying a new lipstick). It's that inner and outer beauty are never really distinct. 'The beauty myth,' wrote Naomi Wolf in her book of the same name, 'is always actually prescribing behavior and not appearance.' It is a way of demonstrating compliance through a willingness to undergo procedures that are arduous, repetitive, painful and, more often than not, pointless. If you live in a culture where most women look one way, the ideal will be that you should look another, and if most women start to look that way, the ideal will shift again. Female beauty ideals inculcate constant self-scrutiny and dissatisfaction; that is part of their purpose. As such they can create feelings of not just physical, but moral inferiority.

For girls today, social justice kindness culture can operate as an extension of this. It demands the same obsessive self-judgement, the same strictures, the condition of being tracked by the male gaze. As with external beauty practices, the point is not really the thing in itself – particular acts or choices of words. It is that you are kept in a constant state of hyper-vigilance, which feeds the self-objectification spiral.

Qualities such as entitlement and unkindness become additional flaws that must be worked on. Female privilege has acquired a similar status to female fat – a supposed indicator of excess for which young women should constantly check themselves (*Is my privilege showing?*) The 'greedy' girl on the scales in *Take a Look at Yourself* has a woke equivalent in the 'cis girl' jealously hoarding her privileges and policing her boundaries (*If you have been inclusive from an early*

age, boundary reframing shouldn't be necessary). The privilege framework, notes Phoebe Maltz Bovy in *The Perils of 'Privilege'*, 'asks all the many privilege-loosely-defined women to apologize for taking up space, for speaking their mind, which women already do, copiously'. I cannot count how many hungry hours I spent thinking of 'scales girl', resolving not to be like her; if 'cis girl' had been around, I'd have done the same with her.

It may not seem that you are being bullied into any of this. Everything can fall under the rubric of 'work on the self'. Just as the beauty industry has successfully marketed dull, repetitive, sometimes painful rituals as 'pampering', female emotional suppression and unforgiving self-scrutiny can be packaged as 'gratitude work', 'inclusion' and 'kindness therapy'. These are projects aimed at making you acceptable to others and yourself – only they are never-ending projects, so you will never be fully acceptable.

All of this feeds into a more general sense that you can no longer simply 'be' in your own self, a self which emerges at a time when the relationship between one's physical appearance and how one is expected to interact with the world is becoming incredibly complex. For their 1992 book *Meeting at the Crossroads*, Lyn Mikel Brown and Carol Gilligan interviewed a number of girls as they went through this stage. What they found was that many experienced a sudden loss of confidence as they felt themselves 'moving from flesh to image'. The girls became extremely conscious of being watched and talked about, 'judged against standards of perfection and ideas of relationship'. There is no clear distinction between physical and moral objectification; it is as one, and the internet makes things even more difficult for girls today. In 2023's *Perfect*, another book based on interviews but with particular attention paid to the impact of social media, Rosalind Gill points

out that online perfection 'is not only about appearance but also about displaying the "right" kind of feelings and attitudes'. It is an opportunity to showcase your self-discipline and virtue not just through the meals you photograph or the filters you apply, but the hashtags you use, the causes you promote, the pronouns you select, the likes you add – and even the women you denounce.

Always remember that others know better than you

Brown and Gilligan describe girls approaching adolescence as facing 'a central relational crisis'. They are aware that 'to speak of what they know through experience of themselves and of relationships creates political problems', but not to speak also comes at a cost, leaving 'a residue of psychological problems: false relationships and confusion as to what they feel and think'. This describes one of the most fundamental dilemmas presented by femininity: it forces women and girls to present a false face and pay an enormous internal price, or to refuse to do so and bear the external consequences. As Kenlon writes with regard to conduct guides, 'if a woman conforms to the ideal, she submits and is oppressed. If she does not conform, she is punished and is oppressed.' Hurt yourself, or someone will do it for you.

 When today's teenage girls encounter mainstream feminism, male-dominated social justice activism and adult-approved inclusivity training, they may come up against rules and moral principles which do not feel right to them. Rape victims are compared to fascists; maternal feelings are dismissed as regressive; lesbian sexual boundaries are bigoted; wanting a sporting category of your own makes you selfish

and exclusionary. If girls are confused, they may be advised that this is a symptom of their privilege; they lack the deep insight of the most marginalised. The secret to managing all this is 'just be kind'. Don't ask questions; don't worry your pretty little head about things you do not understand; ignore gut feelings and learn to stay silent. Your experience of yourself and the world is partial and irrelevant. You can tell yourself this, but it does not make the experience or the knowledge vanish.

As some feminists (the 'unkind' ones) have pointed out, this starts to look a lot like socialising young women not just to behave in a stereotypically feminine manner, but to disregard their own awareness of risk. To avoid 'political problems' – in the context of feminist networks, school and college societies or liberal workplaces as well as 'traditional' power structures – they must try to convince themselves they are ignorant, or that their knowledge is of a lesser value. This is certainly the message for young women who may feel uncertain about the presence of males in female-only spaces. For example, in 2015 signs were placed in the toilets at Bristol University for trans awareness week, telling female students that if they saw someone whom they thought should not be there – 'if you think a stranger's gender doesn't match the sign on the door' – 'don't worry about it, they know better than you'. (Posters added in retaliation – 'kindly ignore the fact that men including transgender males rape women every 9 minutes ... kindly surrender your boundaries ... don't worry about it, men know better than you' – were swiftly dismissed as 'transphobic').

A standard message of 'allyship' training is to get 'comfortable with discomfort'. Oxfam's 'Inclusive Language Guide' insists that 'there is a distinction between being uncomfortable and being unsafe; inequality in power is at the heart of

this difference'. Perhaps this would be meaningful advice to someone who has all the physical strength and social status of the adult human male but nevertheless claims his discomfort at being excluded from female-only spaces is more important than women's safety. It is not meaningful advice in its actual context, which is to tell anyone who feels discomfort at having to include male people in female-specific language and spaces that they simply have to get used to it. As discussed in Chapter Seven, men and boys are not being asked to lean into *their* irrational discomfort around gender non-conformity – quite the opposite. Instead, they are happy to project it onto women and girls, whose legitimate feelings must be suppressed.

Two of the things that women and girls rely on to stay safe – noticing a person's sex and trusting gut feelings – have, in the JustBeKindist age, become associated with prejudice. It is easy to see how this is done. Gut feelings are hard to explain. Slogans such as 'fear breeds hate' can be misapplied to suggest that rational fears are irrational phobias. It used to be possible for feminists to justify fear of male people – any male people – simply with reference to violence statistics and basic safeguarding principles. Today's deliberate fuzziness around sex and gender (*But how do you really know what sex anyone is? Are you going to do genital inspections?*) has created a loophole, whereby 'fear of male people' cannot be expressed precisely, and therefore becomes a 'fear of trans people', which then gets equated with 'fear of other marginalised groups'. Even if some part of you still knows what your genuine, legitimate fear is, it can feel easier to just say nothing. It's not as if you need the toilet right now. Maybe you can last the whole day.

Gavin de Becker's 1997 self-help guide *The Gift of Fear* advises women to trust their gut feelings (it was less controversial to do so in 1997). One of the strategies he describes

predatory men deploying is 'typecasting', whereby 'a man labels a woman in some slightly critical way, hoping she'll feel compelled to prove that his opinion is not accurate'. The example he uses is 'snobbish'. A woman will be more likely to tolerate a man who makes her uncomfortable if he has suggested any resistance on her part is down to her being a snob. For the young woman in a 'progressive, inclusive' environment, 'transphobe' or 'bigot' functions in a similar way to 'snob'. It persuades her to drop her defences. Instead of focusing on her instincts, she is redirected towards her inner critic. Perhaps her fear is a phobia. There is such a fine line between the two, how can she be sure?

At the end of *Me, Not You*, Alison Phipps includes a series of questions which any white feminist is called on to ask herself before engaging in anti-rape activism. These questions include:

> What do I know? Am I educated enough to be making an intervention on this issue? [...] Who am I speaking for? Am I primarily speaking for myself? How much space do I occupy with my own experiences, needs and views?

A little self-doubt might be healthy for people in positions of relative safety and security, but when one considers that these questions are appearing in a book about sexual violence, one that positions itself as feminist analysis, the context is profoundly disturbing. The rape victim already doubts herself (was it really rape?); the woman fearing rape doubts herself ('she tells herself not to be so silly', as de Becker puts it). Women really do not need any extra help when it comes to rape and self-doubt. They do not need any extra help when it comes to feeling their demands are a bit much, a bit selfish or not based on a sufficient amount of education. Women – and

particularly young women and girls, whose social and financial support systems can be much more fragile – must fight to keep knowing what they know. To present them with an image of their potential 'bad' selves – the 'fat' girl on the scales, the entitled, exclusionary self who deigns to speak for herself, prioritising her 'own experiences, needs and views' – is another way of reining them in.

In my earlier book *Hags*, I explored the way in which older women are misrepresented and misjudged. Common 'progressive' criticisms of older women are that they are fixated on boundaries and obsessed with safeguarding, both of which are deemed to be out-of-date, wrong-side-of-history positions to take on gender politics. These women, the argument goes, will die out soon; the next generation will be more 'inclusive' – that is, less concerned about trusting their own instincts and more willing to just say yes. I don't think this is necessarily true (you can't burn all the witches; new ones will take their place). Nonetheless, there is a concerted attempt to make younger women – through 'reverse feminist' argumentation and sex-denialist allyship training – more compliant, and less able to access the linguistic and analytical tools earlier feminists have used to override the patriarchal insistence that women are not authorities on their own perceptions. 'Just be kind' isn't only seeking to rob women of boundaries, but of self-knowledge – self-knowledge that can be very hard-won to begin with. 'Believe her' is a much used (and much misunderstood) slogan; perhaps the one we need most is 'believe yourself'.

Prove your devotion

In her study of conduct guides, Kenlon describes a tradition known as 'the wife test', in which a wife demonstrates her

devotion to her husband and elevates his status by submitting to humiliation. One example appears in Geoffrey de la Tour-Landry's fourteenth-century guide for his daughters, *The Book of the Knight of the Tower*. Three men, seeking to win a bet over which of them has the most obedient wife, decide to each ask their wives to jump into a basin, without giving the wives a reason why. The first two wives refuse, and are subjected to physical abuse. Before the third man has the chance to set the task, his wife mishears his request to bring salt to the table as a command to leap on it, which she duly does. 'The men are understandably baffled,' writes Kenlon, 'and when she explains what she thought she heard, the guests are impressed and her husband is declared the winner of the bet.'

The actual task delivers nothing of benefit to the husbands; it doesn't even matter if the wife does something other than that which was originally requested. What matters is that she demonstrates an understanding of her place in the hierarchy. There are many 'just be kind' requests which function in much the same way. Clearly ridiculous, outlandish requests are made of women, which give them the opportunity to 'prove' how devoted they are to the new social justice politics. Many women will do exactly what is required. They will pretend not to notice they are being trolled, not because they are stupid or weak, and possibly not even because they are well disposed towards those making the request. They will say things they do not believe to be true, accept humiliations without complaint and apologise for transgressions they do not believe themselves to have committed. They have seen what happens to the modern-day equivalent of the first two wives in the tale. They do not want it to happen to them.

One example of this can be found in female responses to the *Days of Girlhood* videos produced by the actor Dylan Mulvaney in 2022 to loud applause from 'progressive' fans

and brands. In each, Mulvaney, who is biologically male and had until that point identified as a man, adopted ridiculous, exaggerated poses and embraced the most extreme stereotypes, as if to say, 'Girls, that's you, that is!' The project was viciously cruel, made worse by the fact that girls themselves were not expected to object. Mulvaney, they were told, wasn't mocking girls; Mulvaney was an actual girl. Anyone who disagreed was simply a bigot.

As Jean Hatchet wrote at the time, Mulvaney's performance replayed the ways in which men have often sought to humiliate women by caricaturing them: 'lifting their voice to a squeak, exaggerating hand gestures, pushing out pretend breasts, wiggling their bum, pouting and fiddling with their hair'. The difference with Mulvaney, she pointed out, was that 'women are not supposed to act critically. They are seen as cruel or "transphobic" if they express annoyance at being so grossly insulted.' This is a particularly exquisite form of psychological bullying. Female viewers are not just being mocked but tested: say something if you dare! Once again, like the adolescent girls interviewed by Brown and Gilligan, they have a choice between speaking out and causing 'political' problems, and staying silent and suffering psychological ones.

In her *UnHerd* article 'Why I Stopped Being a Good Girl', Hadley Freeman details the way in which trans activism is granted a free pass when it comes to mocking women and girls. Referring to Andrea Long Chu's description of the essence of femaleness as 'an open mouth, an expectant asshole, blank, blank eyes', Freeman asks 'how did that get past the now ubiquitous sensitivity readers?' The double standards are staggering. 'You can,' Freeman concludes, 'write any old garbage about women.' Long Chu knows this, as does Mulvaney. Long Chu's work has been responded to with, at most, the kind of 'ooh, you are awful!' indulgence

from leftist peers, with reviewer comments such as 'juicily transgressive', 'performatively edgy, frequently hilarious' and 'a thrilling provocation'. For anyone who has actually read *Females*, it is rather reminiscent of being told you're too uptight to see the funny side of Jim Davidson, or simply haven't grasped the iconoclastic subtext of Bernard Manning. Even so, one can understand the willingness of some female critics to showcase their apparent inability to be offended by Long Chu or Mulvaney. If you are made to feel constantly anxious about your political appearance, this is the perfect way of clearing up any doubts about your loyalties. You have the opportunity to play the good wife in contrast to 'bad' wives such as Freeman.

It is very hard to believe that any of the 'good' wives are fully convinced. The situation reminds me of one featured in Rebecca Makkai's novel *I Have Some Questions for You*, which explores sexual exploitation and suspicion in the aftermath of #MeToo. The narrator Bodie Kane, now an adult, recalls the harassment she experienced as a teenager from a male classmate, Dorian, who would use the trick of pretending she was sexually harassing him. In one scene he writes 'I'm so wet for you, Dorian – BK' on the board before a history lesson.

> When Mr Dar arrived, Dorian said, 'Mr Dar, Bodie's sexually harassing me. Look what she wrote.' His voice made it clear he was joking, so Mr Dar chuckled, and the note stayed on the board most of class.

When the message needs to be removed, the teacher jokes about Bodie's 'love letter'. Everyone knows what has really taken place: that Dorian wrote the note and that he is harassing Bodie. As long as he has the flimsiest of covers, though – a

joke cover – Bodie must suck it up, which becomes a form of harassment itself.

One of the dismaying and, I would argue, most hurtful things about the left's embrace of trans activism's troll element has been in witnessing just how little it takes to excuse forcing women and girls to say things nobody believes. No one has to really, truly take someone such as Andrea Long Chu or Dylan Mulvaney seriously. Just seriously enough to come down hard on any woman who dissents. It sends a broader message to girls about what they are worth. You are nothing, but you are permitted some sort of reprieve from being treated as nothing – until the next excuse, an excuse in which no one is really expected to believe, comes along.

Don't be needy

One of the most insidious aspects of 'progressive' misogyny is that, unlike its traditional counterpart, it has embedded itself in political movements which appear to have a more enlightened, empathetic understanding of mental health stigma and the need for safe spaces. JustBeKindists would never tell anyone asking for support and protection that they are a spoilt little snowflake who needs to get a grip. On the other hand, they might call them a pearl-clutching Karen who is weaponising her trauma. It really depends who's asking.

As argued in earlier chapters, the existence of 'progressive himpathy' means that female victims being denied care and attention is not just a problem when women and girls are dealing with the conservative right. The latter may be prone to trivialise and mock 'victim culture', dismissing complaints about sexism, racism and homophobia as the whingeing of elites who do not have any 'real' problems. Nonetheless, at the

other end of the political spectrum, victimhood has a value which makes its allocation to women and girls – the givers, not the takers – taboo in a different way. By this, I mean not the experience of discrimination or abuse, but that of being perceived to have suffered at the hands of morally inferior others. While masochism – enjoying one's victimhood – might be feminine-coded, claiming moral authority and status is male-coded. This creates a push-pull situation whereby women and girls are on the one hand 'natural' victims, but on the other, illegitimate claimants to victim status.

Women's relationship with victimhood has always been complex. 'Playing the victim' and 'turning on the waterworks' have been regarded as ways in which women are able to manipulate men. Misogynists have portrayed women as the dominant sex, possessors of a 'soft' power which is all the more sinister for the way in which it masquerades as weakness. When women are accused of 'policing the boundaries of womanhood' or 'excluding more marginalised people from their definition of womanhood', central to the complaint is that they are misappropriating victimhood in order to assert their own dominance. This threat of the 'wrong' people laying claim to pure victim status is made very clear, for instance, in *Me, Not You*, in which this hallowed status is to be withheld from 'bourgeois white women' – even when they have been raped. Phipps tries to qualify this by asserting that 'being a victim and being a perpetrator are not mutually exclusive' (hardly a novel observation for feminists – Beauvoir began the second part of *The Second Sex* by quoting Sartre's 'half victim, half accomplice'). This does not quite work, though. The inconvenience of the rape victim's claim to victimhood has been made into the very misdeed she 'perpetrates'.

Some recent critics of 'victim culture' have argued that victim status is deemed to confer greater insight and

knowledge. In *Cynical Theories* (2020), Helen Pluckrose and James Lindsay claim that there is an assumption that 'the privileged are blinded by their privilege and the oppressed possess a kind of double sight, in that they understand both the dominant position and the experience of being oppressed by it'. This makes the oppressed's view of reality richer and more accurate, meaning it should always be deferred to. Yascha Mounk makes a similar point in *The Identity Trap* (2023), when he notes that 'the job of a loyal ally is to "listen," to "affirm the beliefs of the less privileged," and to "amplify their demands"'. Neither book connects this assumption of higher knowledge to the distinctly gendered history of male people defining reality, perhaps because feminists – as a homogenous group – are held to be partly responsible for the rise of 'victim culture', weaponising victimhood to sabotage men's claim to be 'owners of truth'. Yet there are ways in which the new victim culture reinforces rather than undermines male epistemic privilege. When sex ceases to be treated as a meaningful axis of oppression, trans women are considered greater victims of gendered oppression than 'cis privileged' women – and hence greater authorities on what sex, gender and womanhood are to begin with. Here, the supposed victimhood of the male person reinforces the male person's authority to define reality (and a relative lack of victimhood) for female people. It does not even matter if the female people are themselves trans (since being trans men, or not being women if non-binary, also makes them privileged). As Kajsa Ekis Ekman rightly observes, 'in this new gender structure, no platform exists from which women can speak without being labelled privileged'.

I am conscious that many critics of 'woke' culture will think that this should be a lesson to feminists when it comes to claiming victim status. Someone more powerful will do

it better than you, and then where will you be? But the fact that some people treat suffering as a game or a competition does not make it any less real or important. The pressure on women and girls not to speak of what they know applies even to their most distressing experiences. Always, they must curate the narrative. Where, then, can they finally turn, if not on their own selves?

Unkind me here

There is a close relationship between the expectation that women and girls are softer, kinder and more yielding than men and boys, and the female body as metaphor and destiny. This is why I included quotations from *The Taming of the Shrew* and *Macbeth* at the start of this chapter. Shakespeare did not pluck the association between female flesh and 'human giver' from nowhere when he created the shrewish Katherine or Lady Macbeth. His early modern audience knew what he was doing; we know what he is doing. Katherine aligns her taming with accepting the 'destiny' allocated to her 'soft, and weak, and smooth' body (however seriously one wishes to take this). Women's 'soft conditions' and their 'hearts' should, she concedes, well agree with their 'external parts'. In modern parlance, one might say that she recognises herself as one whose gender identity matches the sex assigned to her at birth. She comes to terms with her cis-ness. Were she to persist in her rejection of this pairing, she would require a Lady Macbeth-style unsexing – a denial of the body in order to defy expectations of feminine kindness and compassion (though one might feel that Lady Macbeth rather takes her defiance to extremes).

Disidentification from the female body has long been

associated with a rejection of the female social role, and vice
versa. In *The Second Sex*, Beauvoir describes the adolescent
girl feeling 'that her body is getting away from her, that it is
no longer the straightforward expression of her individuality;
it becomes foreign to her; and at the same time she becomes
for others a thing'. She was writing in 1949, describing what
might now be called gender dysphoria. Puberty makes the
girl wrong in herself; the body no longer represents the self
because the outside world will not allow it. This belief – that
the female body should be 'the straightforward expression' of
one's individuality – has not grown any less pervasive in the
surgical age. On the contrary, the increasing normalisation of
treatments which promise girls the opportunity to reject fe-
maleness wholesale, leave girls who resist this option faced with
the question, Well, are you this body? Are you 'soft, and weak,
and smooth'? Are you all 'soft condition' and 'heart'? Are you
'an open mouth, an expectant asshole, blank, blank eyes'? And
if not, why maintain a body that signals that to the world?

One of the things that makes femininity such an insidious
trap is that even if one seeks to reject it by rejecting the body
that attracted all of its demands, there is no real way of doing
so which is not in itself feminine – apologetic, masochistic,
involving the taking up of less space. The rise in teenagers
resorting to breast-binding and top surgery reinforces the
misconception that to be female-shaped is to be something
other than just a person in/as a female body. I understand the
desire, even if I think it is the world, not the body, that needs
to be fixed. To be female-shaped can feel, very viscerally, like
one is aligning oneself with all that is 'soft, and weak, and
smooth'. Sometimes it is hard to make your 'no' heard when
your body already seems to be drowning you out. Sometimes
it seems easier to express your 'no' via the body than to use a
voice that would get you into trouble.

'A woman who is opinionated, determined, or directly lets her needs be known is frequently denigrated or grudgingly described as pushy and aggressive,' wrote Orbach in *Hunger Strike*. 'Less recognized is how forcefully girls and women repress their needs for dependence and nurturance.' In writing about self-imposed starvation, Orbach sought to examine the misdirection of female need – what women and girls do when there are no acceptable, non-harmful ways in which to ask that their desires are met. While any act of self-imposed starvation is an individual matter, in multiple cases there is something very striking about it as a rejection of human giver status: simultaneously a demand for care (*Look how weak I am!*) and a rejection of carer status (*Look how hard and unfeminine I am!*) Stripping the body of female softness – an act of self-harm – can be a desperate means of deflecting traditional expectations. The starving woman cannot be coded as a nurturer, but in order to reach such a state, she cannot be nurtured herself.

Girls can be told to suppress their needs, or to view them as unpleasant entitlements, but these needs remain. As Virginia Woolf put it, 'women are supposed to be very calm generally; but women feel just as men feel'. If telling your own truth is not permissible – if it is now considered unkind to complain of female oppression, or to feel distress at the sexual entitlement of others, or to complain of your sexual assault – you might seek out a story that lands better. 'Suffering that falls through the cracks of the privilege framework,' writes Phoebe Maltz Bovy, 'gets easily dismissed.' When we are denied the space in which to recognise mutual need, suffering must be shoehorned into a politically acceptable template, one that is conceived of in ideological rather than relational terms. Female people who explicitly reject their femaleness suffer enormously (and some, as documented by Hannah Barnes in *Time to Think*, also find

the alternative intolerable) but they do not attract the ire of female people who reject femininity. Rejection of femaleness – like self-imposed starvation, like hysteria – is self-contained. If it is an accusation, it never gets as far as pointing the finger at anyone or anything in particular. It is easier to watch girls crush parts of themselves – thoughts suppressed, body parts bound – than it is to make their experiences count.

One condition for creating a world in which girls feel comfortable in their own bodies is to reject the conflation of femaleness with endless, ever-invisibilised giving. It is not the only condition, but it is a vital one. Girls must be permitted to express their own views and describe their own realities without risking accusations of selfishness, privilege, entitlement or even bigotry. They must be allowed to intrude on other people's stories, and to disrupt other people's beliefs about themselves. As the novelist Sarah Moss has written, 'the answer to disruptive women in non-compliant bodies' should not 'always be silence and discipline rather than making space for us to grow, right up to the end'. In order to be kind, girls first need a world that is kind to them.

JUST BE YOURSELF

10

WHOLE SELVES, RELATIONAL SELVES

... we are wired to be co-dependent, networked into a delicate lattice of connections. Everything we do to try and forget this fact is merely part of an enabling fantasy of autonomous, self-directed personhood, which the grunt work of caring exposes as just that, a fantasy.

Marina Benjamin, *A Little Give*

If you are inclined towards anger or selfishness, please don't be your true self.

Alex Byrne, *Trouble with Gender*

Feminism is not an anti-kindness movement. It is a movement which has repeatedly challenged the definition of 'woman' as a supporting character in the lives of men. It has rejected gender as a social hierarchy which sets femininity (soft, nurturing, dependent, inclusive) against masculinity (hard, aggressive, independent, self-contained). It imagines a world beyond that

of female givers and male takers. None of this has prevented critics from describing it as unkind, anti-maternal, man-hating, exclusionary and selfish. The 'naturalisation' of the female giver role means that when it is resisted – when we seek to accommodate female subjectivity in its own right – this can be viewed as pure meanness. If it costs women nothing to be kind – and our economic structures tend to assume this is the case – then feminists are being cruel for the sake of it.

Once upon a time, I half-believed in the caricature of earlier feminists as unkind. This was a flexible caricature, taking in both liberal and radical elements of the movement. Liberal feminists didn't like children (but they did like careers). Radical feminists didn't like men or sex (but they did like cats). While I sensed this couldn't be the whole story – that feminism probably also had something to do with liking women – I felt that early feminism had not done a good job of selling itself. In my great wisdom, I persuaded myself that most anti-feminism was not rooted in any male resistance to giving up feminine-coded goods and services, but in feminism's own terrible PR. My generation would do it better! I didn't understand that the only way you can make a female 'no' sound feminine is by turning it into a 'yes'. I didn't understand that it wasn't the packaging but the product to which people objected. Some rights really are pie; sometimes, bodies really do matter; even if you believe that your truth will set men free, it will piss them off a great deal beforehand. I was hoping for a shortcut, a way to avoid all this unpleasantness.

Looking back, my standards for feminist 'niceness' were ridiculously high. I can't think of any other political movement that is expected to face down so much injustice so very sweetly and accommodatingly. I, too, wished to end the conflation of femininity with femaleness, but I also thought

third-wave feminism could do with being more feminine, if only as a kind of interim measure, just while we won people over. I know I'm not the only one. In retrospect, I do not think this approach has worked out very well.

One of the arguments of this book is that while one might blame a kind of progressive overreach for the way in which feminists – and other groups who might once have considered themselves to be on 'the right side of history' – now find themselves denounced by their own side as unkind, this is not the whole story. To think this way is to implicate feminism in a problem which many strands of the movement identified and sought to resist at a very early stage, questioning not just one model of 'patriarchy', but patriarchal ideas of the self. Feminism's valuation of female subjectivity does not mean that it has been wholly focused on individual self-determination, regardless of whether or not one's image of this involves the pampered suffrage campaigner, the shoulder-padded glass ceiling-breaker or the 'not like all the others' rejecter of femaleness itself. There is a feminism which prioritises analyses of human interdependency and relational identities, understanding the problem of patriarchy as one of how all human beings relate to one another as opposed to one of how some fixed identities are appreciated more than others. As Carol Gilligan wrote in 1982, 'the most basic questions about human living – how to live and what to do – are fundamentally questions about human relations, because people's lives are deeply connected, psychologically, economically, and politically'. We are not whatever we say we are; we are where we stand in relation to others, whose perspectives will differ.

When Virginia Woolf complained of men viewing women as 'looking-glasses possessing the magic and delicious power of reflecting the figure of man at twice its natural size', she pre-empted a pseudo-feminist identity politics which claims

that when women refuse to perform this function, they deny others the right to exist:

> For if she begins to tell the truth, the figure in the looking-glass shrinks; his fitness for life is diminished [...] The looking-glass vision is of supreme importance because it charges the vitality; it stimulates the nervous system. Take it away and man may die, like the drug fiend deprived of his cocaine.

The kind of identity politics which insists that certain women – the female ones, the privileged ones – cannot have a truth of their own is not a distortion of feminism, or feminism gone too far. It is patriarchal to the core.

JustBeKindism stands in opposition to what many feminists – especially those focused on maternal experience and care ethics – have had to say about being kind. This has not stopped many of us from buying into the former, at least for a while. Some have done it for the reasons I outlined at the start: we thought that a meme-able, slogan-friendly feminism, marketed as liberation for all, would be more popular. We were seeking to manage the overlap between self-sacrifice and compassion as leftist values – the values of the 'good' people – and as 'feminine' values, ones which female people are expected to embody far more than male people (and for whose perceived absence they are punished more severely).

There are also ways in which this ultimately simplistic politics, which offers no real challenge to the status quo, has been made to sound more exciting, rebellious and intellectually sophisticated than it actually is. Because reading Judith Butler feels difficult – why use one T-shirt slogan when you can stretch it out into several opaque treatises? – one can start to think that by nodding along one is engaging in something that

is difficult politically. Yet as Martha Nussbaum wrote in her 1999 essay on Butler, 'Professor of Parody', the real attraction with what this work offers is that it seems 'easier than the old feminism'. 'It tells scores of talented young women that they need not work on changing the law, or feeding the hungry, or assailing power through theory harnessed to material politics,' wrote Nussbaum. 'They can do politics in the safety of their campuses, remaining on the symbolic level, making subversive gestures at power through speech and gesture.' Nobody is saved by this, but at the same time, no one has to hear that most ugly and unfeminine of words: no.

In this final chapter I will explore the way in which some of the values that should be at the heart of creating a kinder, more caring society have been sacrificed to quick-fix JustBeKindism. In dreaming up a world where sex differences are forgotten, the 'true self' is sacrosanct and the invisible hand of kindness will order everything as long as no one interferes, we lose an appreciation of the value of reciprocity, dependency and measured accommodation. Non-sexualised self-sacrifice is dismissed as unthinkingly 'traditionalist' – that is, bound to doing things as they have always been done, for no particular reason beyond the maintenance of old power hierarchies – without any recognition of necessity, compromise or even love. Someone still has to birth the babies, someone still has to wipe up the mess. Claiming that it doesn't always have to be one particular person doesn't alter the fact that it always has to be someone, and sometimes that someone has to be of a particular sex, whether we name it or not. In order to redistribute care – to ensure that everyone can be both giver and taker, in constant exchange – we must be honest about the boundaries, and instabilities, of self.

Don't bring your whole self to work

In his 1995 essay 'Queers, Sissies, Dykes, and Tomboys: Deconstructing the Conflation of "Sex," "Gender," and "Sexual Orientation" in Euro-American Law and Society', law professor Francisco Valdes argued that 'queer legal theory must transcend the limits of current privacy notions and push for sex/gender dignity and equality in all spheres of life'. 'The ultimate goal, dignity and equality, requires the right of sexual minorities to be open,' he wrote, 'to be active in our occupations and secure in our homes without having to choose continually between a life of closet and a life of enduring homophobic bigotries.'

This sounds reasonable. Nonetheless, one might ask whether or not this thinking applies to Kayla Lemieux, a male teacher at a Canadian high school who hit the headlines in 2022 due to being photographed wearing prosthetic Z-cup breasts to work. Lemieux was claiming to be a woman – was this, then, merely a push for 'sex/gender dignity and equality' without being 'limited to conventional (mis)conceptions of privacy'? Or was it, as many felt (including the students who took the photos), overstepping the mark, and quite possibly taking the piss? Was this a creepy man exploiting the flimsiest plausible deniability in order to make students feel uncomfortable, or would even suggesting this constitute a potential denial of Lemieux's true selfhood? For those who could not countenance doing the latter yet still had the capacity to spot the bleeding obvious, it was hard to formulate an acceptable response.

'It feels like the progressive thing to do is to support this teacher's right to self-present in the classroom as she does, or at least to honour her side in the matter,' writes Phoebe Maltz Bovy of the case. At the same time, Bovy noted, very politely,

that there was something about this particular choice of self-presentation which 'makes a mockery of countless young girls who've been told at school that their bodies – developing bodies they themselves are still getting used to – are a distraction'. There's that, and there's also the fact that this mockery may have been the entire idea. It is impossible to know the precise motivation. Does one need to, though? If some forms of self-expression impose so much on the selfhood of others, should we not find somewhere to draw a line? 'Bringing your whole self to work' might seem easy, but not if you take it to its logical conclusion.

Like many beliefs that are now defended without qualification in the name of kindness and inclusivity, 'bringing your whole self to work' starts from an important place. We know that some people have had to engage in far more self-denial and self-suppression than others in order to be accepted in many workplaces. This has been particularly true for those whose sexualities and relationships have been stigmatised, denied formal recognition and even treated as grounds for dismissal. The freedom to talk about one's partners, share stories, have one's losses recognised, should be accorded to everyone, not least because we are all defined by others. This only becomes a problem when one group's self-definition as 'the norm' is permitted to override and deny the social and emotional realities of others.

When individuals share some things that might once have had to remain hidden – relationship status, mental health history, caring responsibilities – this can be characterised as 'bringing one's whole self to work', but this is a shorthand as opposed to a literal truth. It is a way of relating to others, not the revealing of some unchanging inner essence or the exposure of all personal details. In the workplace, just the same as anywhere else, we adapt and make room for others.

We alter who we are according to shifting relational contexts. Equality and inclusion ought to mean not that everyone must be viewed and described by their colleagues in exactly the way they would most desire, but that the shifting and adapting is fairly distributed. It should not mean that there are two classes of people: those who claim all the selfhood, and those who absorb and accommodate. Nor should it mean there is no separation between the work and the non-work self. An inclusive workplace recognises that people have different needs and dependencies outside of work. A kind one makes room for alternative viewpoints within it.

'Bringing your whole self to work' has undergone one of those toxic mutations – akin to those experienced by 'rights aren't pie' and 'biology isn't destiny' – which means the idea of the 'whole self' is taken literally. Since we are social beings, existing interdependently, this cannot really hold. If everyone is being their true self, you will constantly encounter people whose self-perception challenges yours. The only way to protect yourself from this is to ensure that some people get to be a 'whole self' while others have to be supporting actors. To the latter, one might justify their lesser status by calling them allies (the flattering tactic), privileged (the neutral one) or bigoted (the shaming one). Some employees are, to adapt Beauvoir, 'the Subject [...] the Absolute'; others are 'the Other'. Many a woman has experienced discrimination for expressing views on sex and gender in the workplace (or even outside it) which are consistent with *her* sense of self. In such cases, however, 'bringing your whole self to work' only functions in reverse. The woman is, she will be told, preventing others from being *their* whole selves by refusing to validate their identities. She cannot point out that to do so imposes an unreasonable cost on her, by forcing her to deny her own perceptions. This concept of the 'whole self' does not allow

WHOLE SELVES, RELATIONAL SELVES 261

for reciprocity or compromise. In a 2015 essay denouncing 'terfs' in academia, Sara Ahmed hyperbolically declared that we should be 'aiming to eliminate the positions that aim to eliminate people'. *'For if she begins to tell the truth* [or at least, her truth], *the figure in the looking-glass shrinks.'*

This veneration of the anti-pluralistic 'whole self' is presented as the epitome of kindness – if we all just accepted each other, think how free we would be! – yet true kindness involves a willingness to revise our understanding of the self, again and again, as we interact with others. Historically, the problem for women has been that men have expected us to adapt so that they do not have to. Flexibility and openness are viewed as feminine qualities; rigidity and directness are male ones. Script after script – religious, scientific, pornographic, political – 'discovers' that women and girls simply find it easier to adapt their behaviour than poor old men. Female sexuality is posited as 'malleable'; girls, according to Simon Baron-Cohen, are 'better at self-control'. In 2012's *The End of Men*, Hanna Rosin compares 'Plastic Woman', who performs 'superhuman feats of flexibility', with poor 'Cardboard Man', who 'hardly changes at all'. That this 'flexibility' might be more accurately described as the resourcefulness of the subordinate has done little to alter the perception that in situations of conflict or change, it is female selfhood that can take the hit. This stereotype, coupled with male-default understandings of bodies and lifecycles, means that formerly male-dominated workplaces still expect women to adapt to structures and patterns created with men in mind.

'The job market,' Katrine Marçal writes, 'is still largely defined by the idea that humans are bodiless, sexless, profit-seeking individuals without family or context. The woman can choose between being one of these, or being their opposite: the invisible and self-sacrificing one who is needed to

balance the equation.' It is important to understand that this mindset was already in place long before HR departments got on board with promoting twenty-first-century 'whole selfhood'. Women's opportunity to play the game had already been granted on the assumption that they would do their best to 'fit in' by not being too female. If companies then start to promote a model of 'whole selfhood' that is rooted in an ideology which denies the salience of biological sex – and with it, the physical, social and lifecycle differences women are already downplaying in order not to be viewed as liabilities – then who gets to bring 'more' of themselves to work remains as strictly circumscribed as before. The superficial justification for the female employee's self-suppression might have changed, but the expectation and the experience remain the same.

The sociologist Kathleen Lynch points out that individualism is implicated in neoliberal capitalism regardless of whether it is 'constructed positively as individuality, promoting uniqueness, originality and capacity for self-realization, or negatively as indicative of self-preoccupation and self-interest'. There are obvious advantages to a modern-day employer in viewing equality and inclusion through the lens of the 'whole self' rather than that of its relational counterpart. It offers a progressive-sounding way of celebrating those differences which are less likely to cost money or involve serious structural change. The relational self gets pregnant; the relational self has dependents and dependencies; the relational self is not a box you can tick. The relational self does not ask for validation or approval, but for a shared redistribution of time and resources, one that necessitates putting other people's self-perception in question. If by 'being kind' we truly mean striving to centre care and compassion in our politics, then it is necessary, as Lynch argues, 'to develop a political and

cultural appreciation of how the self is co-created, through struggles and negotiations in relationships, for better or worse, both collectively and individually'. This is the opposite of the politics of 'I am whoever I say I am'.

In *A Little Give*, her autobiographical exploration of 'women's work' against the backdrop of the Covid pandemic, Marina Benjamin describes coming to the realisation that for socially progressive movements such as feminism, chasing after authenticity can be a self-defeating objective: 'It may well be more honest, and I suspect we'd be happier for it too, if feminism [...] gave up on its quest and instead accepted the inevitable mess and chaos of our lives.' To abandon our attachments to an illusory authenticity – one that so quickly collapses in the need to position oneself as the hero surrounded by non-player characters, lest one start to doubt one's own existence – offers a route to real change. Relational selfhood is holding back sometimes, taking up more space at others. It involves a much more meaningful recognition of the fact that 'what constitutes through division the "inner" and "outer" worlds of the subject is a border and boundary tenuously maintained' than the author of those words, Butler, could manage. This tenuous maintenance, far from an expression of conservative paranoia, can be revolutionary work.

The semi-porous, unsexy self

Female giving is not a sexual fetish. I have referred to Andrea Long Chu's *Females* rather frequently in this book not because it is a work I particularly like (as you may have noticed), but because it makes the fetishisation of the hollowed-out, endlessly giving female – and its relationship to a pseudo-progressive politics – so obvious. Dworkin's *Pornography*

does this, too, but there the author does not view this position as acceptable, or indeed inevitable. 'The belief that women exist to be used by men is so old, so deep set, so commonplace in its everyday application,' Dworkin writes, 'that it is rarely challenged, even by those who pride themselves on and are recognized for their intellectual acumen and ethical grace.' Feminists seek to challenge the belief nonetheless. There is no feminism in merely noticing what is and saying, 'How interesting,' or even, 'At least it turns me on.' When Long Chu claims that 'to be female is, in every case, to become what someone else wants', all we see is the same sexualisation of female masochism which the misogynist will either dismiss as a mad conspiracy theory (if you are a radical feminist critiquing it) or celebrate as an essential truth (if you are a male person pronouncing on the human condition). For the male person, there is a delight in willing self-abnegation – or rather, a delight in other people's assumed-to-be-willing self-abnegation, and an assumption that if you enjoy imagining it, it can't be so bad for those living it.

One of the most frustrating things about *Females* is that within it, if one were able to strip out the latent sexism and influence of porn, is a message about selfhood that men, not women, would do well to hear. That it is expressed as a truth about femaleness – as opposed to humanity (even if one attempts the trick of saying 'therefore all humans are female') – reinforces the impression that within certain circles, any rejection of the 'human giver, human taker' binary remains taboo. 'You are not the central transit hub for meaning about yourself,' writes Long Chu, 'and you probably don't even have a right to be [...] You do not get to consent to yourself – a definition of femaleness.' All of which is true (and not particularly different from the line taken by feminists exploring care ethics), right up to the last four words. Then

suddenly you are reminded this is about fucking, not who does the washing up, who massages the egos, who gets, as Dworkin put it, 'to define experience, to articulate boundaries and values, to designate to each thing its realm and qualities, to determine what can and cannot be expressed, to control perception itself'. It's not about the fact that 'the self is co-created'. It's about the fact that life would be terribly boring without being able to indulge in fantasies of how the other half lives. It's also about an inability to understand that just because you cannot be everything (the male ideal), that does not mean you are nothing (defined, of course, as female).

Feminists, too, would argue that no one gets to be 'the central transit hub for meaning' about themselves. Alas, the feminist version of this argument is decidedly unsexy, not to mention frustratingly inexact. '*We can strive to make a better world, but in order to achieve it we will each have to suppress some of our own desires some of the time, accept the limitations of our bodies and cope with not everyone seeing us as we would wish to be seen, only with some adjustments made so that everyone has to do this to a roughly comparable degree, not just some people all the time so that others never have to*' is far less bracing than a dramatic 'you do not get to consent to yourself'. As Martha Nussbaum characterised it, 'no bondage, no delight'. 'If some individuals cannot live without the sexiness of domination,' she wrote, 'that seems sad, but it is not really our business.' Today, however, we cannot avoid it being our business when notions of kindness and inclusion have become bound up in respecting identities rooted in a gender hierarchy at the expense of describing said hierarchy's impact on the lives of women and girls.

When boundaries, consent and giving are interpreted almost exclusively through the lens of sexual desire, it be-comes increasingly difficult to talk about the way in which

care enriches us as humans – at least, not without being accused of some rose-tinted, conservative idealisation of drudgery. 'There is something fundamentally unbounded about the care relationship,' writes Marina Benjamin, 'because in caring you can't but entrust something of yourself to the other person and at the same time you absorb something of them into your own being.' When pornified, hierarchical understandings of submissiveness and non-consent combine with denial of the sexed, dependent body and worship of the 'whole self', we move further away from this reciprocal model. We are left instead with an anti-feminist simulacrum of a care ethics. Recounting her desire to undertake voluntary work following the isolation of lockdown, Benjamin describes wanting 'to let the hurt of others in somehow'. She writes of desiring 'a kind of casual interpenetration, a sloughing off of selfhood and a subtle commingling that spoke to the grittier aspects of community: the primal sting that comes with acknowledging our bodily vulnerability to contagion'. This qualified porousness is very different from the conflation of boundaries with bigotry explored in Chapter Eight. If the cruellest political programmes are rooted in a desperate need to exclude the other – the poor, the migrant, the sick – the capacity to live with the 'casual interpenetration' of everyday care offers a far more hopeful solution than the moral shaming and forced 'inclusion' of the old-new purity politics. Kindness is not one person absorbing another. It is the rub, the rough edge where you work out the limits of your shared accommodations, and allow someone not to absorb you or to be absorbed by you, but to change your shape. It is not the absence of borders, because without them, there is nothing to interrelate. Butler might decry those who wish the body 'to achieve an impossible impermeability', but it is Butlerian theory that cannot cope with the fuzzy edges. Not everything

has to be all or nothing, fully open or fully closed. Some things are a 'no', but not all things. This is the discomfort with which we all need to 'get comfortable'.

Care is not narcissistic. It involves a willingness to get dirty, both physically and politically. It means putting the protection of real bodies ahead of the protection of an idealised self-identification. Everyday people – with their diverse, dependent, ageing, needy bodies – matter more than the fantasy self.

It starts with the body

Come the environmental apocalypse, will feminists be debating whether or not 'cis' is a slur? Will they be complaining about women being rebranded 'menstruators' or 'uterus havers'? Will they still care about the sex and gender inclusion policies of the 2024 Olympics?

I am quite prepared to believe that they, and everyone else, will have far bigger issues to deal with. I am also 100 per cent certain that this will be a world in which everyone knows what sex everyone else is, and in which it matters even more than it does today.

It will be a world in which the salience of biological sex – its relationship to power, to reproduction, to resource redistribution – is brought into super-sharp focus. It will also be one in which, if we have already jettisoned the linguistic, political and organisational tools women need to resist exploitation, women (and children) will suffer far more than is necessary. In *The Guilty Feminist*, Deborah Frances-White blithely asks, 'If we won't respect the binary and form ourselves into two orderly camps, how will they know who to oppress?' There's no doubting 'they' will know. When things fall apart, it will

not be your personal lack of respect for 'the binary' that saves you.

As the philosopher Alex Byrne has noted, supporters of the primacy of gender identity over biological sex tend not to think the body terribly important. Whereas 'someone's gender identity is supposed to be part of their nature, their very essence, their true self', the body 'is a mere container or a vehicle, no more a part of a person's nature than their clothing or hairstyle'. Treating the body as irrelevant is part of the 'just be kind' package. This is in spite of the fact that recognising material needs and realities should be central to any meaningful politics of redistribution. Sex denialism is aligned with sacrifice denialism, the belief that no one need give up anything other than their 'conservative' insistence that particular bodies impose particular limitations on us and make us dependent on others in particular ways. This way of thinking makes it much harder for feminists to articulate and promote feminist policies regarding care, love, relationships and community. It does not redistribute the duties imposed on women because of their bodies so much as make the imposition invisible.

The conclusions that patriarchal ideology has drawn from biology – that there are sex differences which justify female exploitation – are not inevitable ones. Pretending not to notice biology – using language to suggest femaleness is 'assigned' to the privileged cis woman, almost at random – can be a way of drawing the same conclusions (we exploit the uterus haver in the name of correcting reproductive injustice, not the woman because that's what women are there for – just as long as we're exploiting, all the same). We will always notice sex difference; the point is to draw different conclusions, ones rooted in recognition of women's full humanity.

It is important in this to be clear about what is and isn't

'biological essentialism'. 'Society,' writes Marçal, 'has told [woman] that she cannot be rational because childbirth and menstruation tie her to the body, and the body has been identified as the opposite of reason [...] man has been allowed to stand for self-interest and woman has stood for the fragile love that must be conserved.' It is biological essentialism to expect women to be self-sacrificing and passive because they are female-bodied. Essentialist expectations can even extend to demanding that women deny their own femaleness (whereas men get to remain male). It is the opposite of biological essentialism when we say that there is nothing about being female that makes one a human giver, and nothing about being male that prevents one from giving.

Drawing attention to the social and political salience of sex difference is considered regressive because female bodies are disproportionately associated with care, and caring is associated with conservatism, restriction and immaturity. Caring – when it is bound, as it should be, to bodies and dependency – disrupts the 'progressive' march towards unqualified freedoms for all. It gets in the way of a vision of progress which is rooted in binary understandings of what matters and what does not. 'When the focus on individuation and individual achievement extends into adulthood and maturity is equated with personal autonomy,' argues Gilligan, 'concern with relationships appears as a weakness of women rather than as a human strength.' In this way, insisting on the necessity of care is coded as psychologically and politically immature, an unfortunate fixation of those who lack the intellectual capacity to think beyond the physical self. This is true even when women are not the ones doing the caring. Care, writes Lynch, has been seen as 'an aberration in the adult human condition' because adulthood has been 'closely aligned with the ideals of independence and autonomy'. Those

who do hands-on care work, she suggests, 'become abject by
association; they are devalued by doing work that is often
dirty, tiring and demanding, but lacking in status and power'.
People (often, but not always, women) who perform this type
of work are not helped by ideologies – be they traditionally
religious, or nominally progressive – which treat the body as
a mere container, dependency as childish and self-perception
as a fundamental, unchanging truth.

Rejecting the individualism of both capitalism and its
'progressive', social justice-tinged variants is not just possi-
ble, but necessary for everyone. 'Just be kind' will not cut
it. Creating a better society has to involve, as Lynch writes,
'recognising the relationality and interdependency of care'. It
must also involve a full recognition of sex difference, not just
for specific reasons (sporting categories, medical research etc.)
but as a much broader principle. As Clare Chambers argues
in *Intact*, 'destroying the sex/gender distinction in favour of
gender means that culture retains its role as something that
transcends nature; and nature retains its role as something
that limits, that constrains, that corrupts'. Devaluing nature –
seeking to control and transcend it – will one day destroy
us all. There are some things we cannot deny or identify
our way out of. The body is one, the world is another. The
dependency-denying half of the human race might have had
a good run, but there is no longer time to pretend.

AFTERWORD

Of course, both men and women needed to behave well and abide by heavenly and earthly laws in order to maintain a functional society, but books for and about women identified, and often created, vices and virtues that they claimed were specific to women.

Tabitha Kenlon, *Conduct Books and the History of the Ideal Woman*

I have learned that there is something worse than people telling me I'm a bad person, and that is allowing bullies to reframe the world, to dictate what we can all think and to define my reality.

Hadley Freeman, 'Why I Stopped Being a Good Girl'

In the aftermath of the Covid-19 pandemic, a website by the name of A Gift of Kindness appeared. Its message was 'Above all be kind. It doesn't cost you a penny.' Central to the site was a page inviting visitors 'to relate your kindness stories, to

share joy and hope with others by recalling any small gift of kindness towards you, or someone you know, and how that felt'. Each story has its own all-caps heading and an accompanying stock photo. I have read several and found them all rather cheering.

There's HAND KNITTED JUMPER THANKS, in which Margaret from Frome recounts how her dear friend Helen 'kindly knitted me a woolly jumper for Easter with a portrait of TV's Nick Knowles on the front'. And MOBILE PHONE RESCUE, in which Harold from Warrington remembers getting his phone 'stuck on a slightly high wall', but thankfully 'a passing motorist kindly lent me 6 tins of kidney beans to stand on – stacked – as sort of makeshift stilts to achieve the necessary height as well as a baguette to hoik the phone down with' ('sadly, during all the commotion I never learnt their name, but I will always remember that act of kindness'). My favourite, though, is the *Silence of the Lambs*-inspired CUSTOM SUIT – WOW!, in which Clarice from York thanks her friend 'Jame Gumb who sewed me together a beautiful custom suit from material he had lying about his house!'

Not all of the entries are quite so gleefully mocking. Indeed, I've a feeling the site was intended to be taken seriously rather than serve as the kindness version of *Viz* Top Tips. The main page features an image of Captain Sir Tom Moore, the war veteran who inspired lockdown Britain by walking laps round his garden to raise money for the NHS. The message board is offered 'With love from Captain Sir Tom's family – Hannah, Colin, Benjie and Georgia xx'. Of course, all this reads a little strangely now. Since her father's death, Hannah Ingram-Moore has been embroiled in controversy over her family's use of the proceeds from books written by Captain Tom and Captain Tom memorabilia. Kindness might not 'cost you a penny', but the Moore family seem to have done well

from the nation's generosity all the same. As the *Guardian* concluded, 'the feelgood story of lockdown' has turned sour. It is hardly surprising, then, if many are tempted to treat A Gift of Kindness with less reverence than its creators might have desired.

It is easy to be cynical about the popular turn to kindness. During the summer of 2020, we clapped for NHS workers while, as we now know, members of the government flouted their own lockdown rules. The observation that no one can be paid in claps – that these are a poor substitute for awarding essential workers the pay they deserve – has been made many times. There are parallels with the economic exploitation of unpaid carers, most of whom are female. To talk about money in relation to care is considered unseemly, as though it reveals a lack of real feeling – and possibly even some re-sentment – on the part of the carer. You thought she cared about you, but she's only doing it because she is being paid to. Why would anyone want payment for something they are doing out of love?

This dichotomy affects not just women in caring roles, but anyone whose work can be categorised as providing a feminine-coded good or service. The opposition also extends beyond money into areas such as comfort, consent, bounda-ries and identity. If you're doing something for love – if that is what you are and what you are for – then you shouldn't ask for more (and if, on the other hand, love can be commod-itised, then feeling itself can be sold, switched on and off, as the customer demands). This becomes a way of shaming those who contribute the most as human givers. It becomes a way of offloading guilt and making a sin of asking (Tory peer Lord Markham told nurses considering striking to see their job 'as the vocation that it is'). That the binary is illusory – feelings cannot be sold, nor are they devalued by being fully

recognised and rewarded – is something both left and right have found difficult to fully incorporate into their politics.

It is right to be suspicious of the fetishisation of kindness, compassion and empathy when it is being used to reinforce existing hierarchies and to tell individuals to stop making demands of their own. At the same time, we cannot exist in a state of constant suspicion. The *Woman's Hour* tweet mentioned at the start of this book was well intentioned. However, it appeared at a time when many women – women who may spend endless hours being kind in meaningful, practical, unspoken ways – are feeling vulnerable. The kindness message is being used against them in ways both old and new.

Difficult kindness

In January 2020, the *Guardian*'s Steve Rose wrote a piece on how the term 'woke' has been 'weaponised by the right'. 'Technically,' he wrote, 'going by the Merriam-Webster dictionary's definition, woke means "aware of and actively attentive to important facts and issues (especially issues of racial and social justice)", but today we are more likely to see it being used as a stick with which to beat people who aspire to such values, often wielded by those who don't recognise how un-woke they are, or are proud of the fact.' Rose deplored the way in which 'criticising "woke culture" has become a way of claiming victim status for yourself rather than acknowledging that more deserving others hold that status': 'It has gone from a virtue signal to a dog whistle. The language has been successfully co-opted – but as long as the underlying injustices remain, new words will emerge to describe them.'

There is much in this critique that smacks of JustBeKindism: the attachment to victimhood as a status within a fixed

hierarchy, the repudiation of mutuality (one group 'deserves' victimhood more than others), the seemingly uncritical use of 'virtue signal', the use of 'dog whistle' to suggest you have hidden expertise in what your opponents are *really* saying. Then again, had I never found myself on the wrong side of the 'just be kind' commandments, I might never have had a problem with any of this. As Nicky Clark writes in her essay 'Leaving Kindland, Entering Reality', in which she charts her own move from being one of the 'good' people to committing a crime against wokeness ('I said I liked the wrong person'), being pure is great while it lasts: 'I felt so good. I was on the kind side. "God I'm amazing!" I thought.'

There are many people who criticise 'wokeness' as a way of suggesting efforts to make the world a more equal place have already gone too far. Nonetheless, other criticisms of those who identify as 'woke' target a particular attitude, a lack of tolerance, an absence of self-analysis, a leaning towards author-itarianism, a sense that 'I identify as kind, ergo nothing I do or think can be unkind'. It's a hierarchical, non-relational ap-proach to justice, one that fails to recognise the very networks of dependency that many feminists (and others) have sought to emphasise. Often this approach is accompanied by wide-eyed bewilderment that so many other people aren't as wonderful as you are, as demonstrated by the following tweets:

Call this 'war on woke' what it really is: a war on kindness, compassion, decency.

If to be 'woke' means to be awake, alive to the insights, contexts & needs of others; to aim to be well-informed, thoughtful, compassionate, tolerant, respectful & kind; to want to make the world a better place for all people & all living things, sign me up for that challenge!

Being 'anti-woke' seems to actually mean being out of touch with what people care about. When I see someone use the term 'woke' as a slur, I immediately assume they condone racism, discrimination, and inequality.

Do they, though? It would be strange if so many people not only didn't like the idea of being nice to others, but were desperate to advertise it. 'Woke mob', according to one anonymous definition, is 'a large well informed group of people with basic empathy who are compassionate, committed to dismantling injustices, and making the world a better place for all of humankind'. Unlike, say, their critics, who apparently identify with being total bastards.

Identifying as kind is not the same as being, or even aspiring to be, kind. Identifying exempts us from justifying our beliefs, making it easier for us to take positions not because we have thought them through, but because everyone else in our 'kind' group is doing so. It is not for nothing that 'just asking questions' has acquired the status of 'dog whistle' in certain circles – you are not supposed to interrogate goodness, merely believe in it.

In March 2023 the *Guardian* featured two letters in response to Oxfam's 'Inclusive Language Guide' (already mentioned in Chapter Nine). Both related to the proposal that the gender-neutral term 'parent' always be used instead of 'mother'. Reading the letters side by side, it is obvious which writer identifies as kind and which one is committing the transgression of thinking too much. The writer of the first letter is eager to advertise her puzzlement that anyone could be anything but supportive of the recommendation. She knows that 'there will always be people who get their knickers in a twist over their so-called pride in being white/British/cisgender/heterosexual/relatively wealthy/able bodied etc.' but

still 'can't fully comprehend the distress and hurt apparently caused by this language guide'. Meanwhile, the writer of the second letter is more specific, arguing that retaining the term 'mother' is important because most care work is provided by mothers, and that this should inform Oxfam's position on global wellbeing and development. The contrast is striking. The first letter suggests that anyone who has issues with Oxfam's proposal dislikes progress and is, by some vague association, on the side of racists, homophobes and haters of the poor and those with disabilities. The second explores why this particular application of gender-neutral language may have unforeseen negative consequences, not least for a political and economic analysis of inequality as it affects one half of the human race. This writer is not invested in demonstrating her superiority to those who disagree with her, or in using trivialising language ('knickers in a twist'). She thinks the term 'mother' matters and wants to explain why, perhaps in the hope of persuading others to re-evaluate their position.

It's possible that both writers view themselves as progressive. For some people, however, 'being progressive' has been merged with the idea that any dissent from a set of hardline positions on sex, gender and what 'the other side' is like is proof of unkind, exclusionary tendencies. Of course, it takes two to polarise, and it is not as though some on said 'other side' have not leaned into presenting every single position taken by the opposition as inherently bad. What is dismaying about the left's internal polarisation, though – the positioning of 'good', uncritical leftist against 'bad', nuanced leftist who is probably 'really' on the right – is that it cheapens our understanding of empathy, care and compassion. It reduces them to postures rather than values informing how one operates within a network of relationships – values that one would wish others to share, or even that one might wish to

interrogate and refine, as opposed to values which only serve to differentiate you from morally inferior opponents.

Honest kindnesses

If someone behaves as though I am their equal, I do not want it to be an act of kindness. I want it to be because they think it is true.

These things are not mutually exclusive, especially when following your beliefs comes at a cost. Nonetheless, one problem with JustBeKindism is that it can veer so far from engaging with unpleasant truths, practicalities and limitations that it can feel as though respect for others is justified solely by performances of benevolence. You may not really see someone else as a human being of equal worth, but you are kind enough to pretend they are something they are not.

In his essay *Of the Rise and Progress of the Arts and Sciences*, David Hume proposed that 'as nature has given man the superiority above woman, by endowing him with greater strength both of mind and body; it is his part to alleviate that superiority, as much as possible, by the generosity of his behaviour'. In other words, men should be kind to us not because we are their equals, but because we are their inferiors. Today's JustBeKindism can be a version of Hume's benevolent sexism. We promote a story – and it's just a story – in which all human beings are of equal worth, then pat ourselves on the back for our generosity. We might even go one step further and openly admit to manipulating what counts as truth.

In a 2015 speech asking 'Does feminist philosophy rest on a mistake?', Amia Srinivasan argued that 'sometimes by saying something often and persuasively enough – that marriage isn't just for straight people, that men and women are

equal, that transwomen are women – we can make it true'. This is trivially true. Language evolves, laws change and some accepted meanings fall out of favour and others replace them. If we want to insist some agreed meanings no longer matter, though, we should have a good reason why. Female people will still exist even if we do not have a noun (or a politics) just for them. Women will still have as much human worth as men regardless of how often it is said they do not. There is a risk in giving so much power to the saying. Your inherent value – even whether or not you exist as part of a definable group – is not dependent on other people's good will.

Feminism, anti-racism, gay liberation – these are not movements whose success is based on persuading the world to kindly, politely pretend those they represent are not inferior (as if, deep down, everyone knows that they are). As a child I often heard it suggested that the problem with feminism was that feminists wanted everyone to lie about what men and women were really like, as though it was one thing not to constantly remind women of their physical, moral and intellectual defects, and quite another to take the pretence so far as to place them in positions of influence. Those who currently suggest both sexism and transphobia are inevitable consequences of acknowledging the immutability and political salience of biological sex – therefore we shouldn't recognise it at all – imply that such thinking is correct.

If we believe that the truth is for unkind people only, our opinion of those towards whom we are 'just being kind' cannot have been very high to begin with. To argue for honesty is not to argue for unkindness. It is to advocate having enough faith in yourself and other people to know that who you really are is not incompatible with being recognised as a person of worth, or with finding that worth in others, too.

Am I kind or not?

To be writing a book about kindness (or unkindness) is em-
barrassing because it implies either total confidence in one's
own ability to be kind, or absolute cynicism about one's own
and everyone else's acts of kindness. At least, that is what I
have felt whenever I have tried to explain what I have been up
to. I hope that what I have finally produced suggests neither
of these things.

We are always in the act of imposing a moral on our acts,
hoping that others will buy it (or I am, at any rate). There are
times when I fear that this explains my attraction to femi-
nism. How can I be sure I am not treating the entire political
analysis as an acceptable channel through which to express
my own self-interest? *Don't do that to me* becomes *don't do
that to women in general. I'm not saying this for my sake, but
for everyone's. This woman's experience, which might seem
remote and distant to mine, is actually a conduit through
which I express my own rage without having recourse to my
own, less marketable examples. They'd think I was attention-
seeking, or lying. They wouldn't understand.* Of course, such
over-thinking is the worst self-indulgence. There I am, *taking
a look at myself*, trapped in front of the mirror as always.

Even the most careful feminism deals in generalisations, or
it will consume itself. I worry about the balance between what
I think it essential to assert, again and again – that we have
inner lives and boundaries, that our needs are as real as those
of men, that there is nothing aggressive or artificial about
the expression of these needs – and how the world actually
works. Women and girls are accused of performing because
we cannot opt out of the performance, at least not fully. Every
expression and interaction can be double-edged. 'I wonder,'
writes Leslie Jamison in *The Empathy Exams*, 'if my empathy

has always been this, in every case: just a bout of hypothetical self-pity projected onto someone else.'

JustBeKindism does not recognise this complexity. It doesn't like that our motives will never be knowable in any absolute sense, yet fundamental to kindness and compassion is uncertainty. It is renouncing a quest for true selfhood. It is being willing to be less and more of ourselves, because others will shape us, too. It is finding the balance where we are moulded, transformed, compromised, not one person occupying another, but all being changed by our mutual dependency.

NOTES

Introduction

1 *The backlash is at once:* Susan Faludi, *Backlash: The Undeclared War Against Women* (London: Vintage, 1993). p. 12

1 *I'll define as female:* Andrea Long Chu, *Females* (London: Verso, 2019). p. 14

2 *In the autumn of 2023:* <https://twitter.com/BBCWomansHour/status/1724502462575575400> [accessed 19 November 2023].

2 *Stop grooming women:* <https://twitter.com/SurrogConcern/status/1724731192279273836> [accessed 19 November 2023].

2 *Telling women we should:* <https://twitter.com/_Leyanelle_/status/1724581549817970735> [accessed 19 November 2023].

2 *Be kind be kind be kind:* <https://twitter.com/PinkstinksUK/status/1724807925183721894> [accessed 19 November 2023].

2 *Gender – the patriarchal tool:* <https://twitter.com/BradfemlyWalsh/status/1724563988686462991> [accessed 19 November 2023].

2 *Nobody (and I mean *nobody*):* <https://twitter.com/WideyMcKnacker/status/1724730262922183049> [accessed 19 November 2023].

3 *'the new buzzword'*: Samuel Fishwick, 'Kindness is the
 New Buzzword – But is it Losing its Meaning?', *The Times*
 <https://www.thetimes.co.uk/article/kindness-is-the-new-
 buzzword-but-is-it-losing-its-meaning-5vqddv8dp> [accessed
 5 April 2023].

3 *saw the University of Sussex launch:* Sussex Centre for
 Research on Kindness, University of Sussex <https://www.
 sussex.ac.uk/research/centres/kindness/> [accessed 10
 November 2023].

4 *'Women ... have never been allowed':* Katrine Marçal, *Who
 Cooked Adam Smith's Dinner?* (London: Portobello, 2015).
 p. 29

4–5 *'that they are support animals':* Author interview with Kate
 Long, 28 April 2023.

5 *'Kindness ... has taken the place':* Author interview with
 Francesca C. Mallen, 3 May 2023.

5 *it is possible to purchase on eBay:* '10 Girls Pastel White
 Heart Knickers Brief Pants Be Kind, Happy, Brave, Nice',
 eBay <https://www.ebay.co.uk/itm/125369497348?hash=
 item1d309ab704:g:O2wAAOSw7UliqLdE&amdata=enc%
 3AAQAIAAAA0DhukN7sN7oxuv3FlUtEBP62ldCtx5O3OQ
 zfX4HkUUtxsfN69wgwsjK8NVwNaCeXTHg0cWQ%2F1r
 V4CKHawb5IfvbJ0iWlkmJyAed9rWCpvXHlpQfnMhN2n
 KbsxtsnsBAU2d1jFneIVXLW%2Fm%2B0FXOT7x85TPF2
 lalPFIGi8gssJvQHbjVuXj9pYK1SRRr9ZWJHNmJ8wXwbC
 g6yITjPXjGzBuYOvrS9faBGOC7O9fpqmX5Xy7f8dBfy9mng
 4W1L3qFccftpYkJCdBlmtI7%2FPxHVcFc%3D%7Ctkp%
 3ABFBM4KTW17di&var=426386709738> [accessed 23
 October 2023].

5 *'a picture of girls' pants':* Claudia Hammond, *The Keys to
 Kindness* (Edinburgh: Canongate, 2022). p. 30

5 *'note to clothing manufacturers':* Julie Burchill, 'Why the
 "Be Kind" Era is Bad for Women', *Spiked* <https://www.
 spiked-online.com/2024/02/06/why-the-be-kind-era-is-bad-for-
 women/> [accessed 6 February 2024].

6 *In a 2023 blog post:* Rachel Hewitt, 'The Tyranny of "Nice"
 and "Kind"', In Her Nature by Rachel Hewitt <https://
 rachelhewitt.substack.com/p/the-tyranny-of-nice-and-kind?
 r=tb7l2&utm_campaign=post&utm_medium=web>
 [accessed 17 May 2023].

6 *'Until recently':* Burchill.

7 *'the demand that women be "nice"':* Helen Saxby, 'Why

Can't Women Just Be Nice?', Not The News in Briefs
<https://notthenewsinbriefs.wordpress.com/2020/04/20/
why-cant-women-just-be-nice/> [accessed 26 April 2023].

8 'human givers': Kate Manne, Down Girl: The Logic of
 Misogyny (Oxford: Oxford University Press, 2018). p. xix

8 'the most powerful white men': Ibid. p. 13

9 'focuses not on raising funds': 'Origin Story', The Love and
 Kindness Project Foundation <https://loveandkindness
 project.org/about-us/origin-story/> [accessed 26 May 2024].

9 'we believe that kindness': The Love and Kindness
 Project Foundation – Non Profit Foundation Site <https://
 loveandkindnessproject.org/> [accessed 26 May 2024].

10 'Don't be silly!': Juno Dawson, You Need To Chill (London:
 Fanshawe, 2022). pp. 29–30

10 'we believe in a pregnant person's right': The Love and
 Kindness Project Foundation – Non Profit Foundation Site.

13 'the caring ones': Paul Bloom, Against Empathy (London:
 The Bodley Head, 2016). p. 119

14 'the female ideal shifts very little': Tabitha Kenlon, Conduct
 Books and the History of the Ideal Woman (London:
 Anthem Press, 2020). p. 103

15 '"profeminist men"': Adrienne Rich, Of Woman Born:
 Motherhood as Experience and Institution (New York: W.
 W. Norton, 1986). p. 214

17 'I am not permeable': Marina Strinkovsky, 'Radfem
 Panic: When Demands for Inclusivity Are a Cover for
 Moral Disgust', It's Not a Zero Sum Game <https://
 notazerosumgame.blogspot.com/2014/09/radfem-
 panic-when-demands-for.html> [accessed 1 February 2024].

17 'feminism has always insisted': Judith Butler, Who's Afraid
 of Gender? (London: Penguin, 2024). p. 145

20 'one of the first tasks': Kathleen Lynch, Care and Capitalism
 (Cambridge: Polity Press, 2022). p. 3

22 'The myth of care': Marçal. p. 123

22 'the feminine mystique of domesticity': Naomi Wolf, The
 Beauty Myth (London: Vintage, 1990). p. 10

28 'the right and the left': Andrea Dworkin, 'Woman-Hating
 Right and Left', in Dorchen Leidholdt and Janice Raymond
 (eds), The Sexual Liberals and the Attack on Feminism
 (New York: Teachers College Press, 1990). p. 28

29 'felt no need to use the phrase': Sophie Lewis, Full Surrogacy
 Now: Feminism Against Family (London: Verso, 2021).

Chapter 1: What is Your Feminism Even For?

33 *Some people ask:* Chimamanda Ngozi Adichie, *We Should All Be Feminists* (London: 4th Estate, 2014). p. 41

33 *I believe it is negligent:* Julia Serano, *Whipping Girl: A Transsexual Woman on Sexism and the Scapegoating of Femininity* (New York: Seal Press, 2009). p. 6

34 *'There is no longer any expectation':* Julie Bindel, *Feminism for Women* (London: Constable, 2021). p. 17

34 *'I myself have never been able':* Rebecca West, *The Young Rebecca: Writings of Rebecca West 1911–17*, ed. Jane Marcus (New York: The Viking Press, 1982). p. 219

36 *Really depressing that now:* <https://twitter.com/HelenMcClory/status/1661693582955147265> [accessed 6 December 2023].

36 *I absolutely feel this:* <https://twitter.com/NinjaBookBox/status/1661701522709725185> [accessed 6 December 2023].

36 *'though all kinds of women are reviled':* Germaine Greer, *The Whole Woman* (London: Black Swan, 2007). Kindle location 4917

37 *'[A woman] is often understood perfectly well':* Manne. p. 23

38 *'it has become taboo':* Kajsa Ekis Ekman, trans. Kristina Mäki, *On the Meaning of Sex: Thoughts about the New Definition of Woman* (North Geelong: Spinifex Press, 2023). p. 234

38 *'Centring reproductive systems':* Quoted in Meghan Murphy, 'Munroe Bergdorf Would Like You to Please Keep Your Vaginas out of His Feminism', Feminist Current <https://www.feministcurrent.com/2018/02/27/munroe-bergdorf-like-please-keep-vaginas-feminism/> [accessed 7 December 2023].

39 *'isn't the reasonable idea':* Kathleen Stock, *Material Girls: Why Reality Matters For Feminism* (London: Fleet, 2021). p. 252

39 *'If somebody wants to join a feminist movement':* Yascha Mounk, *The Identity Trap: A Story of Ideas and Power in Our Time* (London: Allen Lane, 2023). p. 61

40 *'Is You Trans Allyship Half-Baked?':* Sam Dylan Finch, 'Is Your Trans Allyship Half-Baked? Here are 6 Mistakes that Trans Allies are Still Making', Everyday Feminism <https://

everydayfeminism.com/2015/06/6-common-mistakes-trans-allies/> [accessed 6 December 2023].

40 *'When Privilege Goes Pop'*: Jamie Utt, 'When Privilege Goes Pop: How Today's Mainstream Conversations on Privilege can Hurt Justice Movements', Everyday Feminism <https://everydayfeminism.com/2015/03/pop-culture-and-privilege/> [accessed 6 December 2023].

41 *'5 Ways to Avoid Common Ally Pitfalls'*: Jamie Utt, '5 Ways to Avoid Common Ally Pitfalls by Learning from Your Mistakes', Everyday Feminism <https://everydayfeminism.com/2016/02/learn-about-allyship-mistakes/> [accessed 6 December 2023].

41 *'the need to account for multiple grounds'*: Kimberlé Crenshaw, 'Mapping the Margins: Intersectionality, Identity Politics, and Violence against Women of Color', *Stanford Law Review*, 43:6 (1991) <https://doi.org/10.2307/1229039>. p. 1245

41 *'because women of color'*: Ibid. p. 1252

42 *'white middle-class women'*: Victoria Bateman, *Naked Feminism: Breaking the Cult of Female Modesty* (Cambridge: Polity Press, 2023). p. 204

42 *'prudishness'*: Ibid. p. 5

42 *'into good girls and whores'*: Ibid. p. 6

42 *'for simply stating the basics'*: Bindel, *Feminism for Women*. p. 16

42 *one study indicates;* Stewart Cunningham and others, 'Sex Work and Occupational Homicide: Analysis of a UK Murder Database', *Homicide Studies*, 22:3 (2018) <https://doi.org/10.1177/1088767918754306>.

43 *'Anything that might be thought'*: Kenlon. p. 114

44 *'the radical notion that women are people'*: Marie Shear, 'Celebrating Women's Words', *New Directions for Women*, 15:3 (1986) <https://jstor.org/stable/community.28041159>. p. 6

44 *'The problem'*: Janet Radcliffe Richards, *The Sceptical Feminist: A Philosophical Enquiry* (Abingdon: Routledge, 1980). p. 341

45 *'First and foremost'*: Laura Schwartz, 'Feminist Thinking on Education in Victorian England', *Oxford Review of Education*, 37:5 (2011) <http://www.jstor.org/stable/23119462>. p. 672

45 *'become the more'*: Josephine Butler, *The Education and*

Employment of Women (London: Macmillan and Co., 1868). p. 18

45–6 '*a means, a very great means*': Frances Power Cobbe, *The Duties of Women: A Course of Lectures* (Farmingdale, NY: Dabor Social Science Publications, 1978). p. 180

46 '*predominantly socially constructed*': Schwartz. p. 678

46 '*feminism evolved*': Sandra Kim, 'Why Everyday Feminism is for Everyone', Everyday Feminism <https://everydayfeminism.com/2012/07/feminism-is-for-everyone/> [accessed 29 May 2024].

46 '*because they were homemakers*': Barbara Ehrenreich and Deirdre English, *For Her Own Good: Two Centuries of the Experts Advice to Women* (New York: Anchor, 2005). p. 216

46 '*the truly scientific housekeeper*': Ibid. p. 217

47 '*the most self-assured*': Deborah Frances-White, *The Guilty Feminist* (London: Virago, 2018). p. 47

48 '*God, feminism is so serious*': Caitlin Moran, *How to Be a Woman* (London: Ebury, 2011). p. 12

48–9 '*The ironic misandrist*': Amanda Hess, 'Ironic Misandry: Why Feminists Joke about Drinking Male Tears and Banning All Men', *Slate* <https://slate.com/human-interest/2014/08/ironic-misandry-why-feminists-joke-about-drinking-male-tears-and-banning-all-men.html> [accessed 10 July 2023].

49 *one can still buy 'male tears' mugs:* 'Mediocre White Man Tears Mug, Funny Ceramic Novelty Coffee Mugs, Tea Cup Gift Present Mug for Christmas Thanksgiving Festival Friends', Amazon <https://www.amazon.co.uk/Mediocre-Ceramic-Christmas-Thanksgiving-Festival/dp/B095SSPGFM/ref=sr_1_2?crid=37CJANU3C1JXO&keywords=%22white+male+tears%22&qid=1702067963&sprefix=white+male+tears+%2Caps%2C74&sr=8-2> [accessed 8 December 2023].

49–50 '*while plenty of men's rights activists*': Rebecca Traister, *Good and Mad: The Revolutionary Power of Women's Anger* (New York: Simon & Schuster, 2018). Kindle location 513

50 '"*I love strong women*"': Gillian Flynn, *Gone Girl* (New York: Crown, 2012). p. 300

50 '*To become a feminist killjoy*': Sara Ahmed, '#KilljoySolidarity', Feministkilljoys <https://feministkilljoys.com/2023/03/06/killjoysolidarity/> [accessed 5 April 2023].

50 'brilliant [...] because feminism': Kira Cochrane, *All the Rebel Women: The Rise of the Fourth Wave of Feminism* (London: Guardian Books, 2013). Kindle location 809

51 'much sympathy with this sentiment': Sara Ahmed, 'Becoming Unsympathetic', Feministkilljoys <https://feministkilljoys.com/2015/04/16/becoming-unsympathetic/> [accessed 5 April 2023].

52 'cruelty to others': Amanda Marcotte, 'What Has Gotten into Republican Women?', *Salon* <https://www.salon.com/2023/05/08/what-has-gotten-into-women/> [accessed 17 May 2023].

53 'the connectedness of women': Gerda Lerner, *The Creation of Patriarchy* (New York: Oxford University Press, 1986). p. 218

53 'a political practice': Dworkin, 'Woman-Hating Right and Left'. p. 31

53 'Feminism ... has fought no wars': Dale Spender, *Women of Ideas* (London: Pandora Press, 1988).

54 'feminism is only for women and girls': Stock. p. 260

55 'a set of expectations': Angela Saini, *The Patriarchs: How Men Came to Rule* (London: 4th Estate, 2023). p. 104

55 'all funds raised in March': <https://twitter.com/WomensPrize/status/1630981798195757060?t=q-GWDNulfr23oTnL0s4bPw&s=09> [accessed 10 April 2023].

55 'empathy, social sensitivity': Helena Morrissey, *A Good Time to Be a Girl: Don't Lean In, Change the System* (Glasgow: William Collins, 2018). p. 59

55 'imperative that women reclaim': Elise Loehnen, *On Our Best Behaviour: The Price Women Pay to Be Good* (London: Bloomsbury, 2023). p. 45

55 'activities and values': Cynthia Eller, *The Myth of Matriarchal Prehistory: Why an Invented Past Won't Give Women a Future* (Boston: Beacon Press). p. 65

56 'As marginal beings': Mary Daly, *Beyond God the Father* (London: The Women's Press, 1986). p. 130

56 'My questions': Carol Gilligan, *In a Different Voice: Psychological Theory and Women's Development* (Cambridge, MA: Harvard University Press, 2003). p. xiii

57 'to hear the different voice': Carol Gilligan, *In a Human Voice* (Cambridge: Polity Press, 2023). p. 23

57 'that we know ourselves as separate': Gilligan, *In a Different Voice*. p. 63

57–8 *The moral imperative:* Ibid. p. 100

58 *'The thinking of women':* Ibid. p. 70

60 *'Wait, are you saying':* Zoe Williams, 'Kate Doesn't Want
 Prince George to Go to Eton – and for Once I Agree
 with Her', *Guardian* <https://www.theguardian.com/
 commentisfree/2024/jan/08/kate-doesnt-want-prince-george-
 to-go-to-eton-and-for-once-i-agree-with-her> [accessed 8
 January 2024].

60 *by a staggering degree:* 'Women and the Criminal Justice
 System 2021', Ministry of Justice <https://www.gov.uk/
 government/statistics/women-and-the-criminal-justice-
 system-2021/women-and-the-criminal-justice-system-
 2021#defendants> [accessed 8 January 2024].

Chapter 2: Kindsplaining

61 *The surest way to work up a crusade:* Aldous Huxley,
 introduction, 24 July 1933, to Samuel Butler, *Erewhon*
 (New York: Easton Press, 1934).

61 *You reject the very concepts:* <https://twitter.com/Another
 Brisket/status/1625843105105686529?t=QO0mcfSYR46QO
 WBdHrhirg&s=09> [accessed 10 April 2023].

63 *labour rights for strippers:* Julie Bindel, 'Billy Bragg is a
 Massive Misogynist', Julie Bindel's Writing and Podcasts
 <https://juliebindel.substack.com/p/billy-bragg-is-a-massive-
 misogynist> [accessed 13 December 2023].

65 *'he hadn't read':* Rebecca Solnit, 'Men Explain Things to
 Me', in *Men Explain Things to Me* (Chicago: Haymarket
 Books, 2014). pp. 3–4

65 *'wars on two fronts':* Ibid. pp. 10–11

67 *'Marriage equality is a threat':* Rebecca Solnit, 'In Praise
 of Threat: What Marriage Equality Really Means', in ibid.
 p. 65

68 *'If a category is removed':* Clare Chambers, *Intact: A
 Defence of the Unmodified Body* (London: Penguin, 2022).
 p. 125

70 *'we will allow you':* Dworkin, 'Woman-Hating Right and
 Left'. p. 29

71 *'protecting and advancing':* Arjee Javellana Restar and
 Kellan Baker, 'Attacks on Abortion and Gender-Affirming
 Care Dismiss Bodily Autonomy', *Seattle Times* <https://
 www.seattletimes.com/opinion/attacks-on-abortion-and-

gender-affirming-care-dismiss-bodily-autonomy/> [accessed 12 January 2024].

72–3 'Basic to the position': Anne Koedt, 'Lesbianism and Feminism', in Anne Koedt, Ellen Levine and Anita Rapone (eds), Radical Feminism (New York: Quadrangle, 1973). p. 248

73 'end goal of the feminist revolution': Shulamith Firestone, The Dialectic of Sex (New York: William Morrow and Company, 1970). pp. 11–12

73 'the oldest, most rigid': Ibid. p. 16

74 'unable to theorize': Chambers. p. 147

74 'those in need': Lynch. p. 38

75 'very successfully misappropriated': Bindel, Feminism for Women. p. 71

75–6 'liberals tend to be troubled': Musa al-Gharbi, 'How to Understand the Well-Being Gap between Liberals and Conservatives', American Affairs Journal <https://americanaffairsjournal.org/2023/03/how-to-understand-the-well-being-gap-between-liberals-and-conservatives/> [accessed 6 April 2023].

76 'absolutely believe in equality of opportunity': 'Alastair Campbell Debates Feminism with his Daughter: "I've Never, Ever Done Housework"', Grazia <https://graziadaily.co.uk/life/in-the-news/alastair-campbell-grace-campbell-feminism/> [accessed 17 May 2023].

76–7 'the interests of men': Lynch. p. 45

78 'love and affirmation': Yasmin Zenith, 'Defending the Indefensible', The Critic <https://thecritic.co.uk/defending-the-indefensible/> [accessed 5 April 2023].

78 'women's sex-based rights and protections': Home, Let Women Speak <https://www.letwomenspeak.org/> [accessed 11 August 2024].

79 'When you suggest': Helen Joyce, 'Joyce Activated, Issue 42', thehelenjoyce.com <https://www.thehelenjoyce.com/joyce-activated-issue-42/> [accessed 5 April 2023].

79 'we glimpsed the iron fist': Brendan O'Neill, 'The Shameful Persecution of Posie Parker in New Zealand', Spectator <https://www.spectator.co.uk/article/the-shameful-persecution-of-posie-parker-in-new-zealand/> [accessed 10 April 2023].

79 'Woman-hating … has been dressed': Bindel, Feminism for Women. p. 34

79 'in the UK, women's voices': Zenith.

80 'As a way of practicing equality': Andrea Dworkin, 'I Want
 a Twenty-Four-Hour Truce During Which There Is No
 Rape', in *Letters from a War Zone: Writings 1976–1989*
 (Chicago: Lawrence Hill Books, 1993), via <http://www.
 nostatusquo.com/ACLU/dworkin/WarZoneChaptIIIE.html>
 [accessed 23 April 2023].

80 'feminism is not a set of rules': Laurie Penny, *Unspeakable
 Things* (London: Bloomsbury, 2014). p. 16

81 'spiteful, toxic political personality': <https://x.com/
 IanDunt/status/1797529676174561757> [accessed 3 June
 2024].

82 'all the responsibility for love and caring': Ehrenreich and
 English. p. 394

Chapter 3: Natural Born Givers

83 *We have to face the fact*: Meredith Tax, 'Woman and Her
 Mind: The Story of Everyday Life', in Koedt, Levine and
 Rapone. p. 26

83 *It is literally impossible to be a woman*: Emily Burack,
 'Read America Ferrera's Full Barbie Movie Monologue',
 Town & Country <https://www.townandcountrymag.com/
 leisure/arts-and-culture/a44725030/america-ferrera-barbie-
 full-monologue-transcript/> [accessed 20 December 2023].

84 *I did not want her to be compliant*: Marianne Grabrucker,
 trans. Wendy Phillipson, *There's a Good Girl: Gender
 Stereotyping in the First Three Years of Life: A Diary*
 (London: The Women's Press, 1988). p. 7

84 'building brick by brick': Ibid. p. 10

85 'the selective perception': Ibid. p. 50

86 'ridiculous stories': Mary Wollstonecraft, *A Vindication
 of the Rights of Men and A Vindication of the Rights of
 Woman* (Cambridge: Cambridge University Press, 1999).
 p. 114

86 'chastised more severely': Robin Lakoff, 'Language and
 Woman's Place', *Language in Society*, 2:1 (1973) <http://
 www.jstor.org/stable/4166707>. pp. 50–1

86 'whether or not women have': Deborah Cameron, *The
 Myth of Mars and Venus* (Oxford: Oxford University Press,
 2007). p. 140

86 'comparing both diaries': Ros Ball and James Millar, *The
 Gender Agenda: A First-Hand Account of How Girls and*

Boys Are Treated Differently (London: Jessica Kingsley, 2017). p. 10

86 *'feminine-coded goods and services'*: Manne. p. 130

87 *'the system is rigged'*: Burack.

87 *'the figure that the human female takes on'*: Simone de Beauvoir, *The Second Sex* (London: Picador, 1988). p. 295

88 *'what is now called the nature of women'*: John Stuart Mill, *The Subjection of Women* (London: Longmans, Green, Reader, and Dyer, 1870). p. 39

88 *feminists have not relied on*: Hammond. p. 30

89 *'There would be little need'*: Jane Clare Jones, *The Annals of the TERF-Wars and Other Writing* (Willingdon: Radical Notion Books, 2022). p. 59

89 *girls were no more liberated*: Cordelia Fine, *Delusions of Gender* (London: Icon Books, 2010). p. 208

89 *'economically relevant'*: Marçal. p. 30

91 *'Instead of being goal oriented'*: John Gray, *Men are from Mars, Women are from Venus* (London: Harper Element, 2021). p. 20

91 *'Society needs both'*: Simon Baron-Cohen, *The Essential Difference* (London: Penguin, 2004). p. 185

92 *'things such as gadgets'*: Ibid. pp. 98–9

93 *'that women have a natural vocation'*: Cameron. p. 11

93 *'any psychic operation'*: Chu. p. 14

94 *'No form of gender equity'*: Serano. p. 6

94 *'Stop Using Phony Science'*: Simón(e) D. Sun, 'Stop Using Phony Science to Justify Transphobia', *Scientific American* Blog Network <https://blogs.scientificamerican.com/voices/stop-using-phony-science-to-justify-transphobia/> [accessed 15 June 2023].

94 *'Here's Why Human Sex'*: Agustín Fuentes, 'Here's Why Human Sex is Not Binary', *Scientific American* <https://www.scientificamerican.com/article/heres-why-human-sex-is-not-binary/> [accessed 15 June 2023].

95 *'tell us everything'*: Ibid.

95 *'recognition that expected feminine social roles'*: Stock. p. 173

95 *'half in a hothouse environment'*: Mill. p. 39

95 *'certain aspects of femininity'*: Serano. p. 6

95 *'a foundational text'*: 'Whipping Girl Second Edition is Out this Week!', Whipping Girl <https://juliaserano.blogspot.com/2016/03/whipping-girl-second-edition-is-out.html> [accessed 25 March 2024].

95 *twice as much unpaid care work:* 'Why the Majority of the World's Poor Are Women', Oxfam International <https://www.oxfam.org/en/why-majority-worlds-poor-are-women> [accessed 2 December 2023].

Chapter 4: Sexual Kindsploitation

103 *Instead of being physically violated:* Daly. p. 123
103 *Women are there:* John Berger, *Ways of Seeing* (London: Penguin, 2008). p. 55
104 *'most refusals do not even':* Cameron. p. 94
104 *'some "misunderstandings" are tactical':* Ibid. p. 89
105 *'consent is sexy':* 'Consent is Sexy and Sexy is Mandatory', A Room of Our Own <https://www.aroomofourown.org/consent-is-sexy-and-sexy-is-mandatory/> [accessed 23 May 2023].
105 *'an endless round of miserable promiscuity':* Mary Harrington, *Feminism Against Progress* (London: Forum, 2023). p. 64
106 *'shy and socially awkward':* Abe Asher, '"It's Manipulative": Parents Defend Girl Who Turned Down Classmate with Autism's Valentine's Day Request', *Independent* <https://www.independent.co.uk/life-style/tiktok-autism-crush-rejected-valentines-day-b2293106.html#Echobox=1677230506> [accessed 10 April 2023].
107 *'resort to railing violently':* Laura Bates, *Men Who Hate Women* (London: Simon & Schuster, 2020). p. 26
107 *'the problem with the incel community':* Samantha Cole, '"Redistributing Sex" is a Toxic Conversation about Toxic People', *Vice* <https://www.vice.com/en/article/evqy3j/what-are-incels-redistributing-sex-new-york-times-ross-douthat> [accessed 29 May 2023].
108 *'boys are being "triggered"':* Sian Griffiths, 'Why MeToo Fallout Is Wrecking the Lives of Schoolboys', *The Times* <https://www.thetimes.co.uk/article/why-metoo-fallout-is-wrecking-the-lives-of-schoolboys-lkblpkw35> [accessed 10 April 2023].
109 *'the power to dominate men':* Andrea Dworkin, *Intercourse* (New York: Basic Books, 2008). p. 18
109 *'the cliché of White Feminism':* Phoebe Maltz Bovy, *The Perils of 'Privilege': Why Injustice Can't be Solved by Accusing Others of Advantage* (New York: St Martin's Press, 2017). p. 182

109 'Why Modern Feminism': Ibid. p. 183

110 'require an amount of tact': Kristen Roupenian, 'Cat
 Person', New Yorker <https://www.newyorker.com/
 magazine/2017/12/11/cat-person> [accessed 26 May 2024].

110 Amia Srinivasan's essay: Amia Srinivasan, 'Does Anyone
 Have the Right to Sex?', London Review of Books <https://
 www.lrb.co.uk/the-paper/v40/n06/amia-srinivasan/does-
 anyone-have-the-right-to-sex> [accessed 15 August 2023].

111 'galling': Ibid.

112 'no one really wants': Ibid.

112 something which Gavin de Becker explores: Gavin de
 Becker, The Gift of Fear: Survival Signals That Protect Us
 from Violence (Gavin de Becker, 2010). p. 66

112 'the flow of sympathy': Manne. p. 23

113 'a perfectly bred specimen': Srinivasan, 'The Conspiracy
 Against Men', in The Right to Sex (London: Bloomsbury,
 2021). p. 7

114 'Overcoming the Cotton Ceiling': 'In January of 2012,
 Planned . . .', Planned Parenthood Toronto, Facebook
 <https://www.facebook.com/PPToronto/posts/in-january-
 of-2012-planned-parenthood-toronto-in-partnership-with-
 other-local-pr/10150615471958021/> [accessed 19 January
 2024].

114 'if you were to say': Caroline Lowbridge, 'The Lesbians
 Who Feel Pressured to Have Sex and Relationships with
 Trans Women', BBC News <https://www.bbc.co.uk/news/
 uk-england-57853385> [accessed 16 January 2024].

114 drew widespread condemnation: Jim Waterson, 'BBC
 Rejects Complaints that it Published Transphobic Article',
 Guardian <https://www.theguardian.com/media/2021/
 nov/01/bbc-rejects-complaints-that-it-published-transphobic-
 article> [accessed 7 June 2024].

114 'someone saying they would rather kill me', 'after repeatedly
 explaining': Lowbridge.

115 'often face sexual exclusion': Srinivasan, 'Does Anyone
 Have a Right to Sex?'

116 'There is no entitlement to sex': Ibid.

117 'anti-porn feminists': Srinivasan, 'Talking to My Students
 About Porn', in The Right to Sex. p. 66

118 'strangulation, gagging, binding': Helen Rumbelow,
 'I'm Watching What the Kids Are Watching: Porn. It's
 Disturbing', The Times <https://www.thetimes.co.uk/article/

a2da8e10-ee6f-11ed-87b0-716b9284a2b0?shareToken=85e1
04ce2ebacdbabb1dc8efe494027b> [accessed 17 May 2023].

119 '*pornhub.com forward slash*': Polly Barton, *Porn: An Oral History* (London: Fitzcarraldo Editions, 2023). p. 149

119 '*One of the pros*': Ibid. p. 155

119 '*criticism of pornography*': Ibid. p. 125

119 '*Dworkinian position*': Ibid.

119 '*to square the positive*': Ibid. p. 126

120 '*sincere, sound, and persuasive*': John Maier, 'Why Do Progressives Watch Porn?', *UnHerd* <https://unherd.com/2023/03/why-do-progressives-watch-porn/> [accessed 10 April 2023].

121 '*for men, physical prowess*': Kenlon. p. 38

122 '*getting fucked makes you female*': Chu. p. 60

122 '*to be femme*': Maggie Nelson, *The Argonauts* (London: Melville House, 2015). pp. 39, 9

122 '"*Nature*" ... *slowly replaced religion*': Kenlon. p. 157

124 '*a passive partner*': Lili Loofbourow, 'The Female Price of Male Pleasure', *The Week* <https://theweek.com/articles/749978/female-price-male-pleasure> [accessed 14 June 2023].

125 '*defined as freely available*': Lynch. p. 42

Chapter 5: Emotional JustBeKindism

126 *Men expect women:* Valerie Solanas, *The SCUM Manifesto* (Washington, DC: Elektron Ebooks/Olympia Press, 2013). Kindle location 134

126 *The poet, the mystic:* Andrea Dworkin, *Pornography: Men Possesing Women* (London: Penguin, 1989). p. 81

126 '*Dear President Vladimir Putin*': Georgia Aspinall, 'Are We Seriously Blaming Putin's Mother for His Invasion of Ukraine?', *Grazia* <https://graziadaily.co.uk/life/in-the-news/annalynne-mccord-vladimir-putin-poem/> [accessed 4 August 2023].

128 '*we've been neglecting our boys*': <https://www.tiktok.com/@bbcradio2/video/7250759705709006107> [accessed 13 August 2023].

128 '*today it is girls*': Steve Biddulph, *Raising Girls* (London: Harper Thorsons, 2013).

129–30 '*Woman's kingdom of emotion*': Marçal. p. 119

130 '*the wish is the mother*': Janet Radcliffe Richards. p 164

131 *And I'm sorry:* Dworkin, 'I Want a Twenty-Four-Hour Truce During Which There Is No Rape'.
132 *'increasingly aware that their disorders':* Rich. p. 124
133 *'fight for men':* Frances-White. p. 243
133 *'the resurgent energy':* Loehnen. p. 46
133 *'we don't let boys express':* Gina Martin, *No Offence, But . . .: How to Have Difficult Conversations for Meaningful Change* (London: Transworld, 2023). p. 19
133 *'discouraged from displaying their feelings':* Frances-White. p. 242
133 *'We are in a crisis of toxic masculinity':* Loehnen. p. 312
134 *'gender expectations and norms':* Ruth Whippman, *Boymum: Raising Boys in the Age of Toxic Masculinity* (London: Quercus, 2024). p. 8
134 *locating boys at the G.I. Joe end of a spectrum:* 'The Barbie-GI Joe Scale', Butterflies and Wheels <https://www.butterfliesandwheels.org/2019/the-barbie-gi-joe-scale/> [accessed 9 June 2024].
134 *'go on doing for men':* Rich. p. 214
135 *'little research into the impact':* Pragya Agarwal, *Hysterical: Exploding the Myth of Gendered Emotions* (Edinburgh: Canongate, 2022). p. 67
135 *less likely to hurt others:* 'The Nature of Violent Crime in England and Wales: Year Ending March 2020', Office for National Statistics <https://www.ons.gov.uk/peoplepopulationandcommunity/crimeandjustice/articles/thenatureofviolentcrimeinenglandandwales/yearendingmarch2020> [accessed 5 January 2022].
135 *male suicide rates:* Aislinné Freeman, Roland Mergl, Elisabeth Kohls et al., 'A Cross-National Study on Gender Differences in Suicide Intent', *BMC Psychiatry*, 17 (2017).
136 *'make up for the world':* Ehrenreich and English. p. 394
136 *'a few white European men':* Penny. p. 69
136 *'to make up for their lack':* Ibid. p. 70
136 *'a sop':* Ibid. p. 75
137 *'are frequently shamed':* Jenny Lindsay, *Hounded: Women, Harms and the Gender Wars* (Cambridge: Polity Press, 2024). p. 28
138 *'prior history of mental illness':* Colin Barrett, 'He Had His Reasons', *Granta* <https://granta.com/he-had-his-reasons/> [accessed 9 November 2024].
138 *'how different it could be':* 'The Men Who Transform into

Living Latex Female Dolls', *Vice* <https://www.vice.com/en/article/zn8e5j/living-dolls-female-masking-vice-intl?utm_source=vicetwitterus> [accessed 10 April 2023].

139 *boys are twice as likely:* 'Child Physical Abuse in England and Wales: Year Ending March 2019', Office for National Statistics <https://www.ons.gov.uk/peoplepopulationandcommunity/crimeandjustice/articles/childphysicalabuseinenglandandwales/yearendingmarch2019> [accessed 9 February 2024].

138 *girls comprise 80 per cent:* 'Child Sexual Abuse in England and Wales: Year Ending March 2019', Office for National Statistics <https://www.ons.gov.uk/peoplepopulationandcommunity/crimeandjustice/articles/childsexualabuseinenglandandwales/yearendingmarch2019> [accessed 2 February 2024].

139 *'harsh realities':* Kenlon. p. 163

140 *'has sanded her personality down':* Chu. pp. 26–7

142 *'to negotiate the vulnerability':* Jones, *The Annals of the TERF-Wars and Other Writing.* p. 58

142 *'the labour that women take on':* Angelica Ferrara and Dylan Vergara, 'Theorizing Mankeeping: The Male Friendship Recession and Women's Associated Labour as a Structural Component of Gender Inequality', *Psychology of Men & Masculinities,* 25:4 (2024). pp. 391–401

142 *'as usual, muggins here':* Caitlin Moran, *What About Men?* (London: Ebury, 2023). p. 272

143 *'We infantilize men':* Rich. pp. 215–16

Chapter 6: Reproductive JustBeKindism

144 *... in a very real sense:* Mary O'Brien, *The Politics of Reproduction* (London: Routledge & Kegan Paul, 1981). p. 60

144 *Women's reality is not:* Barbara Katz Rothman, *Recreating Motherhood: Ideology and Technology in a Patriarchal Society* (New York: W. W. Norton, 1989). p. 27

145 *'only passive matter':* de Beauvoir. p. 40

145–6 *'convincing women that the child':* Helen Gibson, 'Miriam Cates is Right about Surrogacy', *The Critic* <https://thecritic.co.uk/miriam-cates-is-right-about-surrogacy/> [accessed 9 February 2024].

147 *'is to make nonsense':* O'Brien. p. 49

147 '*Man's nullity as a parent*': Gena Corea, *The Mother Machine: Reproductive Technologies from Artificial Imsemination to Artificial Wombs* (New York: Perrennial Library, 1986). p. 288

148 '*come to the same conclusion*': Rothman. p. 248

149 '*trans-exclusionary*': Lewis. p. 10

150 '*If she had been serene*': Jeanette Winterson, *Oranges Are Not The Only Fruit* (London: Vintage, 1991). p. 166

151 '*half in a hothouse environment*': Mill. p. 39

153 '*the mother/child relationship*': bell hooks, 'Revolutionary parenting', in Andrea O'Reilly (ed.), *Maternal Theory: Essential Readings* (Bradford, ON: Demeter Press, 2007). p. 256

153 '*willingness to glorify*': Ibid, p. 257

154 '*The "good father"*': O'Brien. p. 57

155 '*it was not until 1886*': Corea. p. 288

156 '*men's participation in nurture*': O'Brien. pp. 56–7

156 '*it is possible*': Tania Modleski, *Feminism Without Women: Culture and Criticism in a 'Postfeminist' Age* (London: Routledge, 1991). pp. 82, 88–9

158 '*abortion, contraception*': <https://x.com/reproforall/status/1774454150530490735?t=6-a9bcJSBAwDvW1h8BKyXA&s=19> [accessed 12 June 2024].

158–9 '*must encompass the full range*': Dorothy Roberts, *Killing the Black Body: Race, Reproduction, and the Meaning of Liberty* (New York: Pantheon Books, 1997). p. 6

159 *a $14 billion industry*: David Kaufman, 'The Fight for Fertility Equality', *New York Times* <https://www.nytimes.com/2020/07/22/style/lgbtq-fertility-surrogacy-coverage.html> [accessed 29 August 2023].

160 '*We are Expected to be OK*': Jenny Kleeman, '"We are Expected to be OK with Not Having Children": How Gay Parenthood through Surrogacy Became a Battleground', *Guardian* <https://www.theguardian.com/lifeandstyle/2022/oct/01/how-gay-parenthood-through-surrogacy-became-a-battleground> [accessed 25 August 2023].

160 '*Patriarchal man*': Rich. p. 120

161 '*The women are referred to*': Corea. p. 222

161 '*to think of their wombs*': Arlie Russell Hochschild, *The Outsourced Self* (New York: Metropolitan Books, 2012). p. 99

161 '*To get paid*': Ibid. p. 98

162–3 'it is a means by which': Katha Pollitt, 'The Strange Case of Baby M', *The Nation* <https://www.thenation.com/article/archive/strange-case-baby-m/> [accessed 25 August 2023].

163 'disgust and paranoia': Lewis. p. 39

164 'the very pinnacle': Ibid. p. 48

164 'an insight into the lives': *Facelift*, series 1, episode 1, BBC iPlayer <https://www.bbc.co.uk/iplayer/episode/p0f7f5fy/facelift-series-1-episode-1> [accessed 14 April 2023].

165 'the most kind human being': Heather Greenaway, 'Our Angel Is Exactly What the Doctor Ordered', *Sunday Mail*, 26 March 2023.

165 'the surrogate is not genetically related': Ibid.

165 'extreme babysitting': <https://twitter.com/BrillBeginnings/status/1195769480066023429> [accessed 7 February 2024].

165 campaigns to liberalise surrogacy: 'Surrogacy Law Reform: WPUK Meet with Law Commissions', Woman's Place UK <https://womansplaceuk.org/2023/11/15/surrogacy-law-reform-wpuk-meet-with-law-commissions/> [accessed 9 February 2024].

165 barbarity of unregulated surrogacy: Stephanie Hegarty and Eleanor Layhe, 'Ukraine: Impossible Choices for Surrogate Mothers and Parents', BBC News <https://www.bbc.co.uk/news/world-europe-60824936> [accessed 7 February 2024].

167 'like unwanted and egregious Amazon packaging': Marina Strinkovsky, 'From the Ashes of Every Woman, an Everywoman', The Radical Notion <https://theradicalnotion.org/from-the-ashes-of-every-woman-an-everywoman/> [accessed 20 August 2021].

168 90 per cent of single parents: 'Economic Challenges for Single Mothers', Office for National Statistics <https://bit.ly/3mbCkKg> [accessed 7 February 2024].

168 'the existence of unstigmatized mothers': Martha Albertson Fineman, *The Neutered Mother, the Sexual Family and Other Twentieth Century Tragedies* (London: Routledge, 1995). p. 101

168 'deviant simply because it represents': Ibid. pp. 147–8

168–9 'How can you ask': Kazuo Ishiguro, *Never Let Me Go* (London: Faber and Faber, 2005). p. 258

169 'they tried to convince': Ibid.

7: A Male Ally Walks into a Bar

173 *Self is incrementally expanded:* Dworkin, *Pornography.* p. 40

173 *'some kind of debased':* Ian Crouch, '"This is the Future That Liberals Want" is the Joke that Liberals Need', *New Yorker* <https://www.newyorker.com/culture/culture-desk/this-is-the-joke-that-liberals-need> [accessed 19 December 2023].

174 *'awesome!':* <https://twitter.com/TiernanDouieb/status/837084728469651456> [accessed 19 December 2023].

174 Buzzfeed *ranked the image third:* Julia Reinstein, '38 Great Memes that Defined 2017', BuzzFeed News <https://www.buzzfeednews.com/article/juliareinstein/nothing-but-respect-for-my-2017-memes> [accessed 23 December 2023].

174 *'I won't speak for all liberals':* Julia Reinstein, 'This Far-Right Tweet About "The Future That Liberals Want" Backfired into a Huge Meme', BuzzFeed News <https://www.buzzfeednews.com/article/juliareinstein/this-is-the-future-liberals-want#.wsz5LznN1q> [accessed 23 December 2023].

175 *'What you see':* Bloom. p. 87

177 *'one-boy tornado':* Emma Powys Maurice, 'John Lewis' Joyful New Ad Lets Young Boy Embrace His Inner Stevie Nicks', *PinkNews* <https://www.thepinknews.com/2021/10/13/john-lewis-home-insurance-ad-stevie-nicks/> [accessed 5 January 2024].

177 *'The star of the ad':* Victoria Richards, 'The New John Lewis Advert is a Glorious Antidote to Toxic "Boys Will Be Boys" Messaging', *Independent* <https://www.independent.co.uk/voices/john-lewis-advert-toxic-masculinity-b1938930.html> [accessed 3 November 2023].

177 *'attacked as everything':* Kevin Rawlinson and agency, 'John Lewis Pulls Controversial Advert for Being "Potentially Misleading"', *Guardian*, 27 October 2021 <https://www.theguardian.com/business/2021/oct/27/john-lewis-pulls-controversial-advert-for-being-potentially-misleading> [accessed 1 May 2024].

178 *'Schorschi's father made fun of her':* Grabrucker. p. 150

178 *'we don't discuss the problem':* Ibid. p. 152

178 *'"He's just going through a phase"':* Soraya Chemaly, *Rage*

Becomes Her: The Power of Women's Anger (London: Simon & Schuster, 2018). p. 1

178 *'They were perfectly content'*: Ibid. p. 3

179 *helping to combat them:* Victoria Richards.

179 *'differing roles are not'*: Ekman. p. 261

180 *'expressions of vulnerability'*: Shani Orgad and Rosalind Gill, *Confidence Culture* (Durham, NC: Duke University Press, 2022). p. 74

180 *'capitalize on symbolic sexual boundaries'*: Tristan Bridges, 'A Very "Gay" Straight?: Hybrid Masculinities, Sexual Aesthetics, and the Changing Relationship between Masculinity and Homophobia', *Gender and Society*, 28:1 (2014) <http://www.jstor.org/stable/43669856>. pp. 73, 78

181 *'quite common for well-educated'*: Lynch. p. 44

181 *'borrowing some "soft" female symbols'*: Ibid. p. 50

181–2 *'feel a whole range of feelings'*: Dworkin, *Intercourse*. Kindle location 318

183 *'are not fixed by biology'*: Freddie deBoer, 'I Think You Should Be Kind' <https://freddiedeboer.substack.com/p/i-think-you-should-be-kind> [accessed 10 February 2024].

183 *'a controversy without a problem'*: Ibid.

184 *'by 30 March 2024'*: Reem Alsalem, 'Report of the Special Rapporteur on Violence against Women and Girls, its Causes and Consequences: Violence against Women and Girls in Sports', United Nations General Assembly, Seventy-Ninth Session: Item 27, 27 August 2024 <https://documents.un.org/doc/undoc/gen/n24/249/94/pdf/n2424994.pdf> [accessed 9 November 2024].

184 *As Grabrucker pointed out:* Grabrucker. p. 152

185 *They're coming!*: Jonathan Liew, 'Why the Arguments against Trans, Intersex and DSD Athletes are Based on Prejudice and Ignorance', *Independent* <https://www.independent.co.uk/sport/general/athletics/caster-semenya-news-gender-martina-navratilova-trans-cas-jonathan-liew-column-a8792861.html> [accessed 11 September 2023].

187 *'Here instead is a woman'*: Lucy Ward, 'Pure Joy and a Sports Bra: The Photo that Encapsulates England Women's Euros Win', *Guardian* <https://www.theguardian.com/commentisfree/2022/aug/01/sports-bra-photo-england-womens-euros-win-chloe-kelly-goal-celebration> [accessed 10 February 2024].

187 *'in reaction to the burgeoning success'*: Rachel Hewitt, *In Her Nature* (London: Chatto & Windus, 2023). p. 255
187 *'above all to crown'*: Ibid. p. 260
187 *'Key to sport's capacity'*: Ibid. p. 259
188 *'expected to demonstrate'*: Carrie Dunn, *Woman Up: Pitches, Pay and Periods – The Progress and Potential of Women's Football* (London: Hero, 2023). p. 139
188 *'are hailed and praised'*: Ibid. p. 140
188 *a fifty-year ban:* '100 Years since the Women's Football Ban – What Has Changed?', BBC *Newsround* <https://www.bbc.co.uk/newsround/59532731> [accessed 13 June 2024].
189 *US Rowing's 2023 trans inclusion policy:* 'USRowing's New Gender-Identity Policy Sparks Controversy', *Rowing News* <https://www.rowingnews.com/2023/02/04/usrowings-new-gender-identity-policy-sparks-controversy/> [accessed 11 September 2023].
189 *'this policy destroys'*: Ibid.
190 *'allowed radical feminists'*: Susan Carpenter McMillan, 'Conservative, Feminist and Proud: Our Foremothers Believed in the True Equality of Women, While Honoring Their Uniqueness, and in the Value of All Life', *Los Angeles Times* <https://www.latimes.com/archives/la-xpm-1993-10-27-me-50062-story.html> [accessed 10 February 2024].
190 *'people who bleed across Wales'*: Abbie Wightwick, 'A Campaign about Periods Has Been Criticised for Using the Phrase "People Who Bleed" Instead of Women or Girls', WalesOnline <https://www.walesonline.co.uk/news/health/campaign-periods-been-criticised-using-24728418> [accessed 10 February 2024].
190 *'is the Subject'*: de Beauvoir. p. 16
190 *'not once have I ever'*: deBoer.
191 *'a good-hearted woman'*: Greer. p. 92
191 *'ova don't make a woman'*: Fuentes.
192 *'Surely womanhood'*: Kenny Farquharson, 'How the Trans Row Will End in Compromise', *The Times* <https://www.thetimes.co.uk/article/how-the-trans-row-will-end-in-compromise-z8qs5vvhw> [accessed 15 November 2023].
192 *'the self is hollowed out'*: Chu. p. 13
192 *'a woman cannot say'*: Ekman. p. 260
193 *'we will wonder'*: Farquharson.
193 *'an irrational fear'*: Liew.

193–4 '*a movement committed*': Jane Clare Jones, 'Gay Rights
 and Trans Rights – A Compare and Contrast' <https://
 janeclarejones.com/2018/09/09/gay-rights-and-trans-rights-
 a-compare-and-contrast/> [accessed 4 May 2023].

194 '*the most vulnerable*': Hansard, House of Lords, 11 January
 2010 (Pt 0015) <https://publications.parliament.uk/pa/
 ld200910/ldhansrd/text/100111-0015.htm> [accessed 10
 April 2023].

196 *hereditary peerages in the UK:* Sam Leith, 'Should a Trans
 Woman Inherit a Peerage over Their Older Sister?', *Spectator*
 <https://www.spectator.co.uk/article/should-a-trans-woman-
 inherit-a-peerage-over-their-older-sister/> [accessed 11
 September 2023].

197 '*the burden of change*': Liew.

Chapter 8: Boundaries are for Bigots

198 *It is very tempting:* Judith Herman, *Trauma And Recovery*
 (New York: Basic Books, 2015). pp. 7–8

198 *So once again:* Grabrucker. p. 150

198–9 '*There are many ancient variations*': Mary Beard, *Women
 and Power* (London: Profile Books, 2017). Kindle location
 427

200 '*Feminism … has always been*': Frances-White. p. 25

200 *As Kajsa Ekis Ekman has pointed out:* Ekman. p. 311

203 '*a feminism that isn't inclusive*': Amia Srinivasan, 'What Is
 a Woman?', in Suki Finn (ed.), *Women of Ideas: Interviews
 from Philosophy Bites* (Oxford: Oxford University Press,
 2021). p. 10

204 '*a misogynist's dream*': Sarah Ditum, 'How "TERF"
 Works', Feminist Current <https://www.feministcurrent.
 com/2014/07/29/how-terf-works/> [accessed 16 February
 2024].

205 '*have misunderstood and distorted*': Judith Butler, *Who's
 Afraid of Gender?*. p. 142

205 '*For better or worse*': Ibid. p. 137

206 '*dress however you please*': <https://x.com/jk_rowling/
 status/1207646162813100033> [accessed 13 June 2024].

206 '*the critique of the gender binary*': Judith Butler, *Who's
 Afraid of Gender?*. p. 141

207 '*one puzzle for Butler's account*': Chambers. p. 122

207 '*bad writing award*': 'The World's Worst Writing', *Guardian*

<https://www.theguardian.com/books/1999/dec/24/news>
[accessed 28 September 2024].

208 'human by a standard': Dworkin, Intercourse. p. 154

208 'What constitutes through division': Judith Butler, Gender Trouble (New York: Routledge, 1990). p. 170

208 'for inner and outer worlds': Ibid.

209 'when TERFs claim their gender': Judith Butler, Who's Afraid of Gender?. p. 143

209–10 'Like Trump, Orbán, Meloni: Ibid. p. 145

210 'trans-exclusionary feminists maintain': Ibid.

210 'fixation': Lewis. p. 53

210 'trans-exclusionary and anti-sex-work feminism': Alison Phipps, Me, Not You: The Trouble with Mainstream Feminism (Manchester: Manchester University Press, 2021). Kindle location 1647

210–11 'centres race, giving an additional reading': Ibid. Kindle location 107

211 proved to be its most controversial: 'Classic Review – Against Our Will', Trouble & Strife, 35 (1997) <https://www.troubleandstrife.org/articles/issue-35/classic-review-against-our-will/> [accessed 13 February 2024].

211 'is based on the concept of political whiteness': Phipps. Kindle location 118

212 'hoarding and defending resources': Ibid. Kindle location 276

212–13 '"Taking our country back"': Ibid. Kindle location 351

213 'the white and bourgeois rape victim': Ibid. Kindle location 440

213 'White feminist narcissism', 'the power of "white tears"': Ibid. Kindle locations 802, 876

213 'the white man's image of her': Catharine MacKinnon, 'From Practice to Theory, or What is a White Woman Anyway?', Yale Journal of Law and Feminism, 4:13 (1991). pp. 18–19

214 'instead, we ask the "Angry Dad"': Phipps. Kindle location 983

214 'is to deny that women': Jane Clare Jones, 'Why Feminists Are Not Nazis' <https://janeclarejones.com/2019/10/31/why-feminists-are-not-nazis/> [accessed 9 September 2023].

214 used in 'inclusion' training: Danyal Hussain and Rory Tingle, 'Oxfam Staff Training Document Blames "Privileged White Women"', MailOnline <https://www.dailymail.co.uk/news/article-9671555/Oxfam-staff-training-document-blames-privileged-white-women.html> [accessed 26 March 2024].

214 *'Mainstream feminist activism'*: Phipps. Kindle location 892
214 *'the systematic privileging'*: Ibid. Kindle location 996
215 *'sexual violence happens to bigoted people'*: '265. Creating Our Own World with Kemah Bob and Mridul Wadhwa', *Guilty Feminist* <https://guiltyfeminist.com/episode/?episode=321> [accessed 19 May 2023].
215 *'had to really wash and clean'*: Jean Hatchet, 'Unclean', *The Critic* <https://thecritic.co.uk/unclean/> [accessed 14 February 2024].
215 *'horrific connotations'*: Ibid.
216 *'women built Rape Crisis'*: Ibid.
216 *'often enjoys higher status'*: Herman. p. 219
217 *'female Trump supporters'*: Charlotte Kilpatrick, 'Reactions to Trump's Trial Show the Limits of MeToo', *Prospect* <https://www.prospectmagazine.co.uk/world/61378/maga-trump-sexual-abuse-metoo-carroll> [accessed 16 May 2023].
217 *the vast majority of rapists are male:* 'Sexual Offences in England and Wales: Year Ending March 2017', Office for National Statistics <https://www.ons.gov.uk/peoplepopulationandcommunity/crimeandjustice/articles/sexualoffencesinenglandandwales/yearendingmarch2017> [accessed 14 February 2024].
217 *'most of the time "women's space"'*: Adrian Ballou, 'Why the End of Michfest is Good for Feminism: Two Activists Weigh In', Everyday Feminism <https://everydayfeminism.com/2015/07/end-michfest-good-for-feminism/> [accessed 6 December 2023].
218 *'reframe their trauma'*: Josephine Bartosch, '"Reframe Your Trauma"', *The Critic* <https://thecritic.co.uk/reframe-your-trauma/> [accessed 14 February 2024].
218 *saw her essential surgery cancelled:* Jean Hatchet, 'Over My Dead Body', *The Critic* <https://thecritic.co.uk/over-my-dead-body/> [accessed 15 February 2024].
218 *Dead rats have been pinned:* Luba Fein, 'Vancouver Rape Relief and Women's Shelter', FiLiA <https://www.filia.org.uk/latest-news/2020/4/21/vancouver-rape-relief-and-womens-shelter> [accessed 14 February 2024].
218 *A Brighton-based survivor:* Quoted in Hadley Freeman, 'Why I'm Suing Survivors' Network', *UnHerd* <https://unherd.com/2022/07/why-im-suing-survivors-network/> [accessed 15 February 2024].

219 *issued a statement:* 'Discrimination Against Women in the
 Name of Inclusion: A Statement From Vancouver Rape Relief
 and Women's Shelter', Vancouver Rape Relief & Women's
 Shelter <https://rapereliefshelter.bc.ca/discrimination-against-
 women-in-the-name-of-inclusion-a-statement-from-
 vancouver-rape-relief-and-womens-shelter/> [accessed 2 June
 2024].
219 *'black people don't commit':* Quoted in Freeman, 'Why I'm
 Suing Survivors' Network'.
219 *'screaming harpies who dared':* Kilpatrick.
219 *'violent crimes are real':* Judith Butler, *Who's Afraid of
 Gender?.* p. 166
219–20 *'One might see':* Ibid. p. 167
220 *'the violent desire':* Ibid. pp. 157–8
220 *'calling for segregation':* Ibid. p. 158
220 *'an alibi for forms of discrimination':* Ibid. p. 159
220 *'the framework for understanding':* Ibid. p. 160
221 *'not to replace the doubt':* Karen Ingala Smith, *Defending
 Women's Spaces* (Cambridge: Polity Press, 2022). p. 63
221 *'a state of mind':* Dworkin, 'Woman-Hating Right and Left'.
 p. 38
222 *'forget about rape':* Ibid.
222 *Victims have alleged:* 'Leah Remini Speaks out after Danny
 Masterson's Rape Sentencing', *Entertainment Weekly*
 <https://ew.com/celebrity/leah-remini-speaks-out-after-
 danny-masterson-rape-sentencing-against-church-of-
 scientology/> [accessed 16 February 2024].
222 *'no policy prohibiting':* Tom Williams, 'The Downfall
 of a Sitcom Star: How Danny Masterson's Rape Trial
 Led to Allegations against Scientology, and at Least 25
 Years in Prison', ABC News <https://www.abc.net.au/
 news/2023-09-08/danny-masterson-that-70s-show-rape-
 trial-scientology-prison/102830564> [accessed 25 September
 2024].
223 *'criminal justice represents protection':* Phipps. Kindle
 locations 983, 985
223 *'sees the punishment of bad men':* Srinivasan, 'Sex,
 Carcerealism, Capitalism', in *The Right to Sex.* p. 170
224 *'filed court cases':* Bates. p. 119
224 *'in future, abolition politics':* Phipps. Kindle location 2028
225 *'It seems ... such an innocuous thing':* Strinkovsky, 'Radfem
 Panic'.

Chapter 9: The Inner Beauty Myth

229 *Why are our bodies soft:* William Shakespeare, *The Taming of the Shrew*, in *The Complete Works* (Oxford: Oxford University Press, 1992), pp. 25–53.

229 *Come, you spirits:* William Shakespeare, *Macbeth*, in ibid, pp. 975–1000.

230 *'To look and feel well':* *Take a Look at Yourself* (London: National Dairy Council).

230 *'helped women rehearse':* Kenlon. p. 20

231 *'The definition of womanly behavior':* Ibid. p. 246

232 *a dramatic rise in the reporting:* Denis Campbell, 'Stress and Social Media Fuel Mental Health Crisis among Girls', *Guardian* <https://www.theguardian.com/society/2017/sep/23/stress-anxiety-fuel-mental-health-crisis-girls-young-women> [accessed 20 September 2023].

232 *'unable to develop an authentic sense':* Susie Orbach, *Hunger Strike: The Anorectic's Struggle as a Metaphor for Our Age* (Abingdon: Routledge, 2005). Kindle location 818

233 *'The world gets harder':* Hilary Mantel, 'Some Girls Want Out', *London Review of Books* <https://www.lrb.co.uk/the-paper/v26/n05/hilary-mantel/some-girls-want-out> [accessed 13 February 2020].

233 *'Women ... watch themselves':* Berger. p. 47

234 *'The beauty myth':* Wolf. p. 14

235 *'asks all the many privilege-loosely-defined women':* Maltz Bovy, *The Perils of 'Privilege'.* p. 204

235 *'moving from flesh to image':* Lyn Mikel Brown and Carol Gilligan, *Meeting at The Crossroads: Women's Psychology and Girls' Development* (Cambridge, MA: Harvard University Press, 1992). p. 168

235 *'judged against standards of perfection':* Ibid. p. 164

236 *'is not only about appearance':* Rosalind Gill, *Perfect: Feeling Judged on Social Media* (Cambridge: Polity Press, 2023). p. 4

236 *'a central relational crisis':* Brown and Gilligan. p. 214

236 *'if a woman conforms':* Kenlon. p. 287

237 *'if you think a stranger's gender':* Lucy Sherriff, '"Transphobic" Posters at Bristol University Tell Women "Men Know Better Than You"' *HuffPost* <https://www.huffingtonpost.co.uk/2015/01/21/transphobic-poster-bristol-university-rape-9-times_n_6513804.html> [accessed 22 February 2024].

237 'kindly ignore the fact': Ibid.
237 'comfortable with discomfort': 'It's Okay to Feel
 Uncomfortable with Diversity and Inclusion', Next Pivot
 Point <https://nextpivotpoint.com/the-comfort-with-
 discomfort-of-diversity-and-inclusion/> [accessed 22
 February 2024].
237–8 'there is a distinction': 'Inclusive Language Guide',
 Oxfam <https://oxfamilibrary.openrepository.com/
 handle/10546/621487> [accessed 10 September 2023].
239 'a man labels a woman': de Becker. p. 66
239 What do I know?: Phipps. Kindle location 2047
239 'she tells herself': de Becker. p. 33
241 'The men are understandably baffled': Kenlon. p. 29
242 'lifting their voice': Jean Hatchet, 'The Performance
 of a Lifetime', The Critic <https://thecritic.co.uk/
 the-performance-of-a-lifetime/> [accessed 10 April 2023].
242 'how did that get past': Hadley Freeman, 'Why I Stopped
 Being a Good Girl', UnHerd <https://unherd.com/2022/02/
 why-i-stopped-being-a-good-girl/> [accessed 5 May 2023].
243 'juicily transgressive': Sophie Kemp, 'Andrea Long Chu on
 Her Juicily Transgressive Book, Females', Vogue <https://
 www.vogue.com/article/andrea-long-chu-interview-females>
 [accessed 27 March 2024].
243 'performatively edgy': Eve Tushnet, 'Is Everyone
 Female?', Commonweal Magazine <https://www.
 commonwealmagazine.org/everyone-female> [accessed 27
 March 2024].
243 'a thrilling provocation': 'Females by Andrea Long Chu',
 Verso Books <https://www.versobooks.com/en-gb/blogs/
 news/4479-females-by-andrea-long-chu> [accessed 27
 March 2024].
243 'I'm so wet for you': Rebecca Makkai, I Have Some
 Questions For You (London: Fleet, 2023). p. 69
245 'being a victim': Phipps. Kindle location 169
246 'the privileged are blinded': Helen Pluckrose and James
 Lindsay, Cynical Theories (London: Swift Press, 2021).
 Kindle location 3334
246 'the job of a loyal ally': Mounk. p. 135
246 'in this new gender structure': Ekman. p. 334
248 'that her body is getting away': de Beauvoir. p. 333
249 'A woman who is opinionated': Orbach. Kindle location
 826

249 *'women are supposed to be'*: Virginia Woolf, *A Room of One's Own* (LVL Editions, 2016). Kindle location 916

249 *'Suffering that falls'*: Maltz Bovy, *The Perils of 'Privilege'*. p. 262

250 *'the answer to disruptive women'*: Sarah Moss, 'Men are deemed more masculine for taking up more space, women more feminine for taking up less', *Irish Times* <https://www.irishtimes.com/life-style/people/2024/10/28/men-are-deemed-more-masculine-for-taking-up-more-space-women-more-feminine-for-taking-up-less/> [9 November 2024]

Chapter 10: Whole Selves, Relational Selves

253 *... we are wired*: Marina Benjamin, *A Little Give: The Unsung, Unseen, Undone Work of Women* (London: Scribe, 2023). p. 99

253 *If you are inclined*: Alex Byrne, *Trouble with Gender* (Cambridge: Polity Press, 2023). p. 193

255 *'the most basic questions'*: Gilligan, *In a Different Voice*. p. xiv

255 *'looking-glasses possessing'*: Woolf. Kindle location 455

257 *'easier than the old feminism'*: Martha Nussbaum, 'The Professor of Parody', *New Republic* <https://newrepublic.com/article/150687/professor-parody> [accessed 3 April 2023].

258 *'queer legal theory must transcend'*: Francisco Valdes, 'Queers, Sissies, Dykes, and Tomboys: Deconstructing the Conflation of "Sex," "Gender," and "Sexual Orientation" in Euro-American Law and Society', *California Law Review*, 83:1 (1995) <https://doi.org/10.2307/3480882>. p. 371

258 *Kayla Lemieux*: Brendan O'Neill, 'Kayla Lemieux and the Cult of Validation', *Spiked* <https://www.spiked-online.com/2022/09/25/kayla-lemieux-and-the-cult-of-validation/> [accessed 1 March 2024].

258 *'It feels like the progressive thing'*: Phoebe Maltz Bovy, 'Opinion: Ontario Teacher's Prosthetic Bust Offers a Lesson about Body Shaming', *Globe and Mail* <https://www.theglobeandmail.com/opinion/article-ontario-students-and-educators-receive-a-lesson-in-body-shaming/> [accessed 1 March 2024].

260 *'the Subject [...] the Absolute'*: de Beauvoir. p. 16

261 *'aiming to eliminate'*: 'You Arc Oppressing Us!',

Feministkilljoys <https://feministkilljoys.com/2015/02/15/
you-are-oppressing-us/> [accessed 15 June 2024].

261 'For if she begins': Woolf. Kindle location 455
261 'malleable': Roy F. Baumeister, 'Gender Differences in
 Erotic Plasticity: The Female Sex Drive as Socially Flexible
 and Responsive', *Psychological Bulletin*, 126:3 (2000)
 <https://doi.org/10.1037/0033-2909.126.3.347>.
261 'better at self-control': Baron-Cohen. p. 90
261 'superhuman feats of flexibility': Hanna Rosin, *The End of
 Men* (New York: Riverhead, 2012). pp. 7–9
261 'The job market': Marçal. p. 59
262 'constructed positively as individuality': Lynch. p. 131
262–3 'to develop a political and cultural': Ibid. p. 3
263 'It may well be more honest': Benjamin. p. 160
263 'what constitutes through division': Judith Butler, *Gender
 Trouble*. p. 170
264 'The belief that women exist': Dworkin, *Pornography*. p. 117
264 'to be female is': Chu. p. 58
264 'You are not the central': Ibid. p. 33
265 'to define experience': Dworkin, *Pornography*. p. 43
265 'the self is co-created': Lynch. p. 3
265 'no bondage, no delight': Nussbaum.
266 'There is something fundamentally unbounded': Benjamin.
 p. 100
266 'to let the hurt of others in somehow': Ibid. p. 62
266 'to achieve an impossible impermeability': Judith Butler,
 Gender Trouble. p. 170
267 'If we won't respect the binary': Frances-White. p. 249
268 'someone's gender identity': Byrne. p. 188
269 'Society … has told [woman]': Marçal. p. 29
269 'When the focus on individuation': Gilligan, *In a Different
 Voice*. p. 17
269 'an aberration of the adult human condition': Lynch. p. 52
270 'become abject by association': Ibid. p. 56
270 'recognising the relationality': Ibid. p. 3
270 'destroying the sex/gender distinction: Chambers. p. 149

Afterword

271 *Of course, both men and women*: Kenlon. p. 58
271 *I have learned*: Freeman, 'Why I Stopped Being a Good
 Girl'.

271 'Above all be kind': A Gift of Kindness <https://www.
 agiftofkindness.net/> [accessed 20 October 2023].

271–2 'to relate your kindness stories': 'Your Kindness Stories',
 A Gift of Kindness <https://www.agiftofkindness.net/
 kindness-stories> [accessed 20 October 2023].

273 'the feelgood story of lockdown': Tim Adams, 'The
 Curious Case of Captain Tom: How Did the Feelgood
 Story of Lockdown Turn Sour?', Guardian <https://www.
 theguardian.com/uk-news/2023/dec/10/captain-tom-moore-
 hannah-ingram-moore-daughter-spa> [accessed 20
 December 2023].

273 most of whom are female: 'Unpaid Care by Age, Sex
 and Deprivation, England and Wales: Census 2021',
 Office for National Statistics <https://www.ons.gov.uk/
 peoplepopulationandcommunity/healthandsocialcare/
 socialcare/articles/unpaidcarebyagesexanddeprivation
 englandandwales/census2021> [accessed 24 March 2024].

273 'as the vocation that it is': 'Top Tory Tells Nurses to See
 the Job "as the Vocation That It Is" Rather than Striking',
 NursingNotes <https://nursingnotes.co.uk/news/politics/top-
 tory-tells-nurses-to-see-the-job-as-the-vocation-that-it-is-
 rather-than-striking/> [accessed 24 March 2024].

274 'weaponised by the right': Steve Rose, 'How the Word
 "Woke" Was Weaponised by the Right', Guardian,
 <https://www.theguardian.com/society/shortcuts/2020/
 jan/21/how-the-word-woke-was-weaponised-by-the-right?
 CMP=Share_AndroidApp_Other> [accessed 5 April 2023].

275 'I said I liked the wrong person': Nicky Clark, 'Leaving
 Kindland, Entering Reality', The Critic <https://thecritic.
 co.uk/leaving-kindland-entering-reality/> [accessed 26
 March 2024].

275 Call this 'war on woke': <https://twitter.com/andypic/
 status/1563298983354609665> [accessed 10 April 2023].

275 If to be 'woke': <https://twitter.com/SteveChalke/status/
 1642056589896036354?t=Q2xNLtiWLLlZE7ya82_
 93g&s=09> [accessed 5 April 2023].

276 Being 'anti-woke': <https://twitter.com/DrAnnieHickox/
 status/1643580942651383808> [accessed 5 April 2023].

276 'a large well informed group': 'WOKE MOB', IFunny
 <https://ifunny.co/picture/woke-mob-a-large-well-informed-
 group-of-people-with-RjMaBrtJA> [accessed 14 December
 2023].

NOTES 313

276 *In March 2023:* 'Is Oxfam's Language Guide Taking Sides
 in the Culture War? ', *Guardian*, <https://www.theguardian.
 com/world/2023/mar/31/is-oxfam-language-guide-taking-
 sides-in-the-culture-war?CMP=Share_AndroidApp_Other>
 [accessed 10 April 2023].
278 *'as nature has given man':* David Hume, 'Of the Rise
 and Progress of the Arts and Sciences', in *Essays. Moral,
 Political and Literary* (Indianapolis: Liberty Classics, 1985).
 p. 133
278–9 *'sometimes by saying something often':* Amia Srinivasan,
 'Does Feminist Philosophy Rest on a Mistake?', speech
 given at the KCL MAP Conference: Identity and
 Underrepresentation, 4 July 2015 <https://users.ox.ac.
 uk/~corp1468/Research_files/Does%20Feminist%20
 Philosophy_KCL%20talk.pdf> [accessed 9 November 2024]
280–1 *'I wonder':* Leslie Jamison, 'The Empathy Exams', in *The
 Empathy Exams: Essays* (London: Granta, 2014). p. 23

ACKNOWLEDGEMENTS

This book started life as an initial sense of irritation at the repetition of a particular phrase – how it was used, whom it targeted, what kind of messages it reinforced. I am enormously grateful to the people (all of them truly kind) who allowed me to develop this into something more.

As ever, I owe a huge debt of thanks to my brave, tireless agent, Caroline Hardman. I am also deeply indebted to Ursula Doyle, for all her insight, support and enthusiasm during the initial stages of this book's development. My publisher Clare Smith's wise comments and guidance on the first draft manuscript allowed me to see a way through so many difficult areas. I'd also like to thank Zoe Gullen for being such a safe pair of hands during the later editorial stages, and Zoe Hood for her enthusiastic work on the book's marketing.

For being generous enough to discuss the issue of kindness in its various guises (and misrepresentations), I'd like to give particular thanks to the following brilliant women: Kate Long; Francesca C. Mallen; Rachel Rooney; Stephanie Davies-Arai; Stella O'Malley; Onjali Rauf. I am also incredibly privileged to have benefited from the friendship and

feminist insight of Marina Strinkovsky, Jane Clare Jones, Rebecca Reilly-Cooper, Anya Palmer, Rachel Hewitt, Sarah Ditum, Michelle Arouet, Juliet Oosthuysen, Karen Kruzycka, Gia Milinovich and others.

Acknowledgement remains a fraught issue in feminism. I am very conscious in writing this work that I have used ideas developed by many women over many years, and shared with me in multiple discussions. I'm also conscious that in recent times expressing opinions on particular topics – especially those relating to sex and gender – has led to many women experiencing a great deal of punishment for their 'cruelty', and very little credit for their thoughtfulness and bravery. There are many women whose names are not mentioned in this book, whose names I may not even know, to whom I owe an enormous debt of thanks.

(Un)kind would never have been completed without the support of my partner, Ewan Johnson, without whom I would have had neither the time to write nor the capacity to disconnect emotionally from many of the book's issues. I can't imagine what it is like to have a partner who is quite so insistent on sticking her hand in the fire while constantly complaining it hurts, but not once have I been asked why, if I don't want everyone to think I'm an unkind person, I insist on writing something which will inevitably make me run such a risk. Ewan has taught me so much about love, trust and kindness, and if I do feel able to take these risks, so much of this is down to him.

I'd also like to thank our three children for their love and wisdom during the writing of this. That, as discussed in these pages, I have often found 'raising boys' messaging unsettling and strange is related not least to the joy I find in raising you – kind, open, generous people, defying norms in the best kinds of ways.

There is a part of me that would like to finish this by adding a long list of all of the people who have ever been kind to me personally, especially in situations where I have not been kind in return. Not only would doing so be ridiculously self-indulgent, such a list would be far too long. I have thought about it, though, all the while I have been writing this. These acts and relationships make us. I hope you know who you are, though the kindest people so often don't. Thank you all the same.

Victoria Smith is the author of *Hags: The Demonisation of Middle-Aged Women*. Her journalism appears in the *Critic*, the *New Statesman* and various other publications.